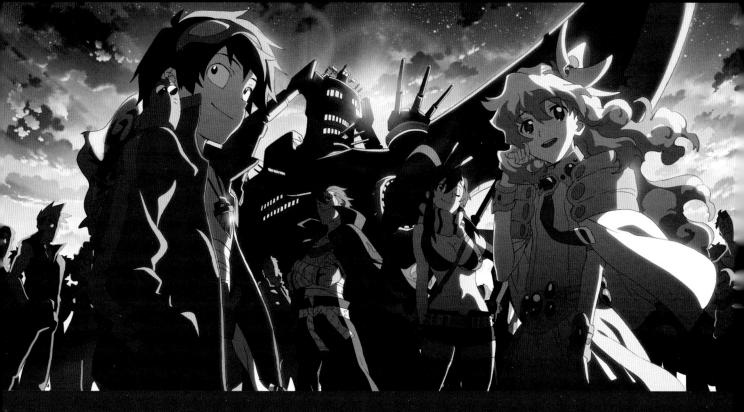

JS / SPIRAL STONE

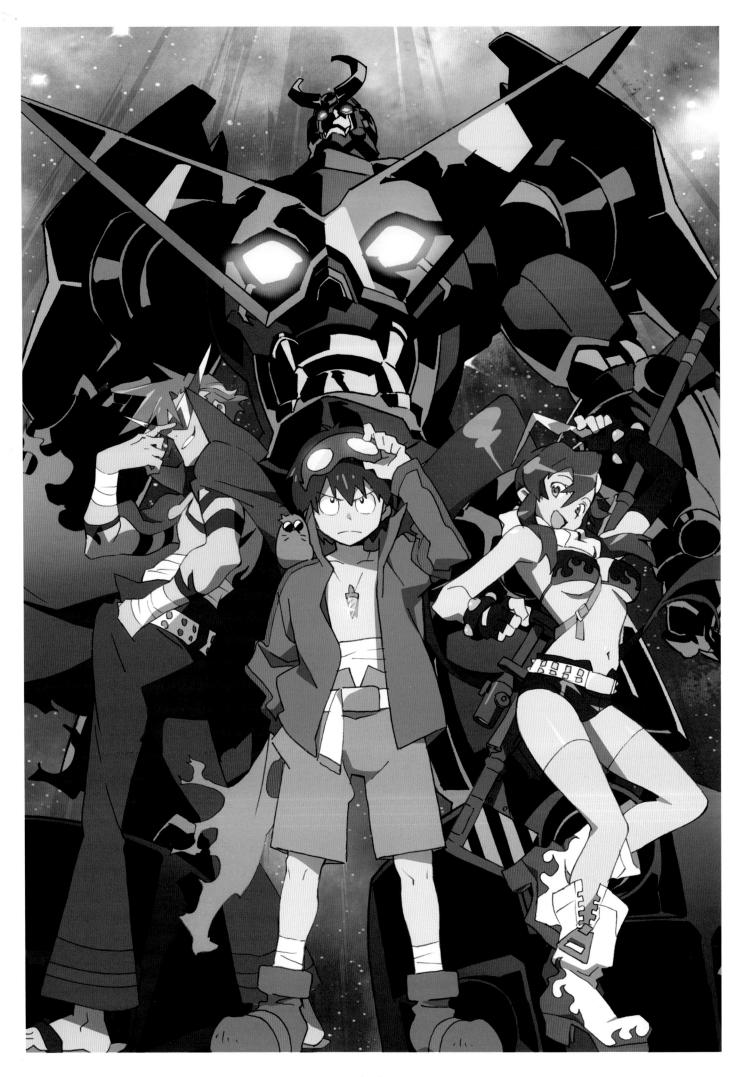

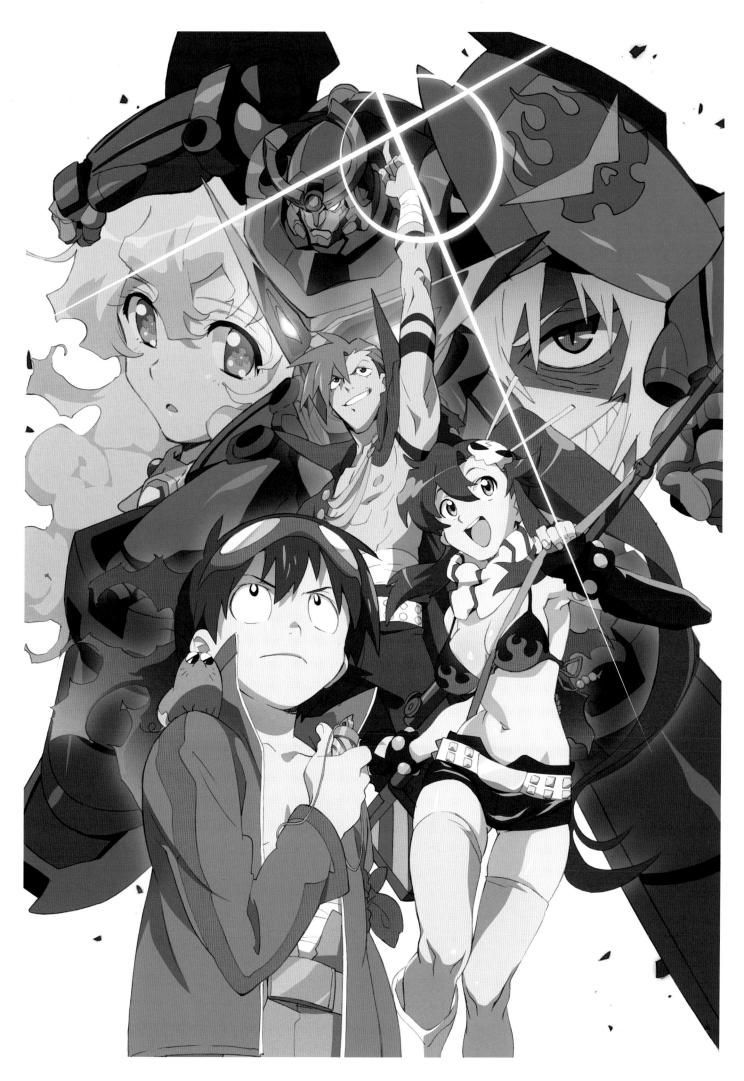

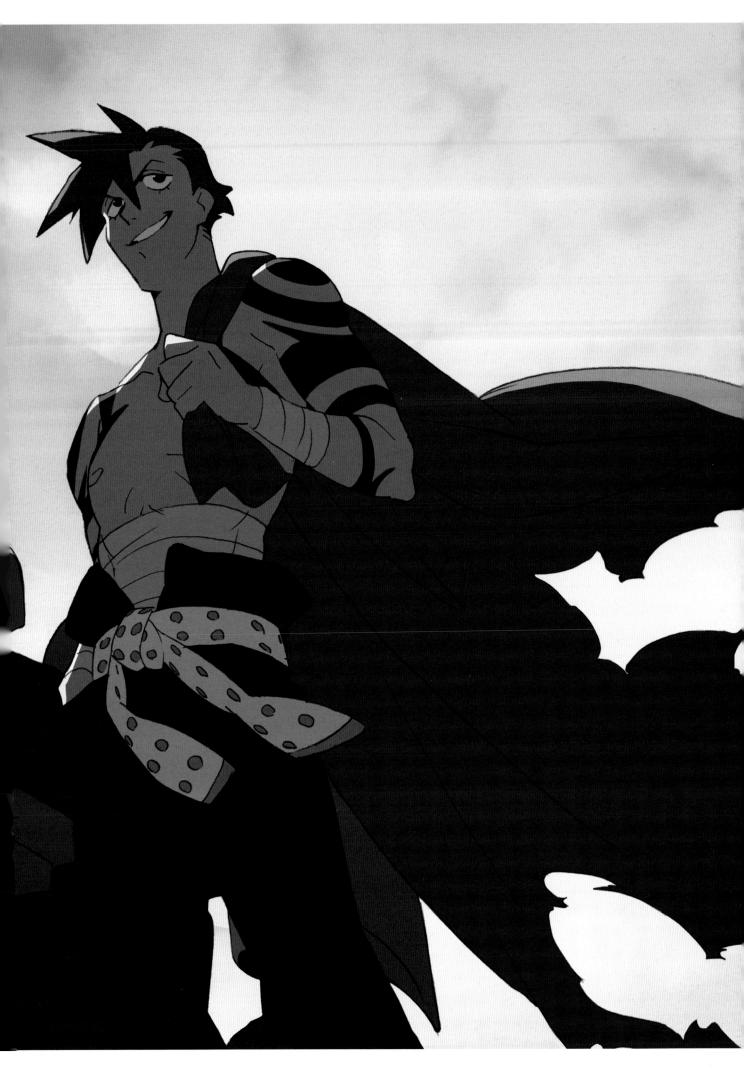

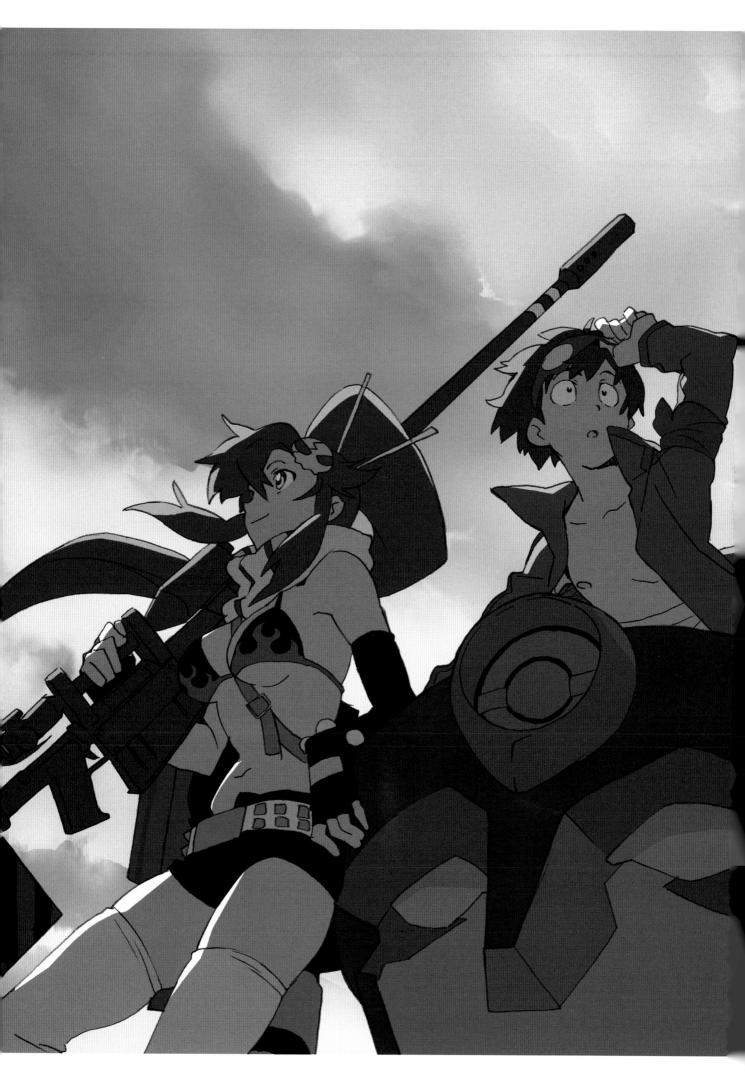

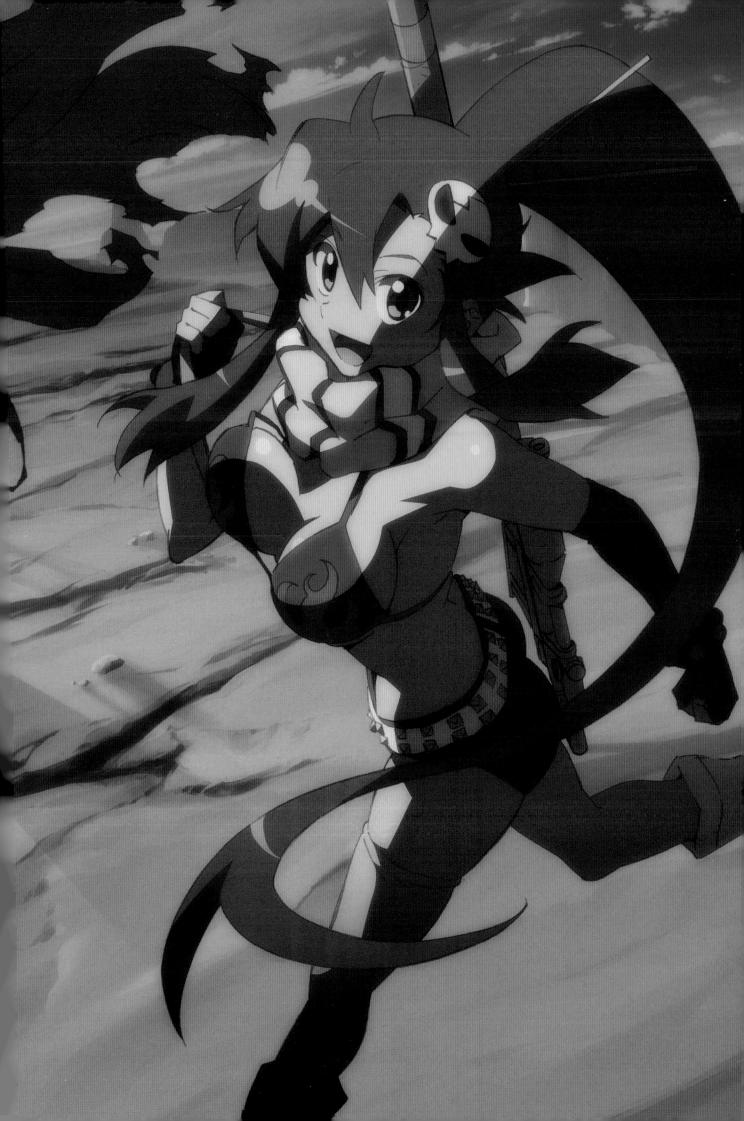

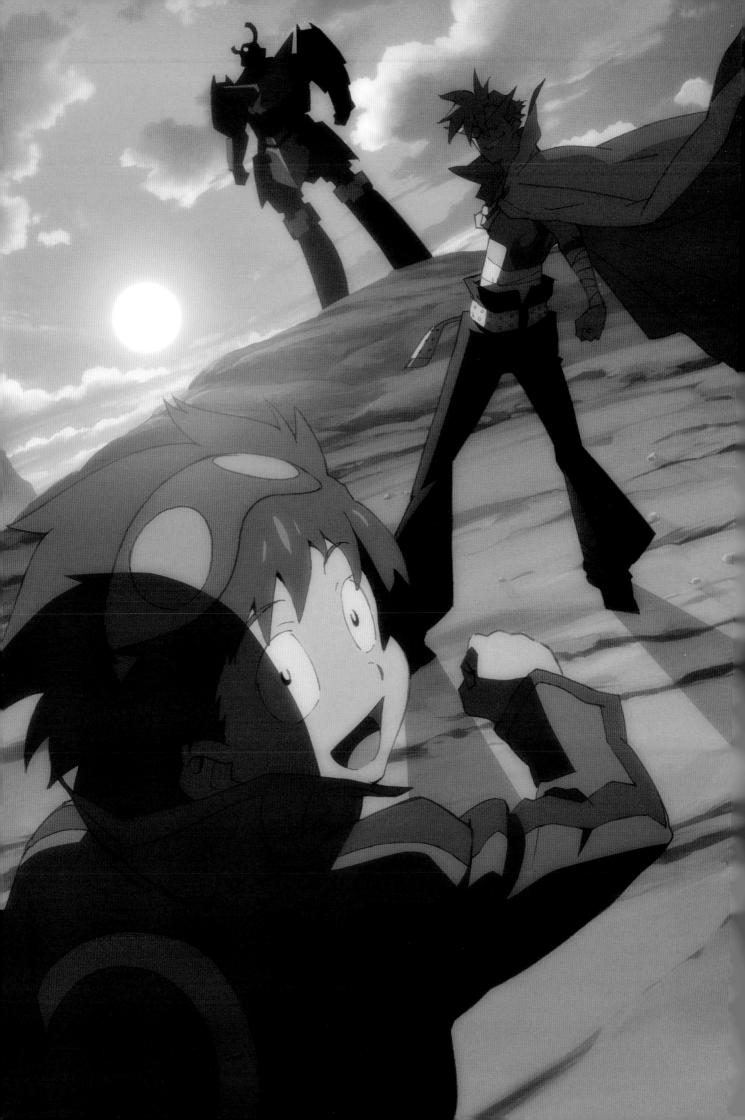

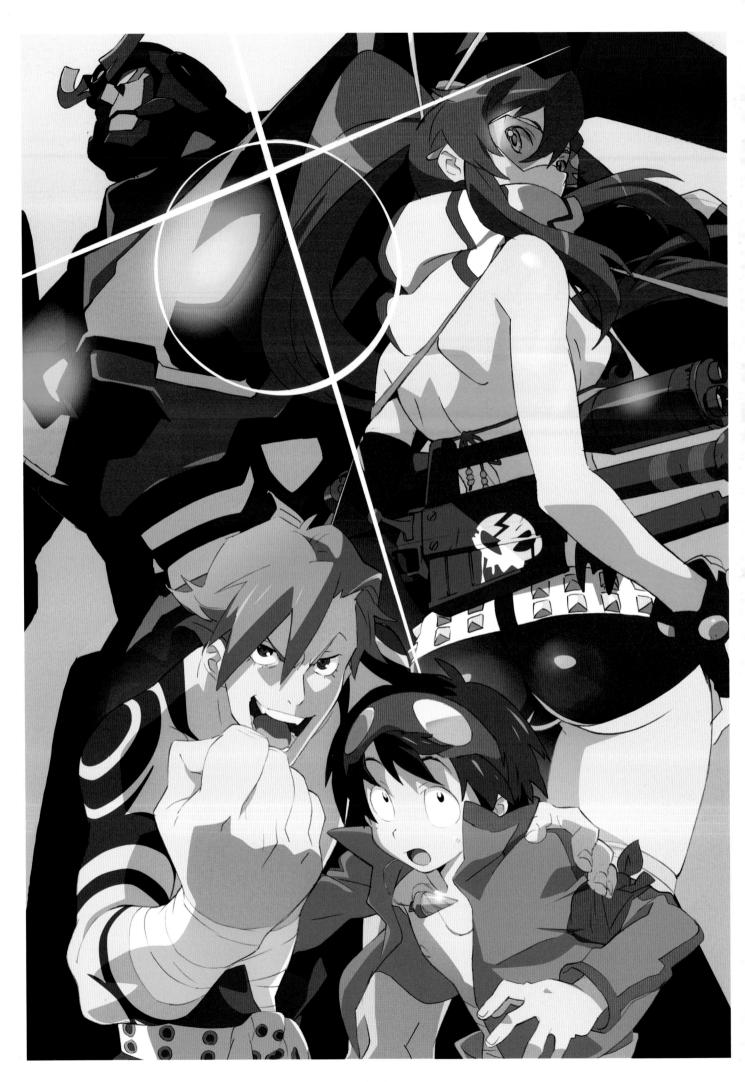

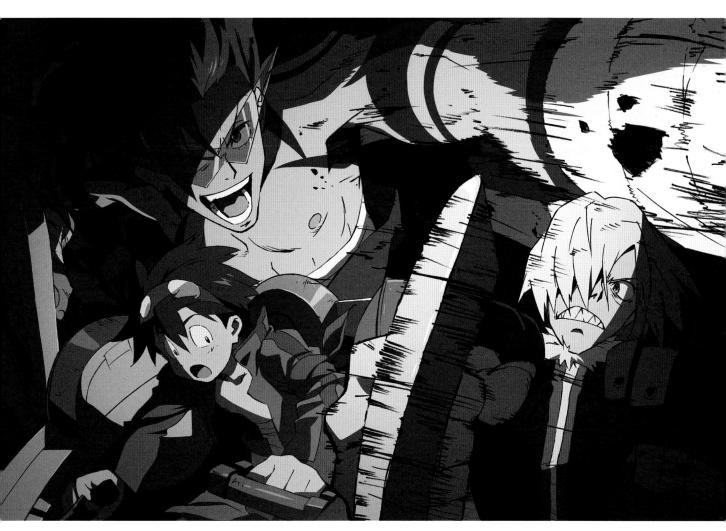

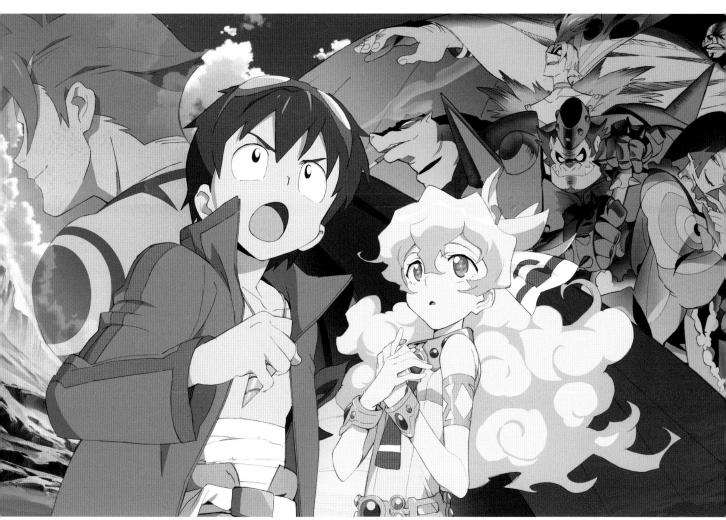

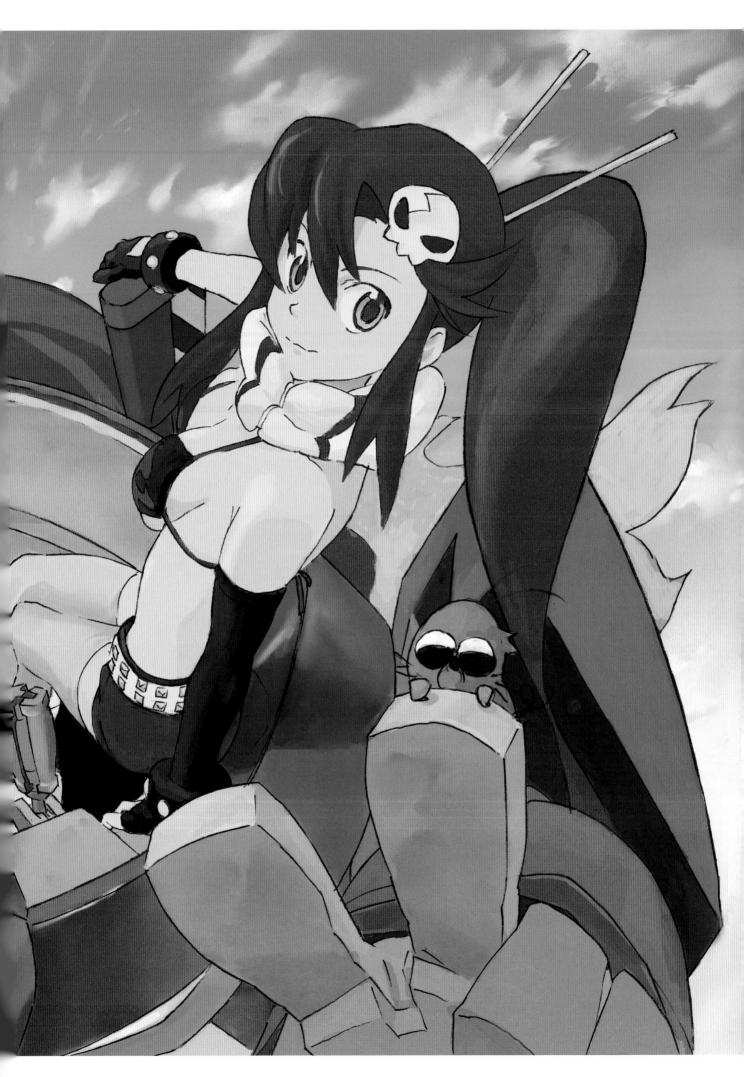

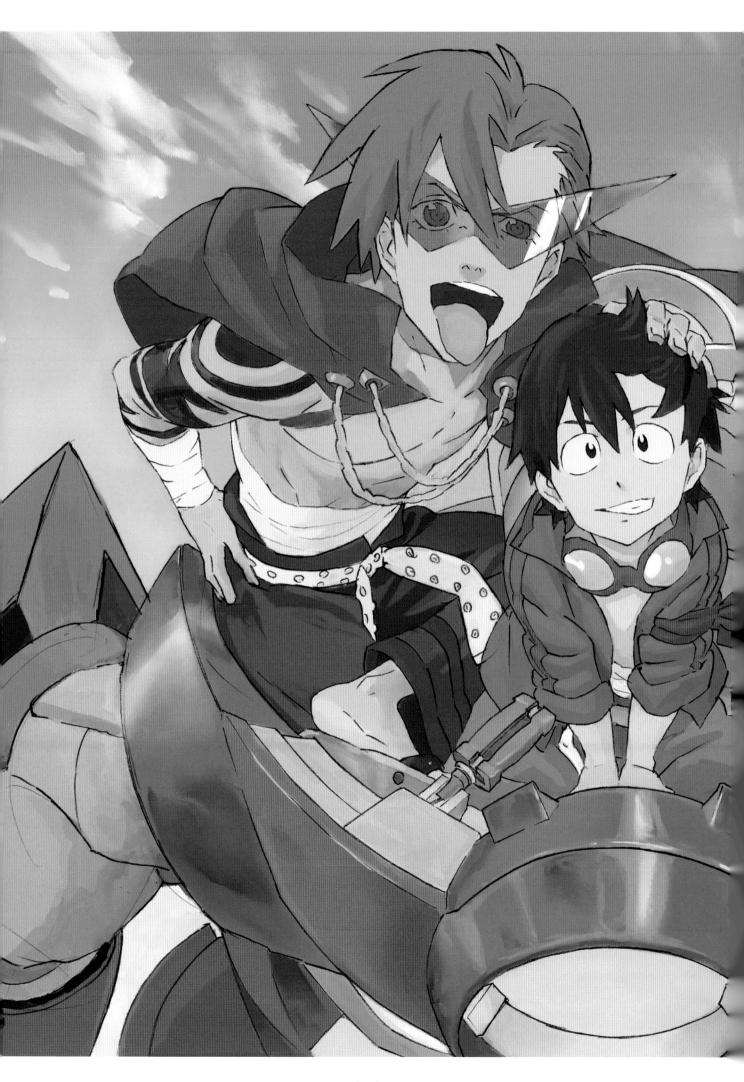

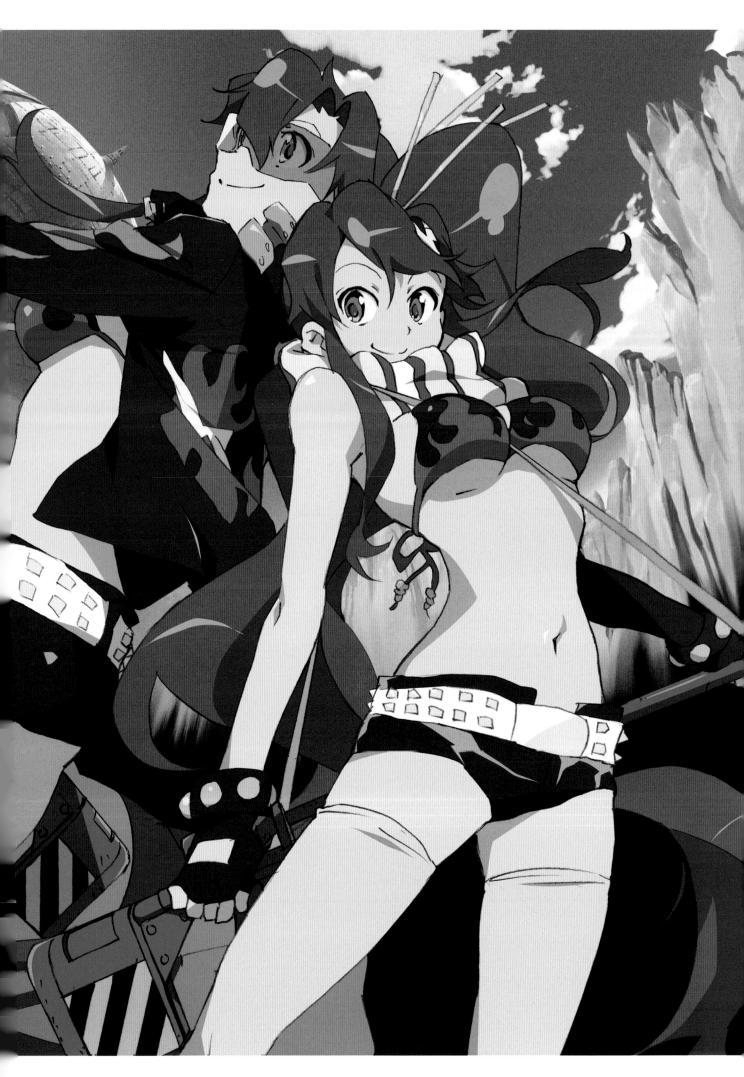

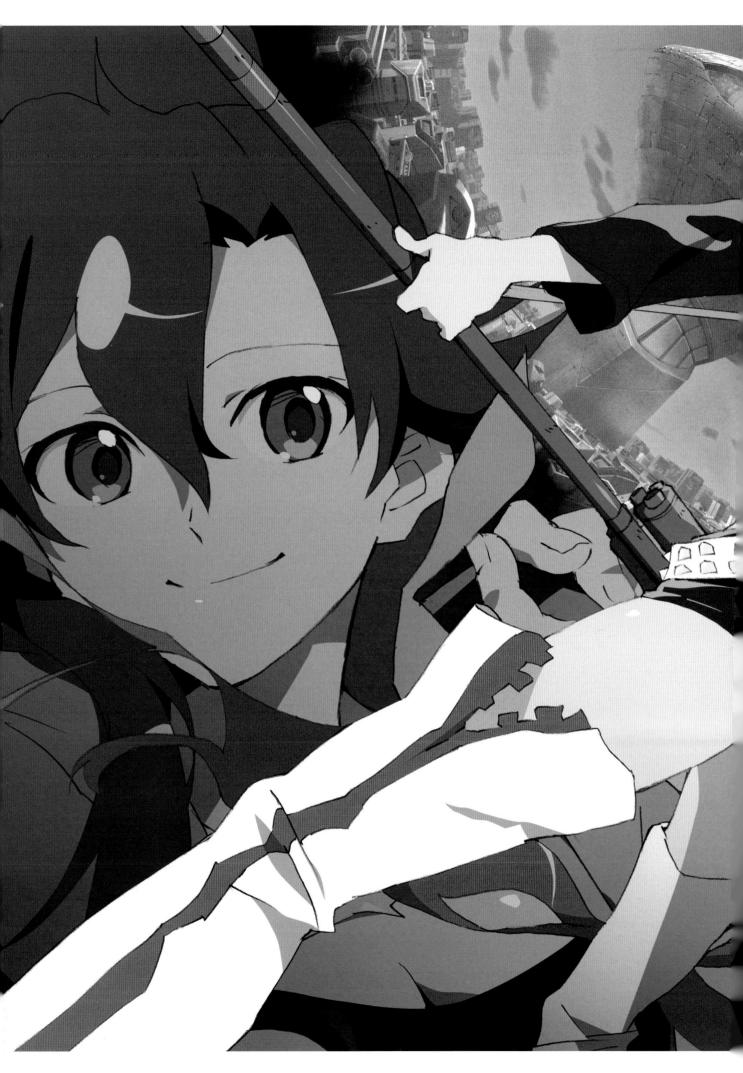

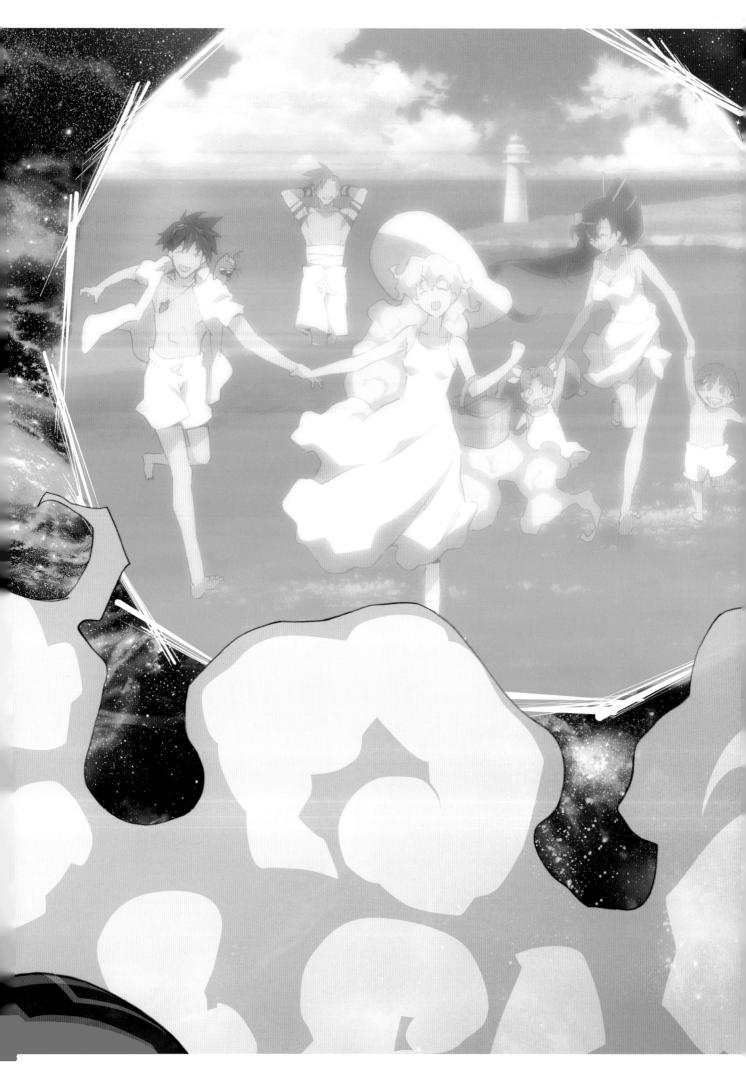

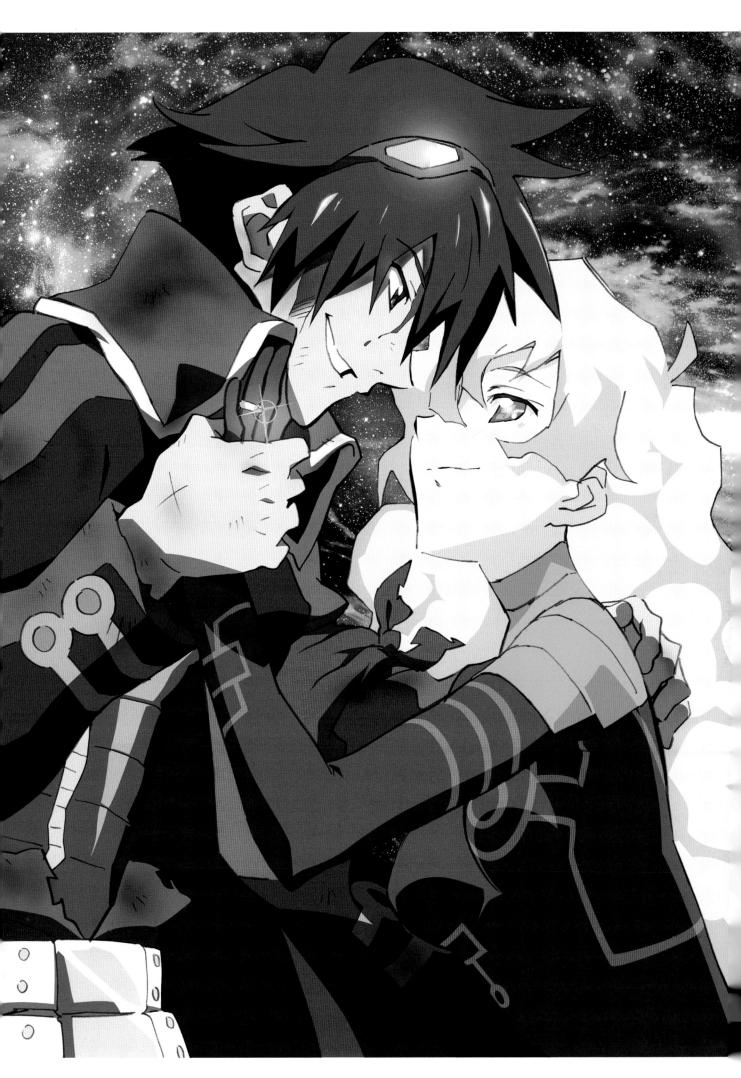

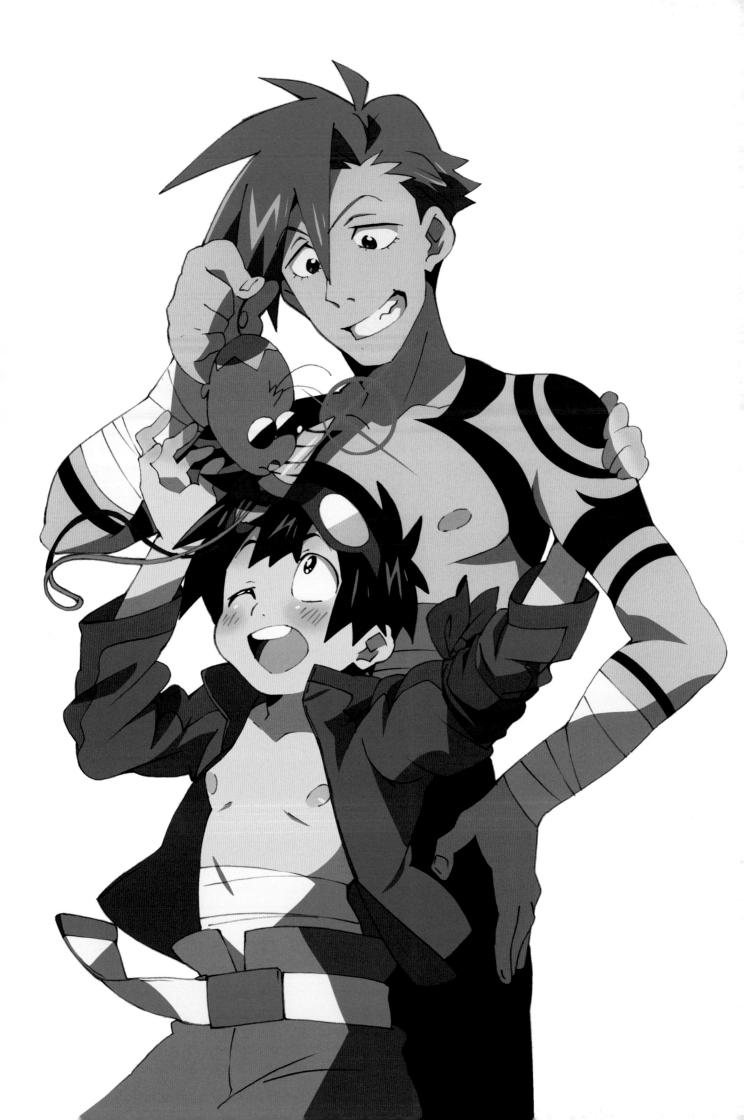

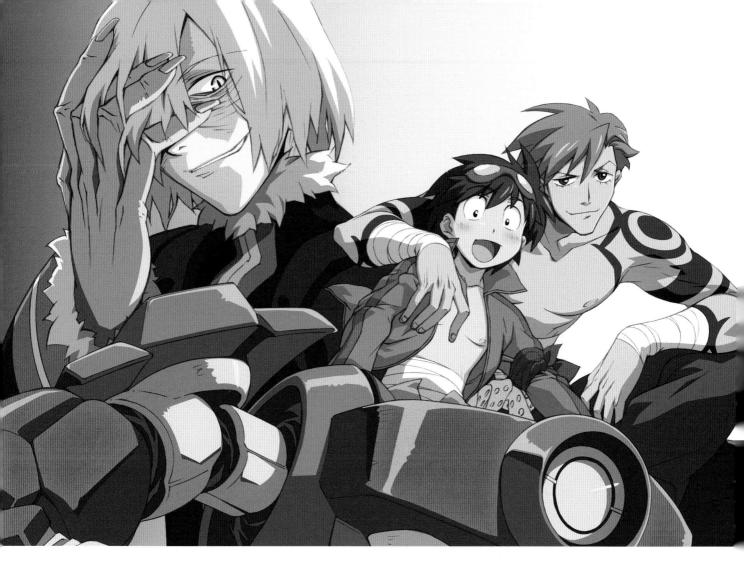

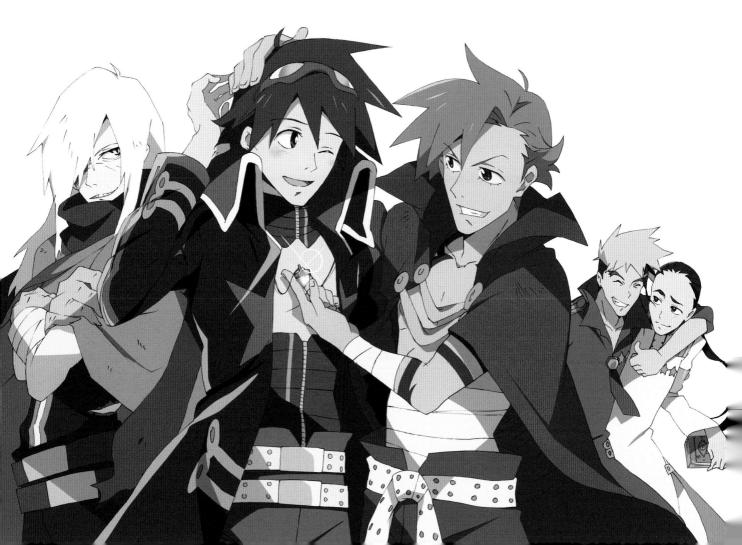

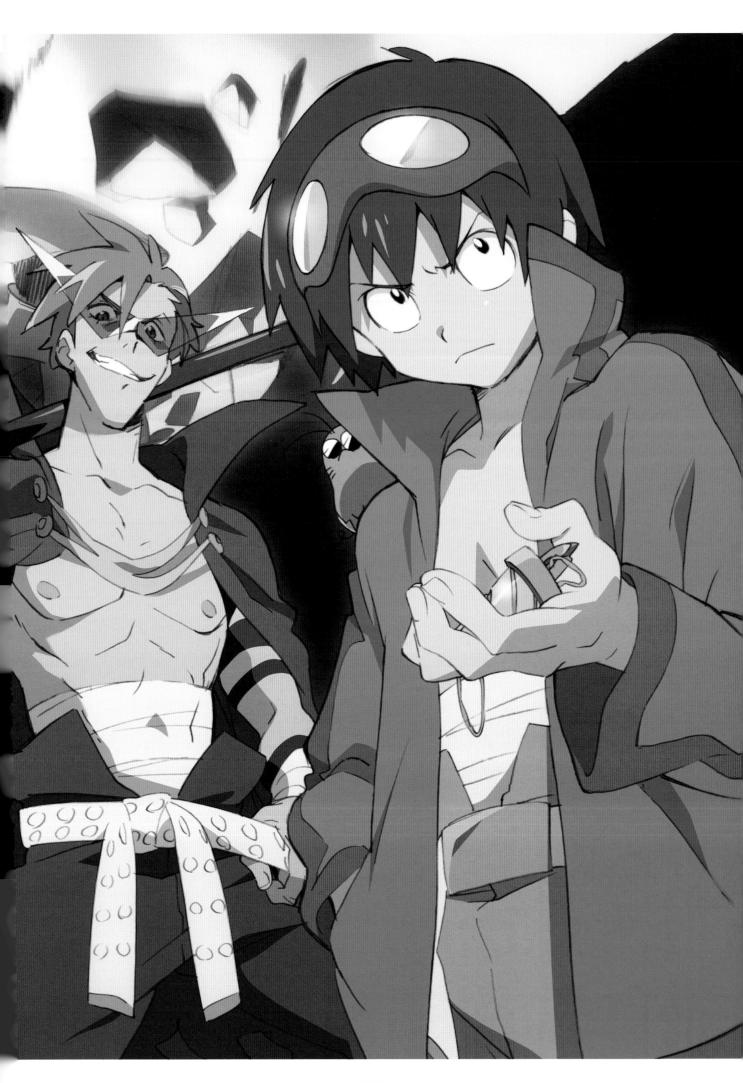

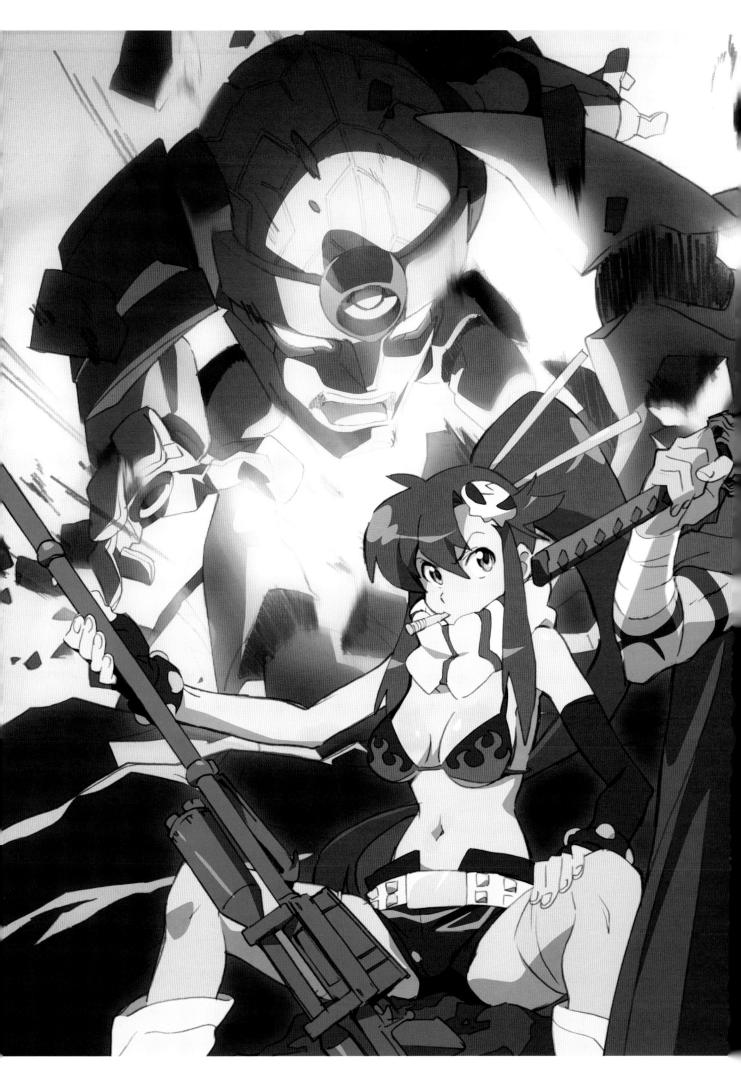

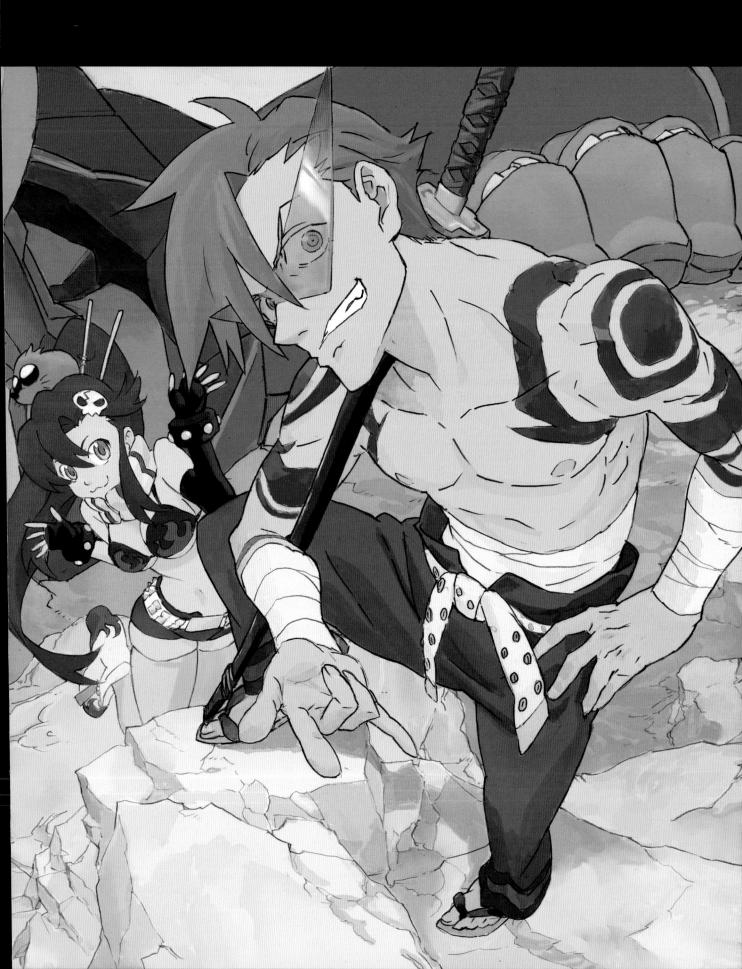

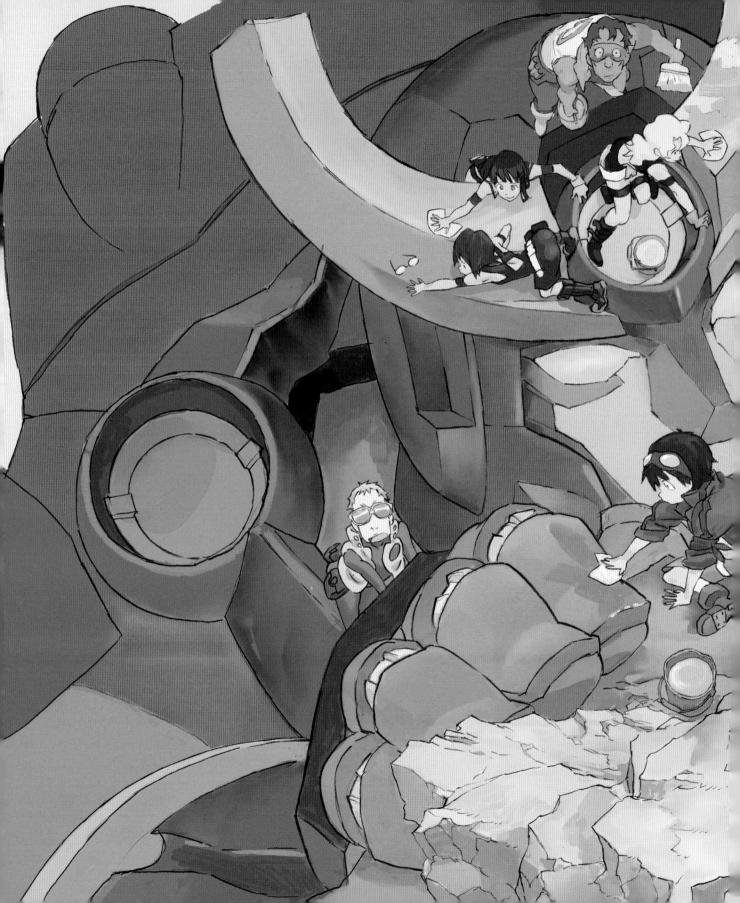

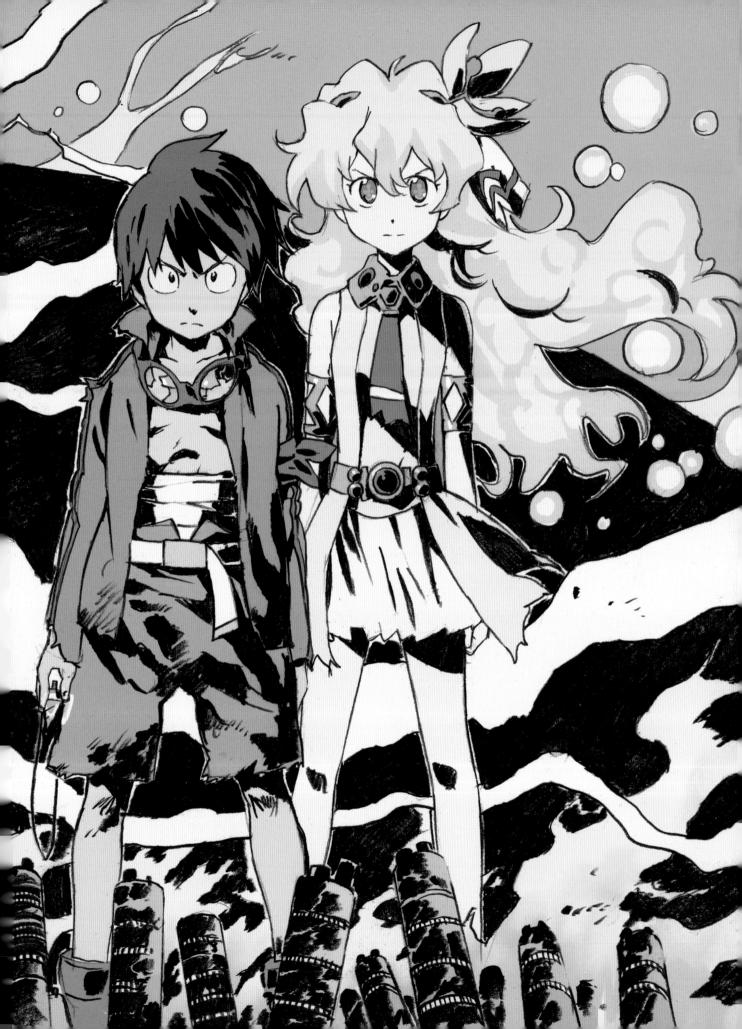

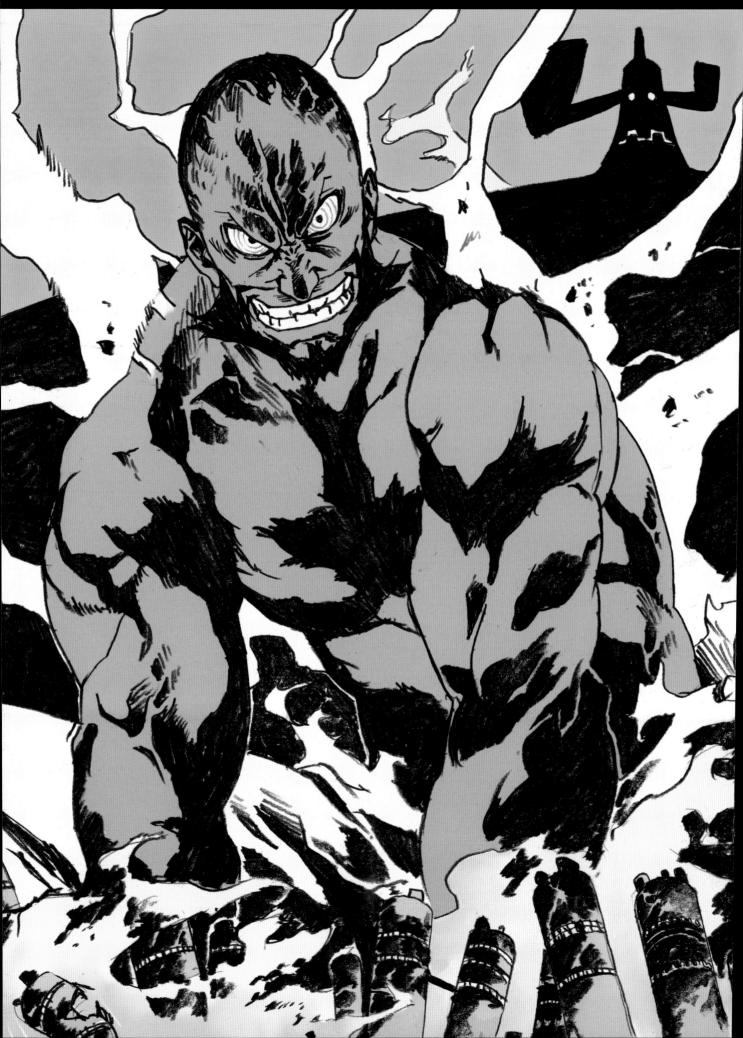

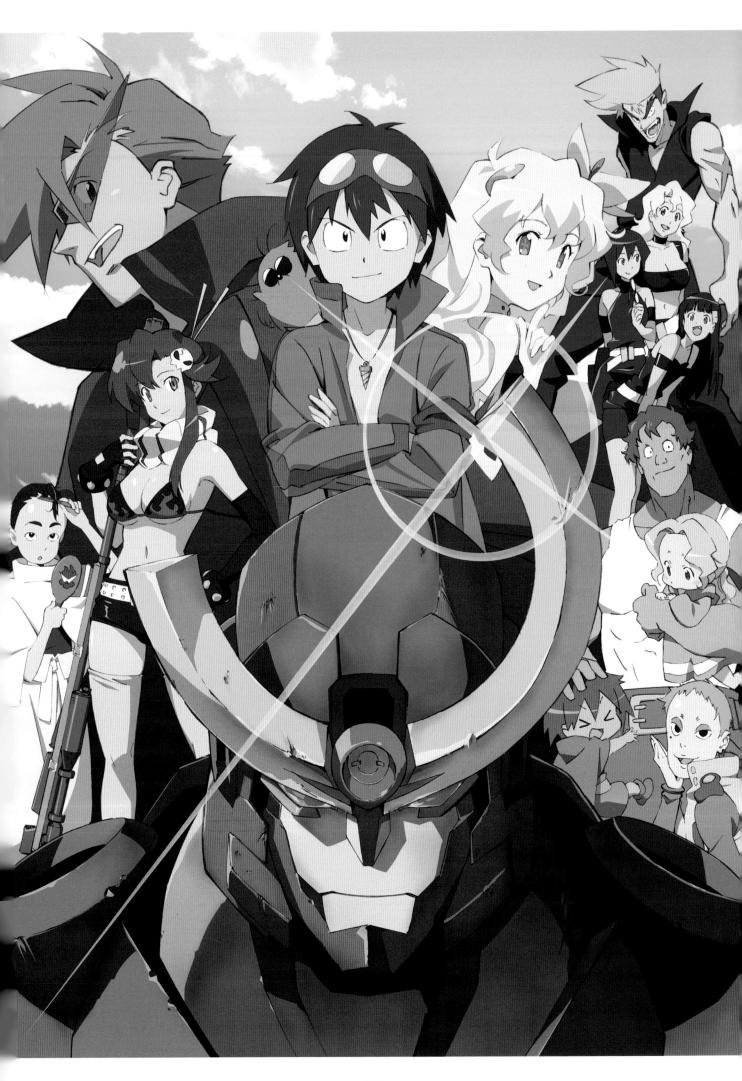

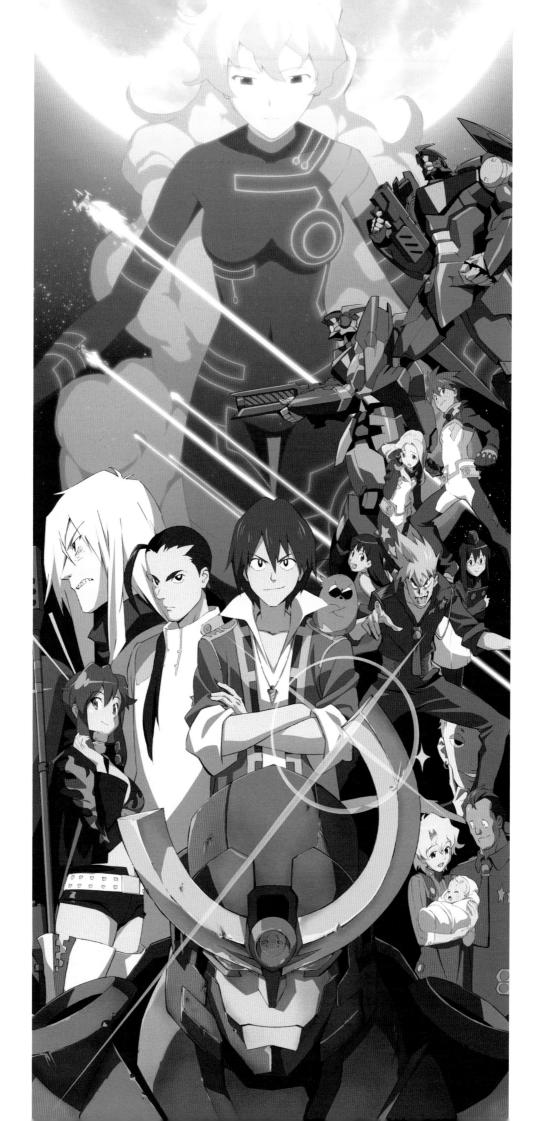

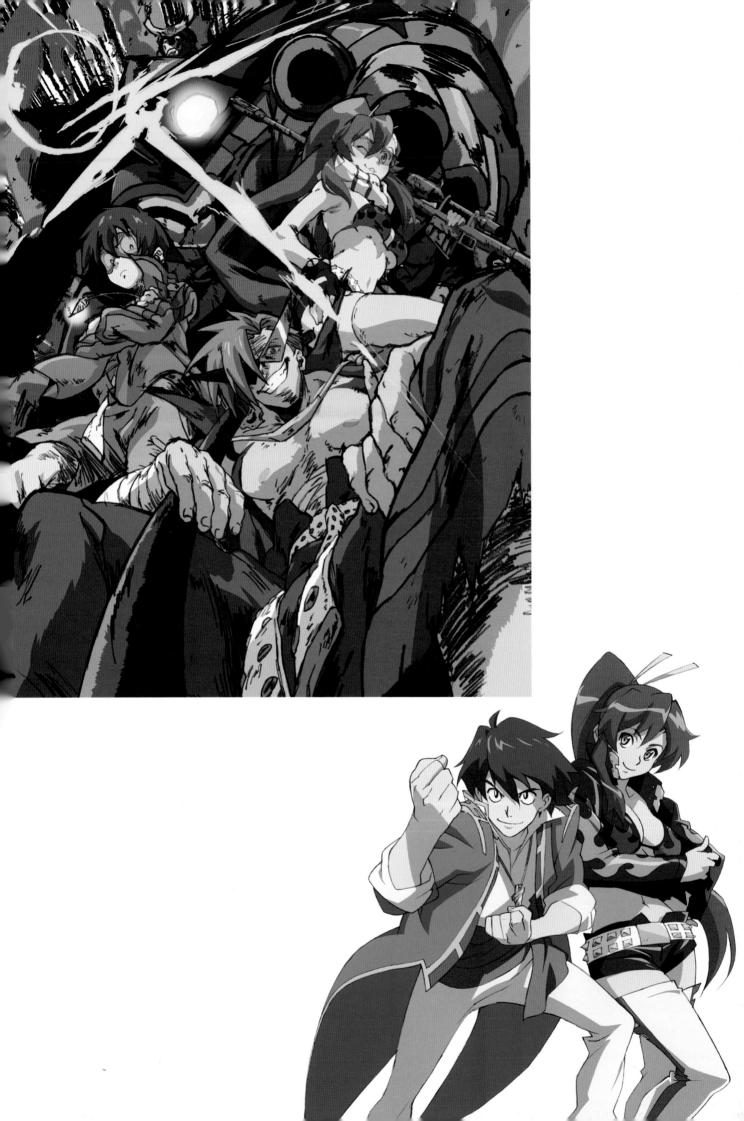

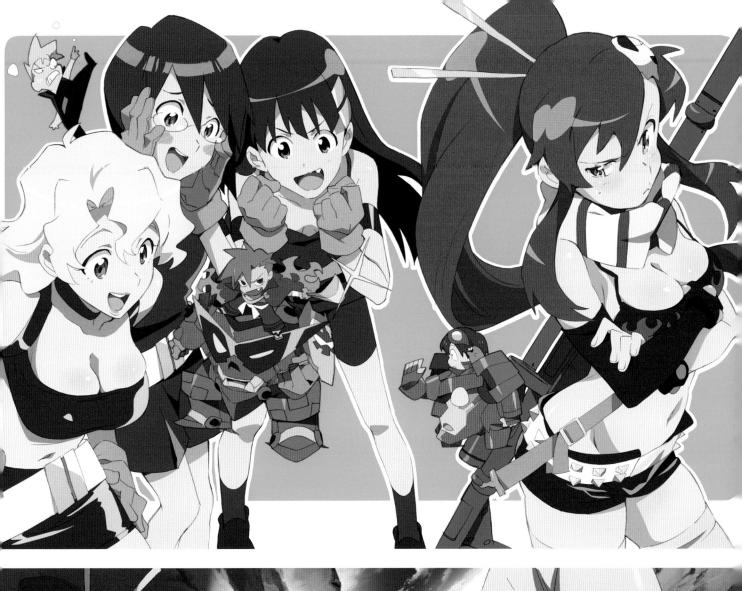

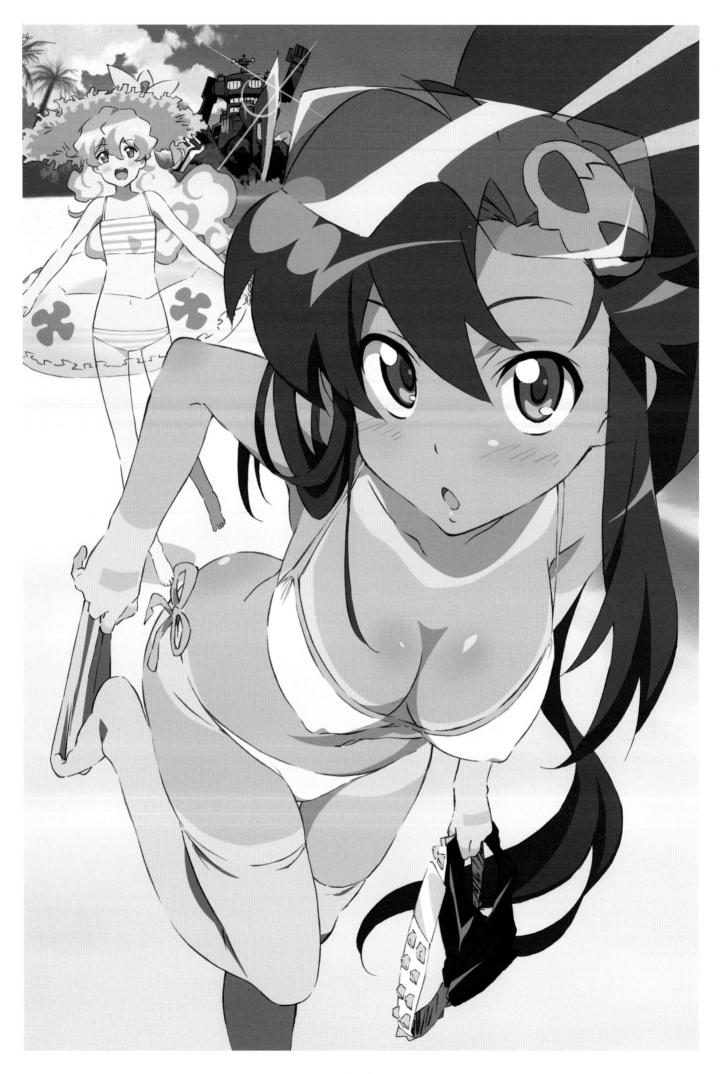

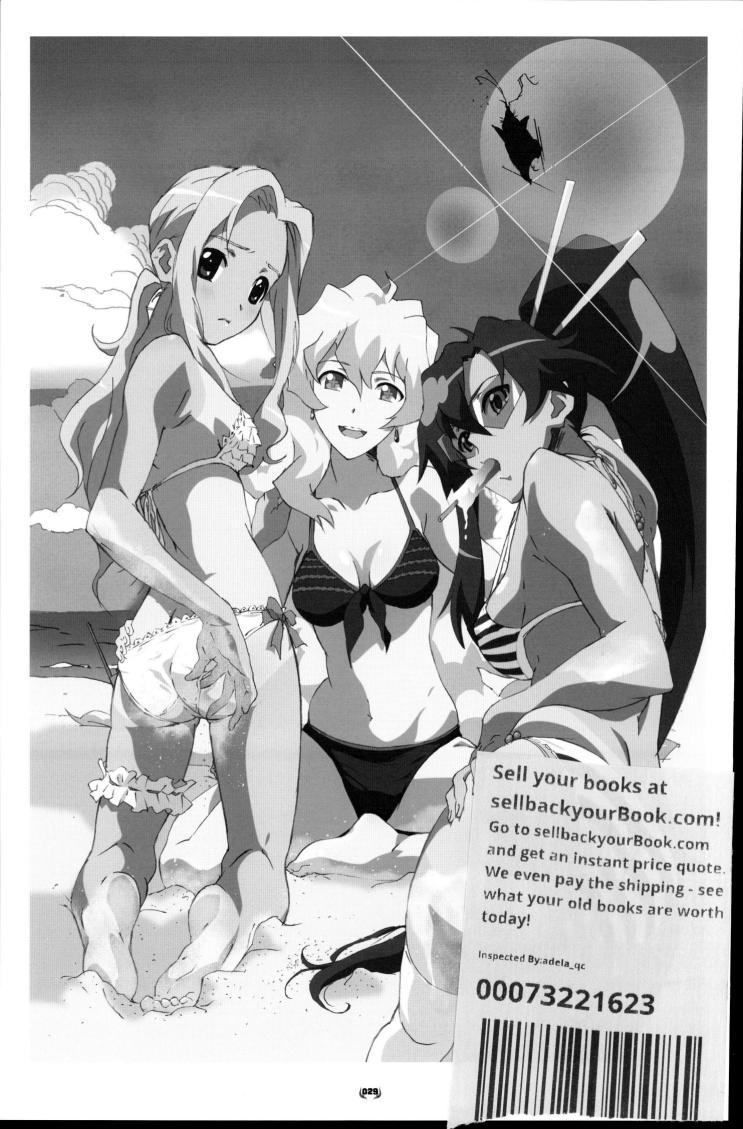

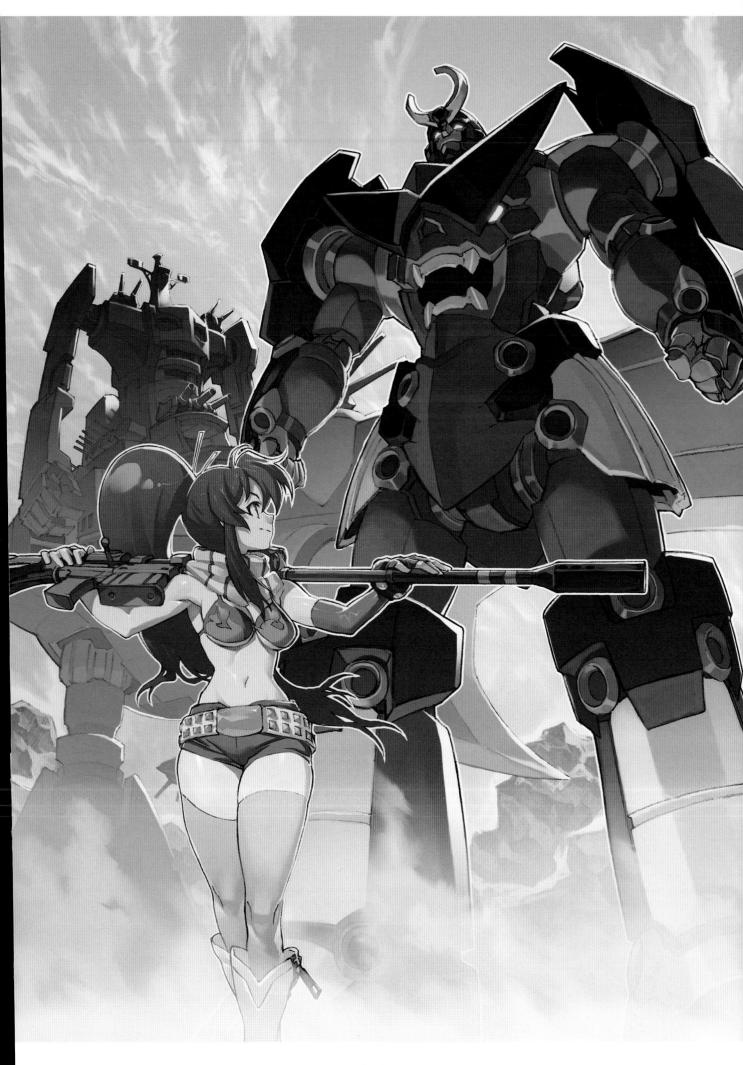

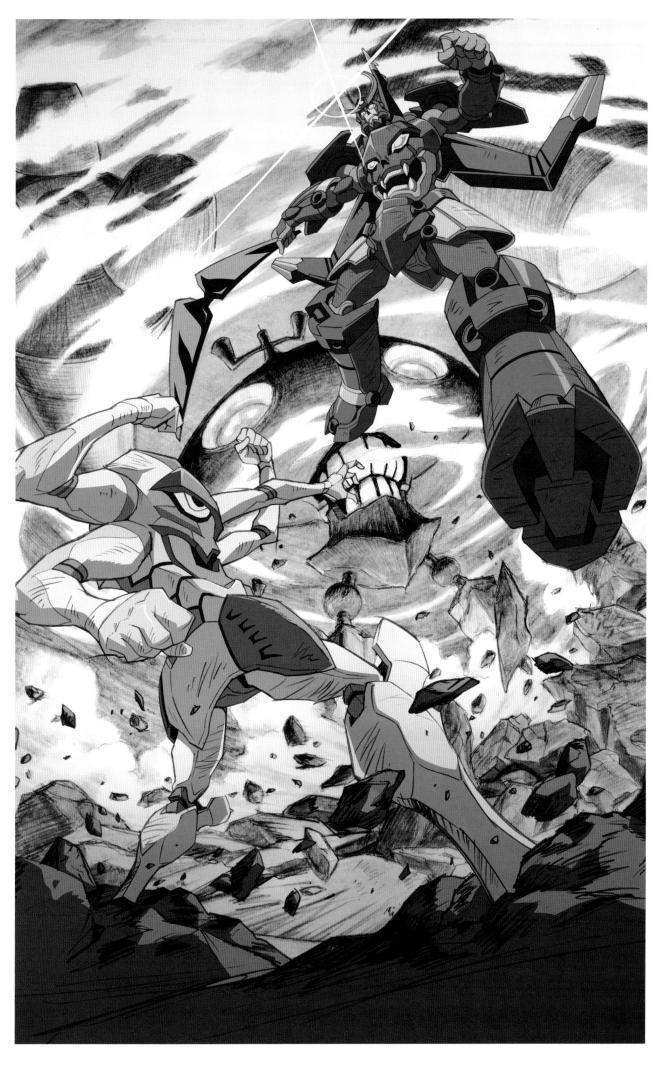

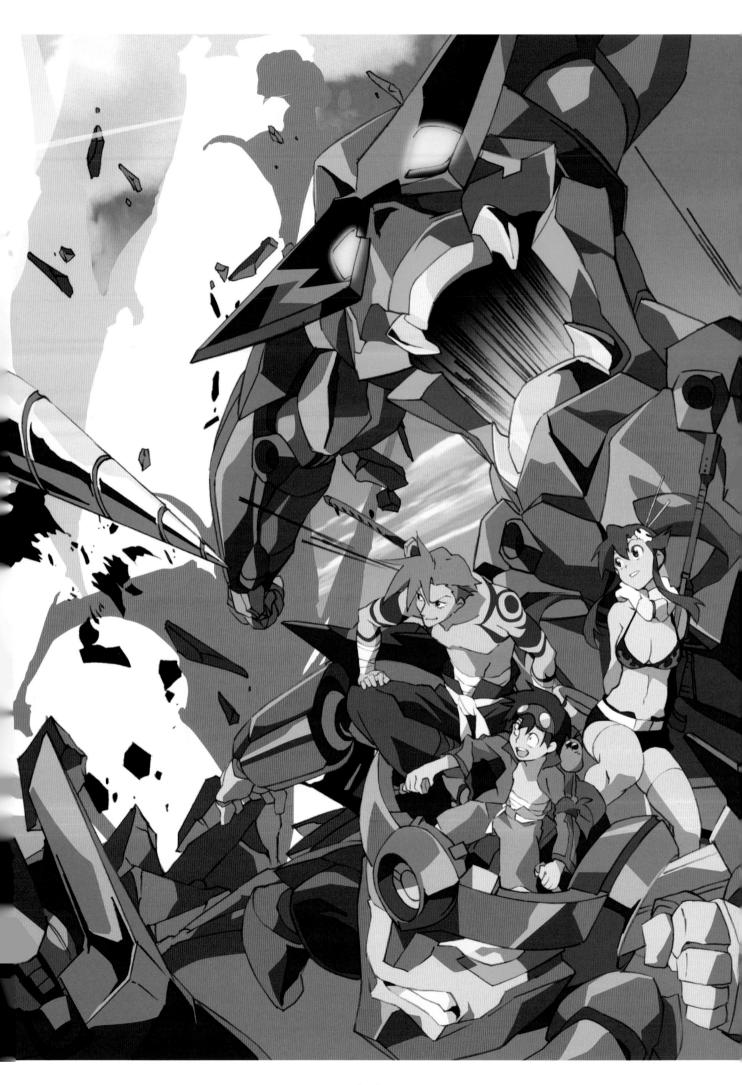

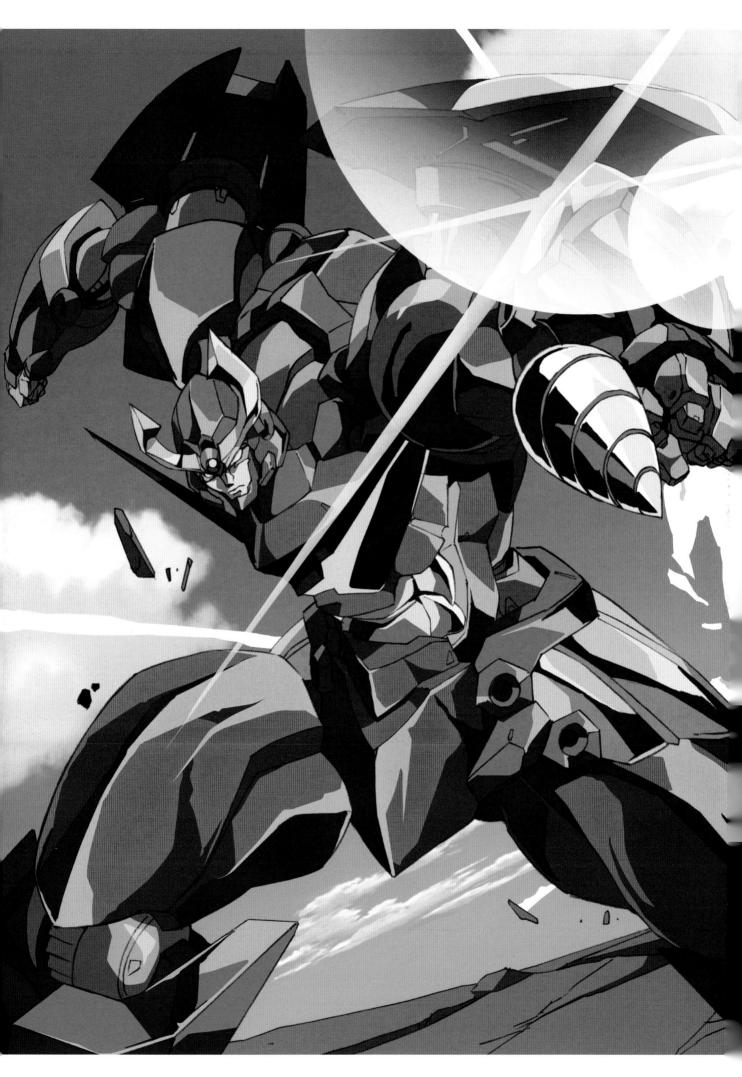

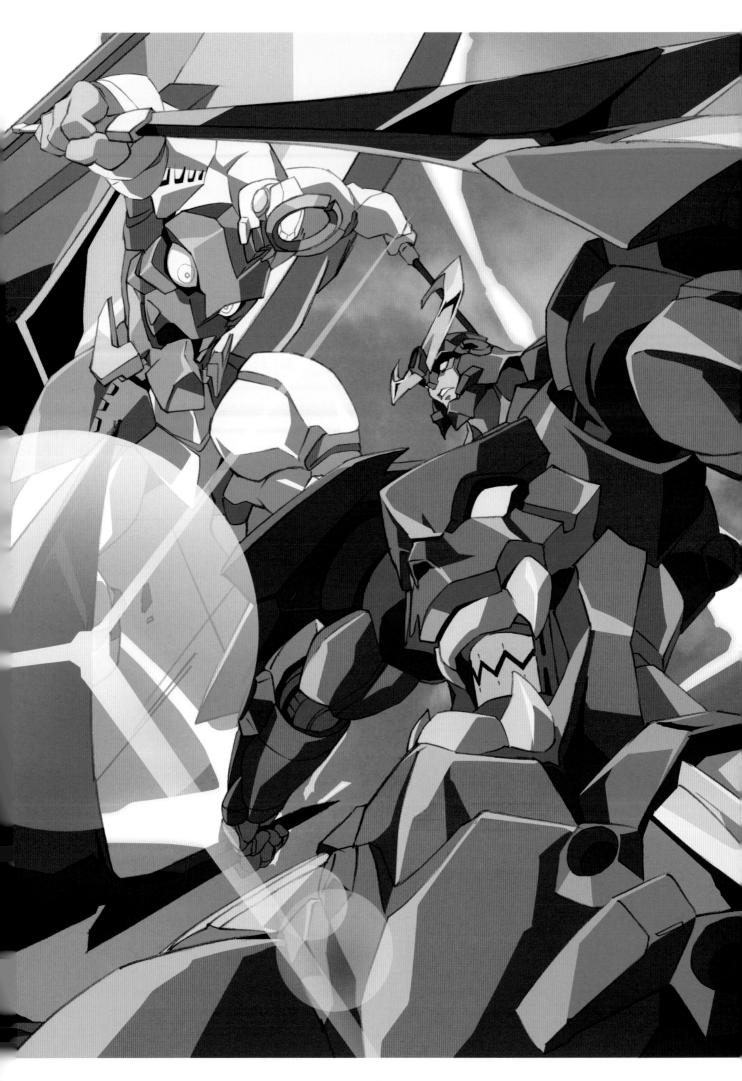

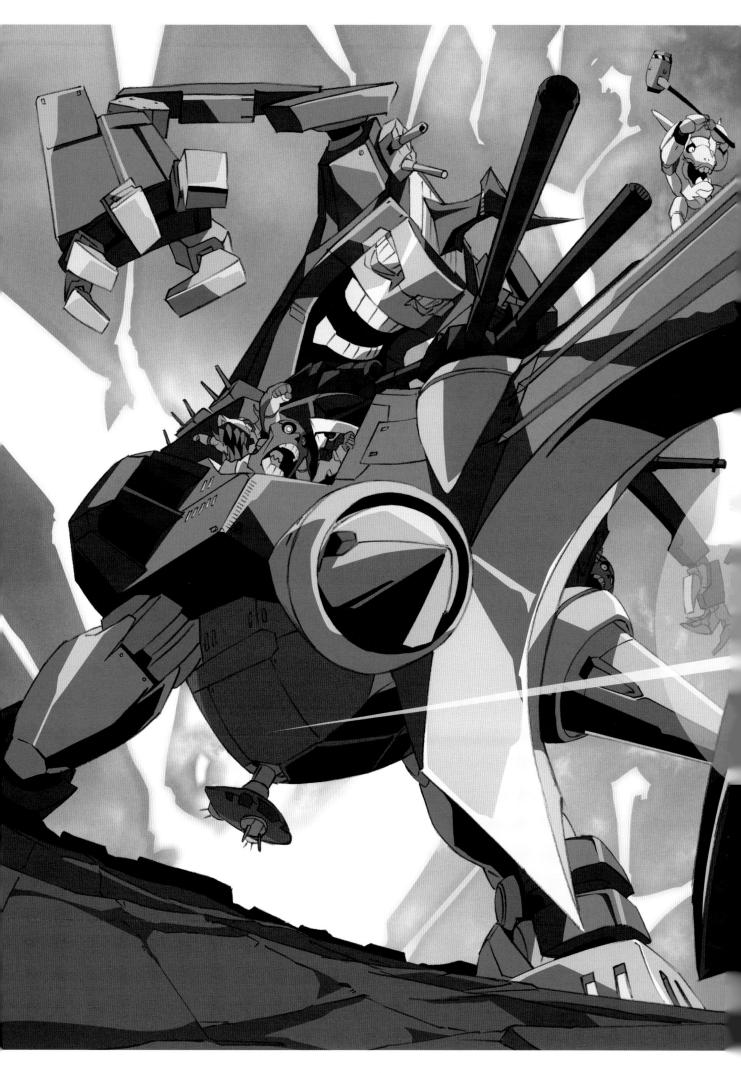

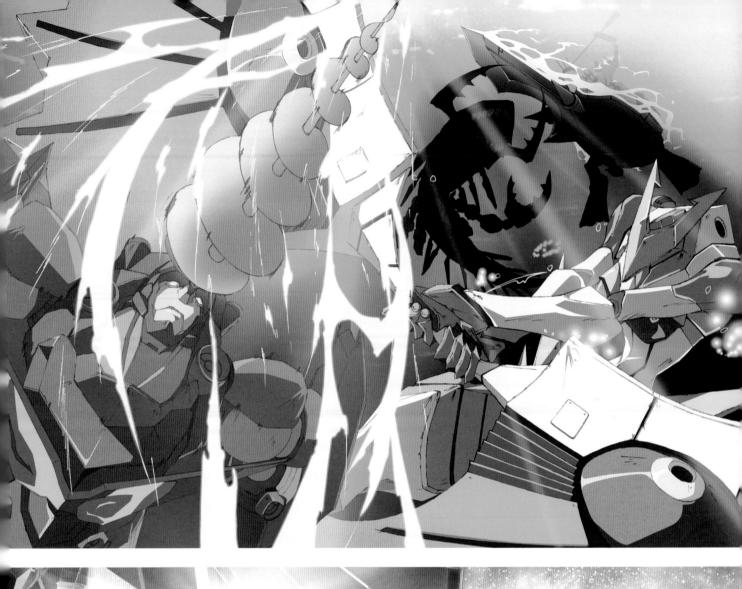

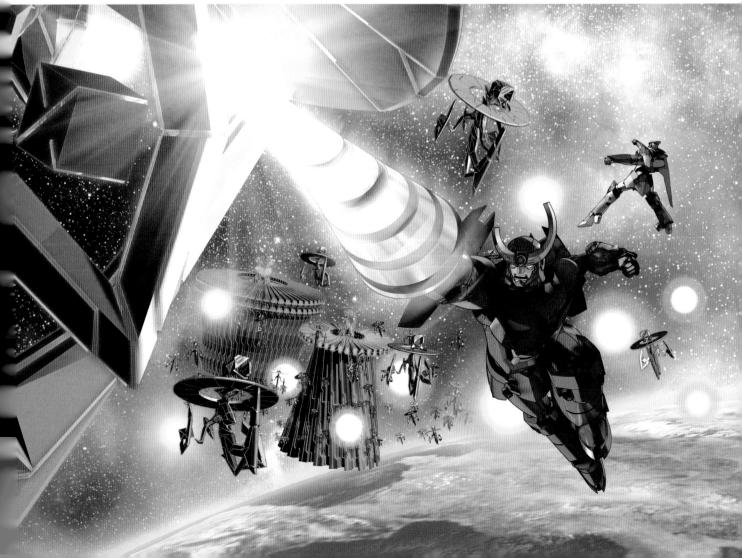

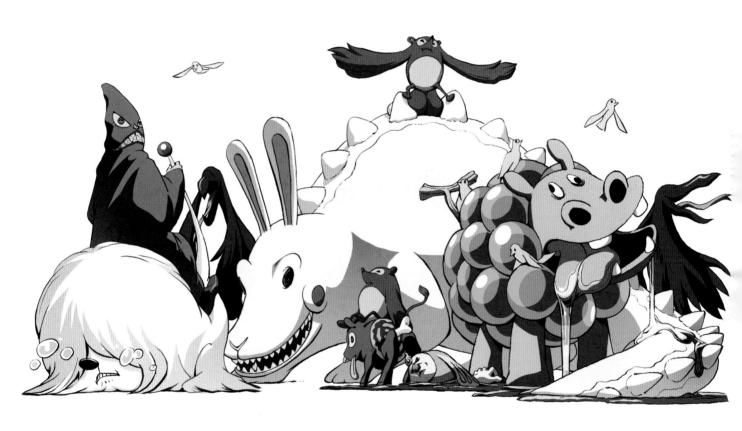

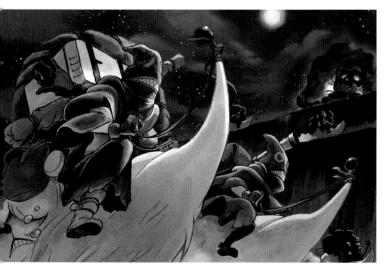

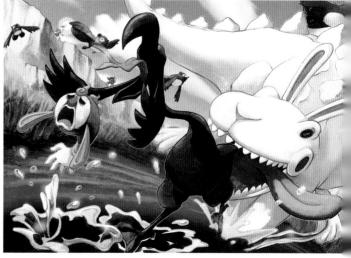

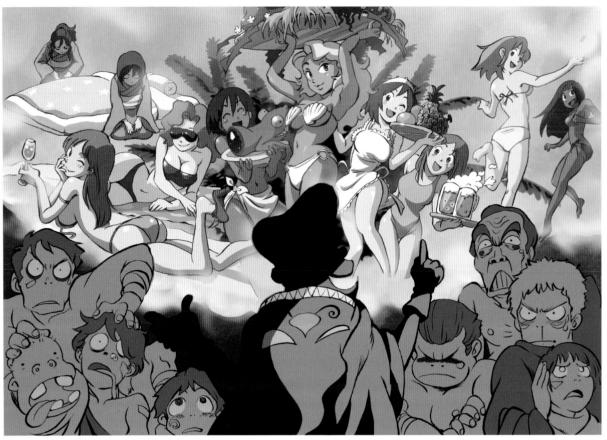

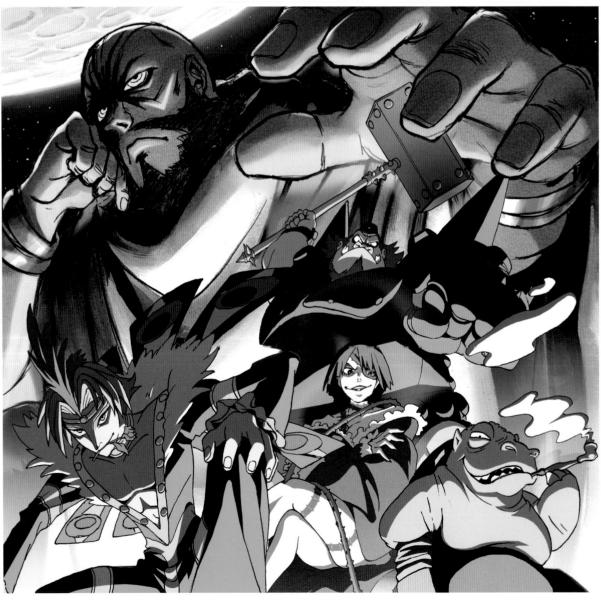

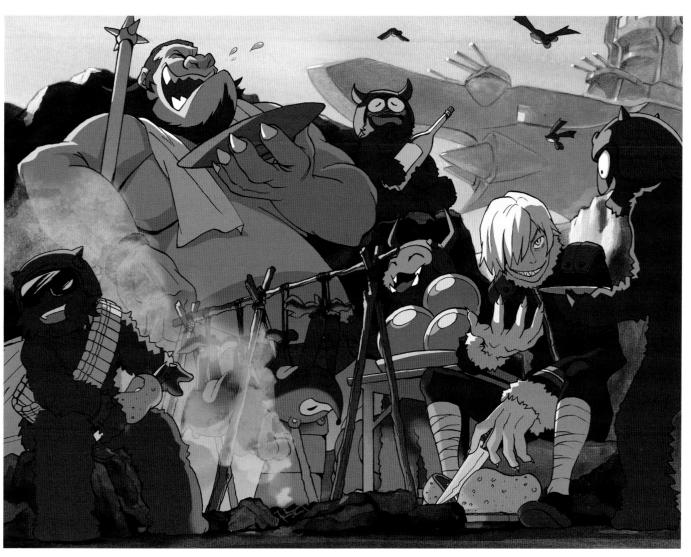

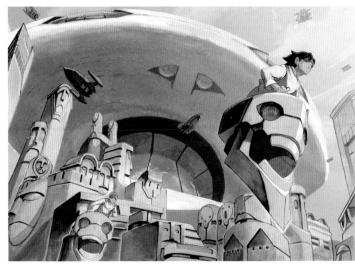

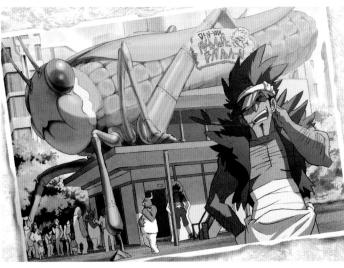

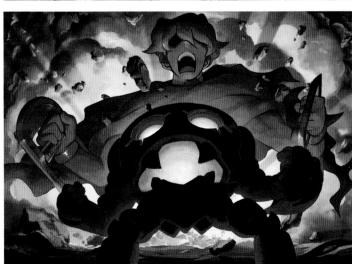

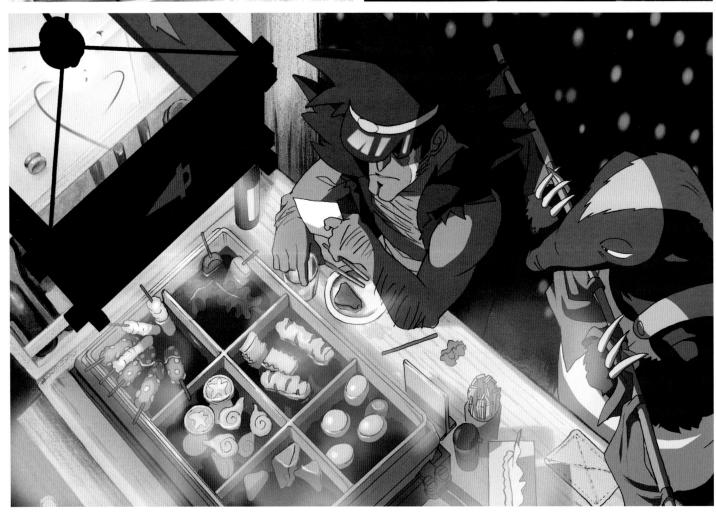

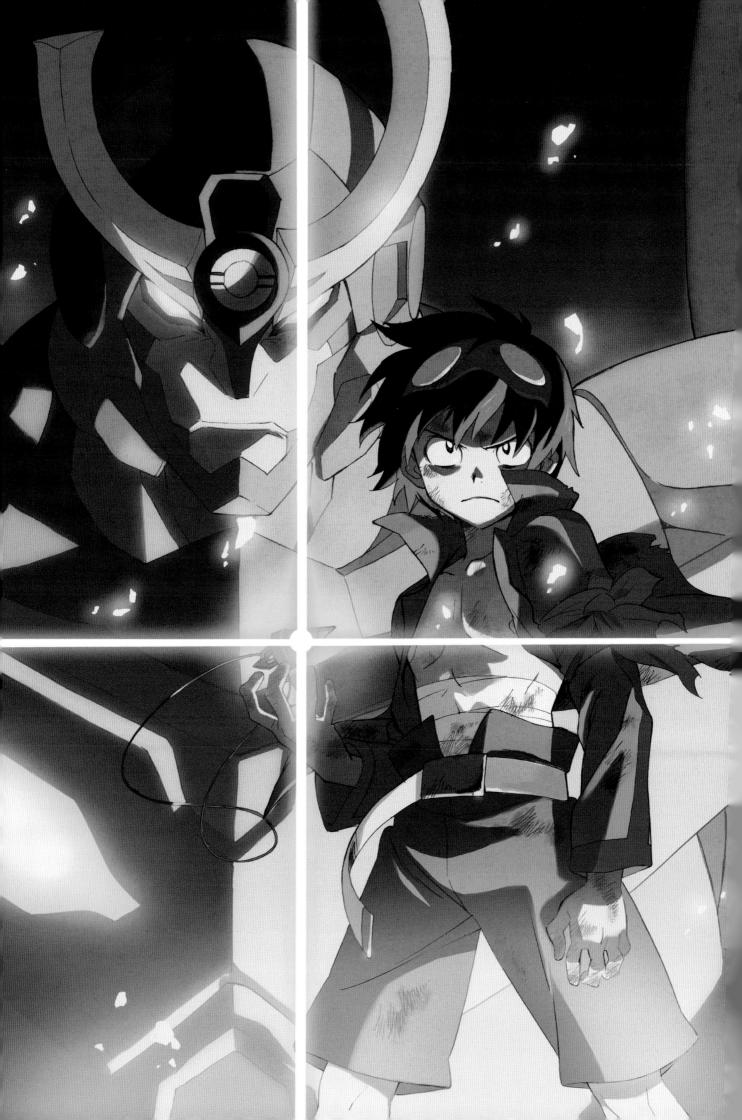

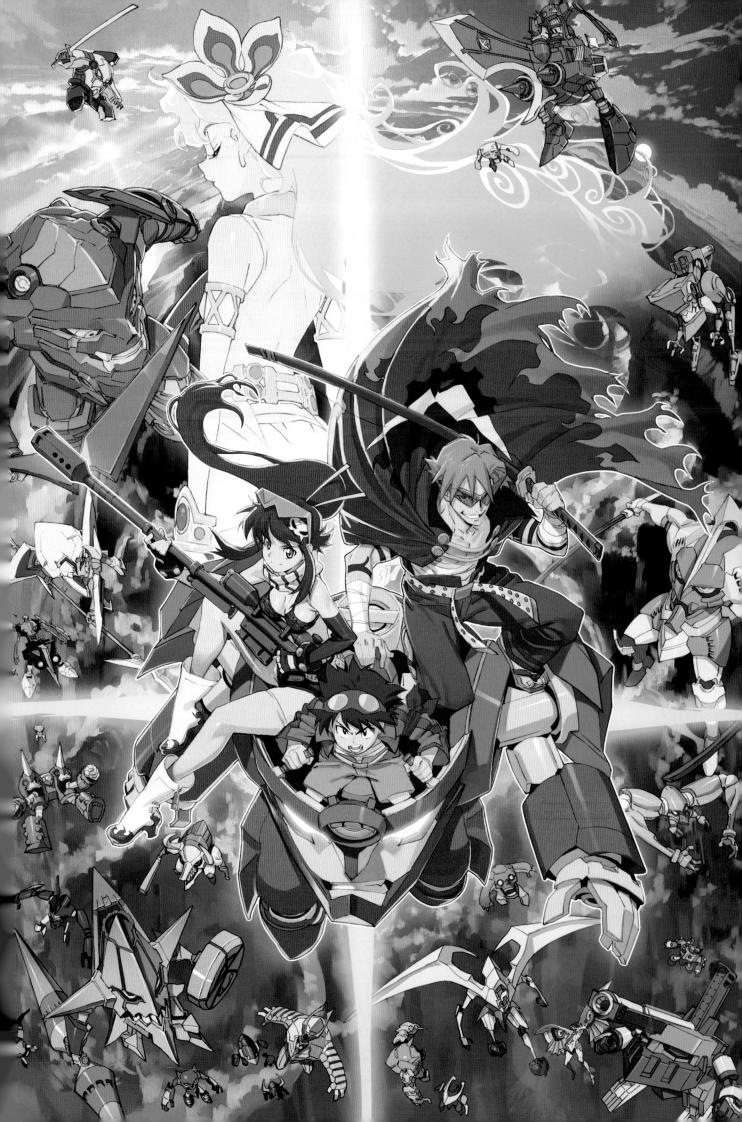

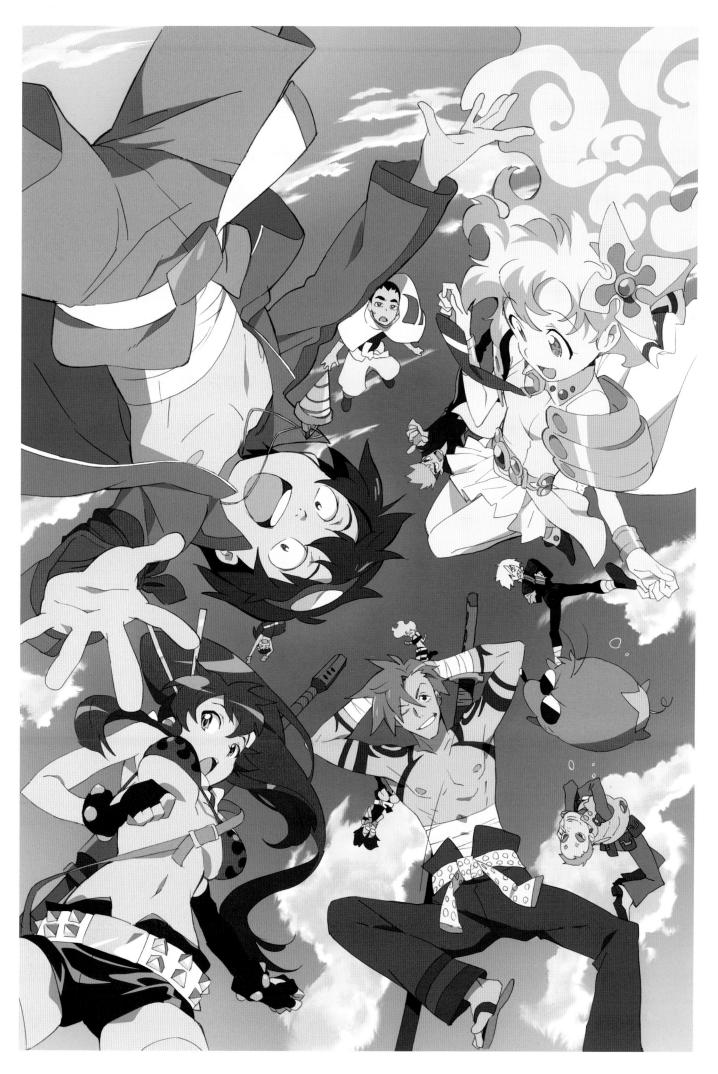

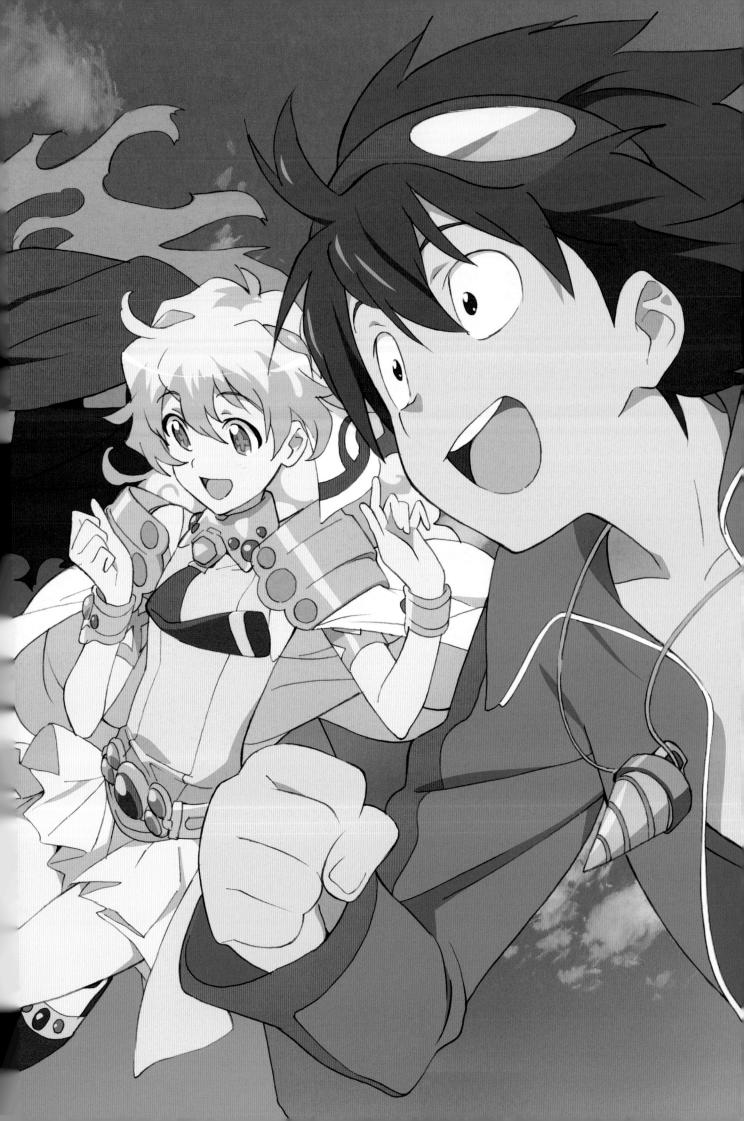

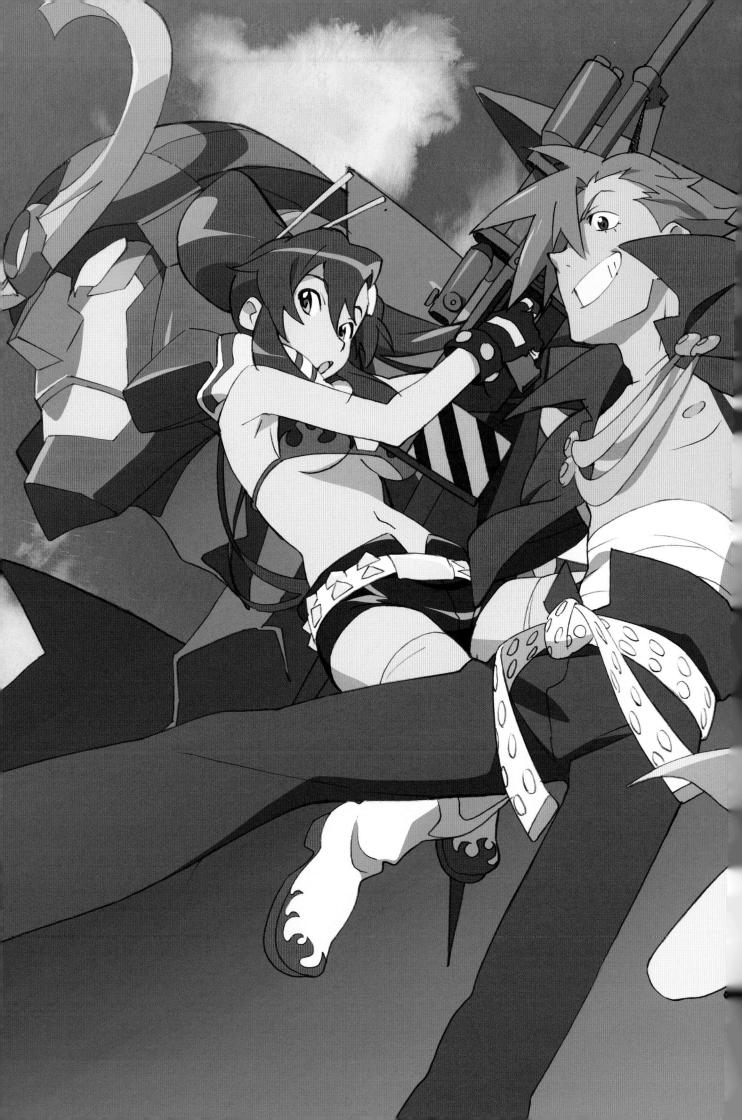

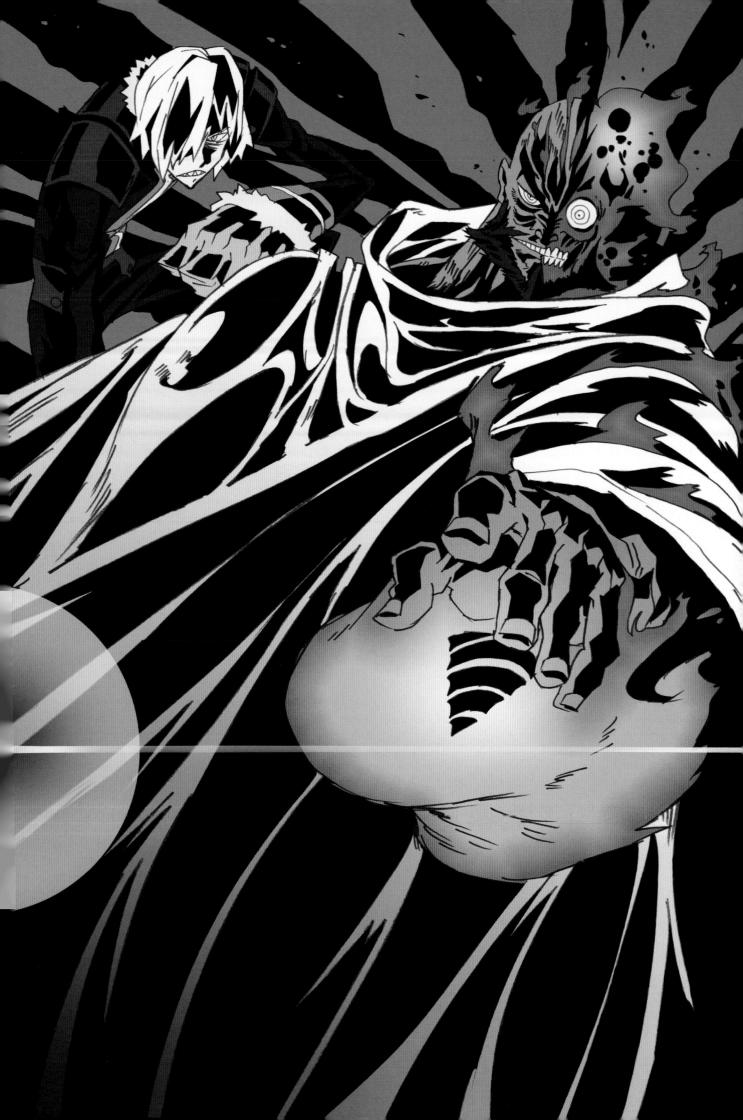

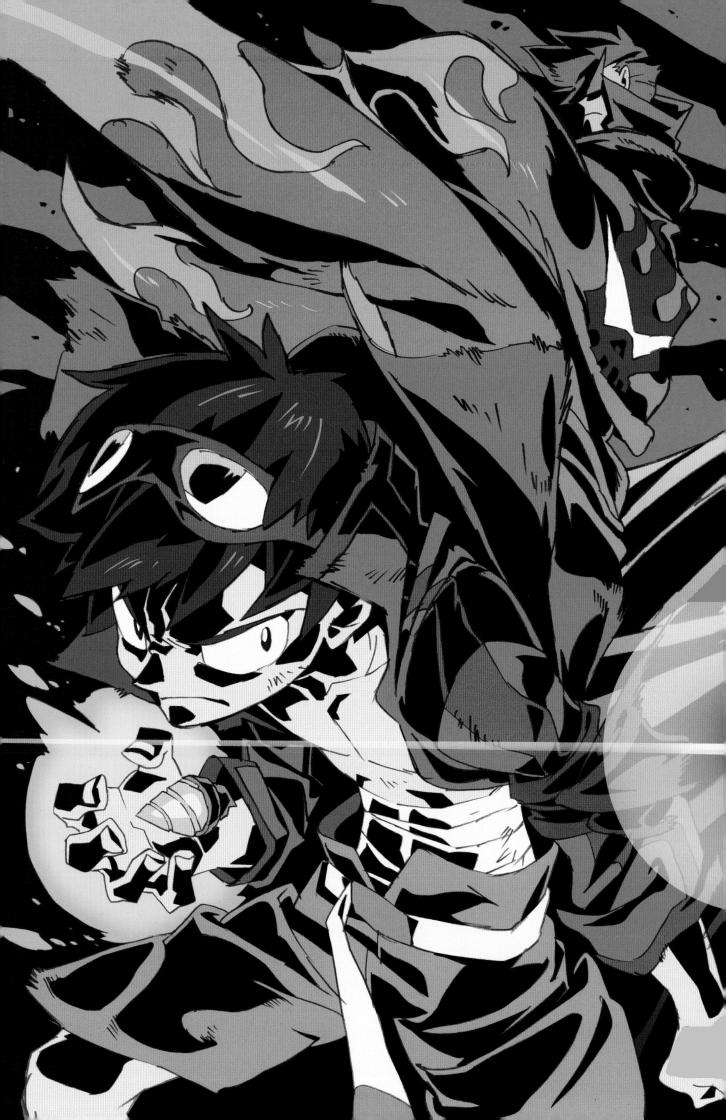

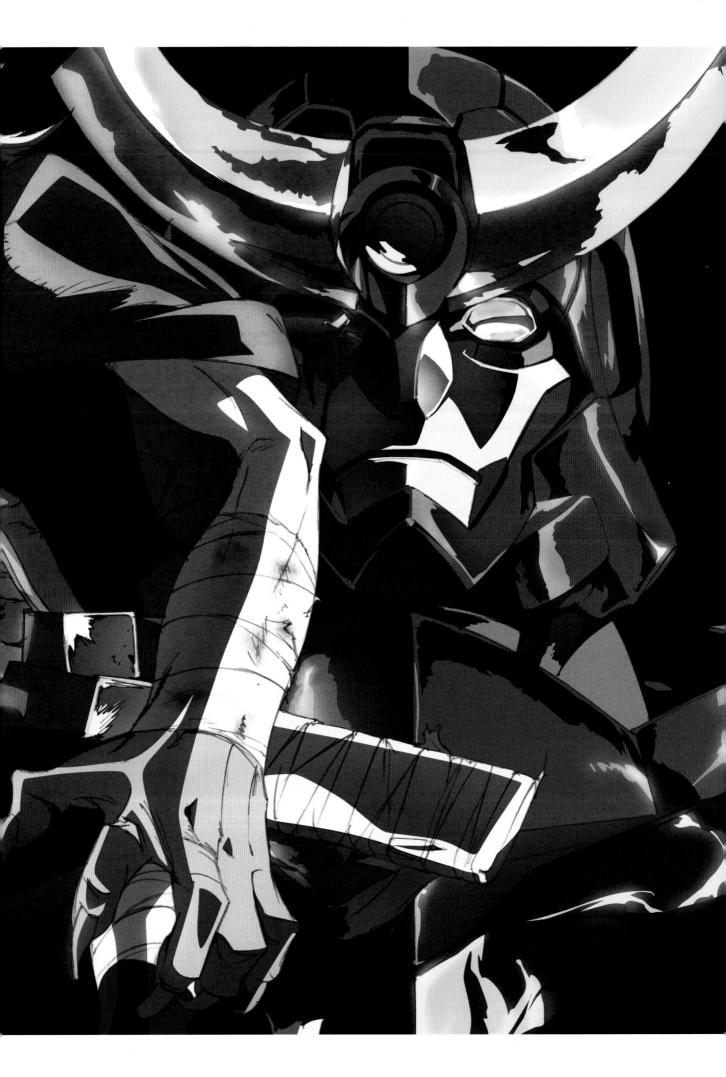

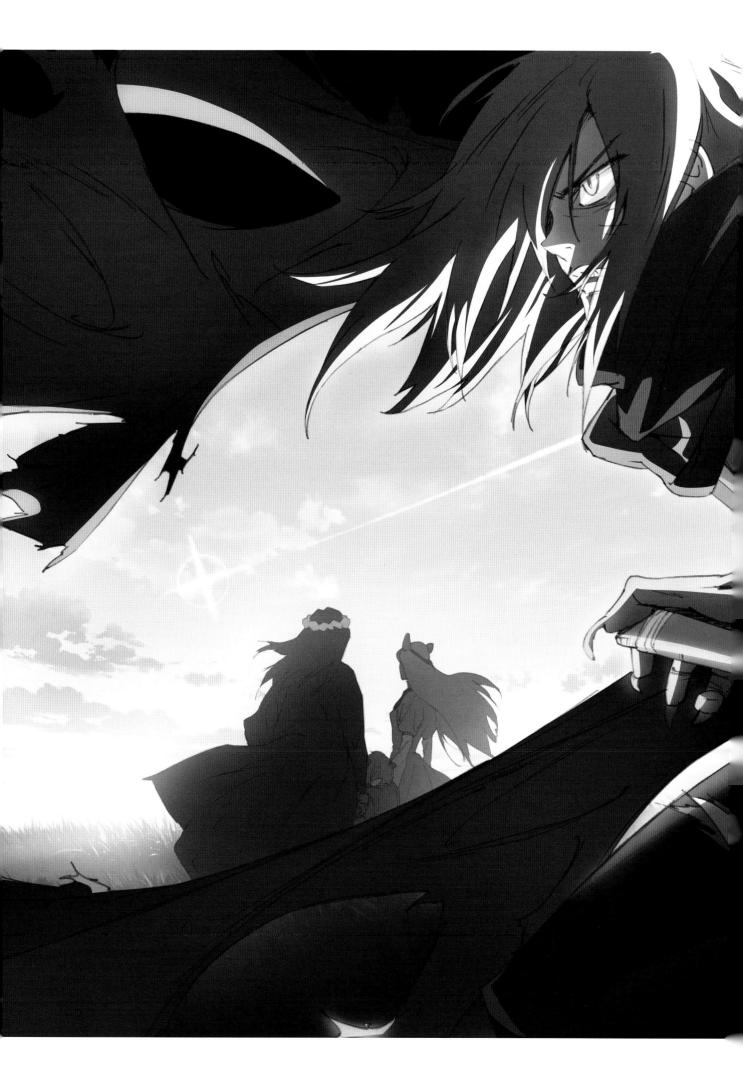

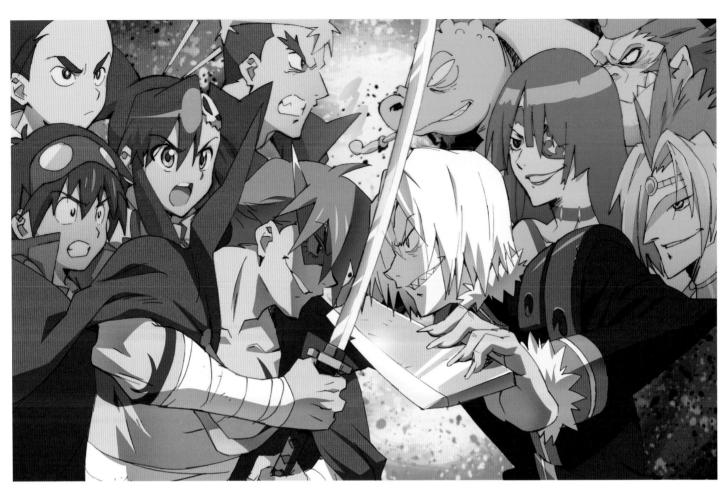

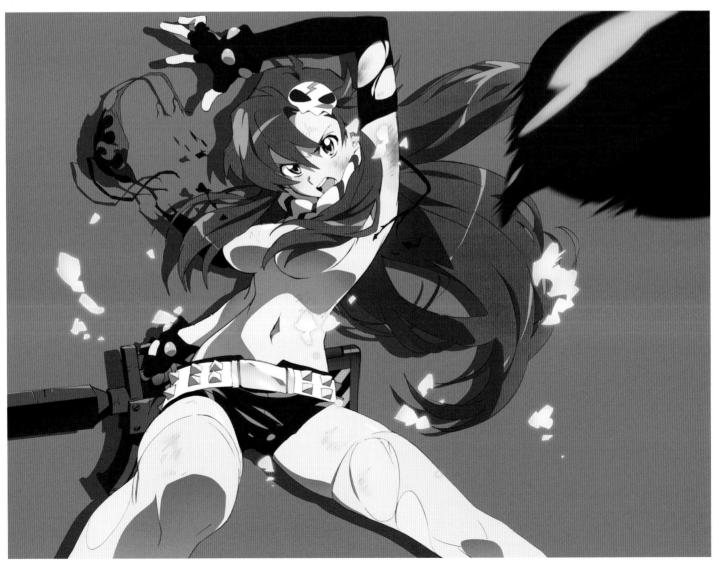

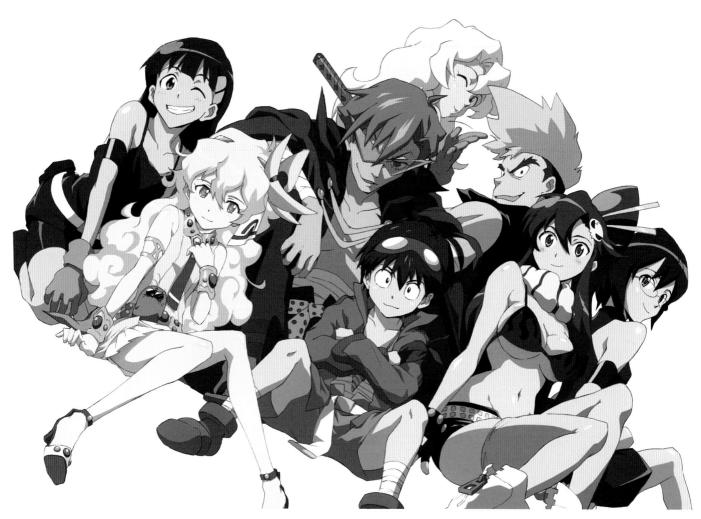

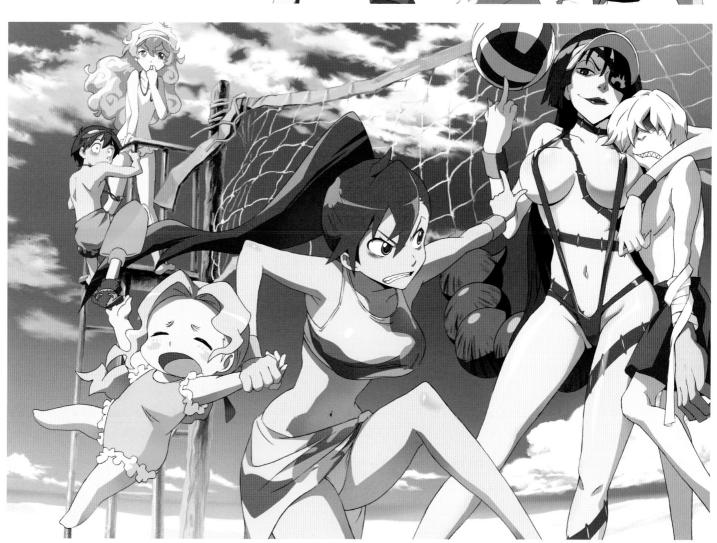

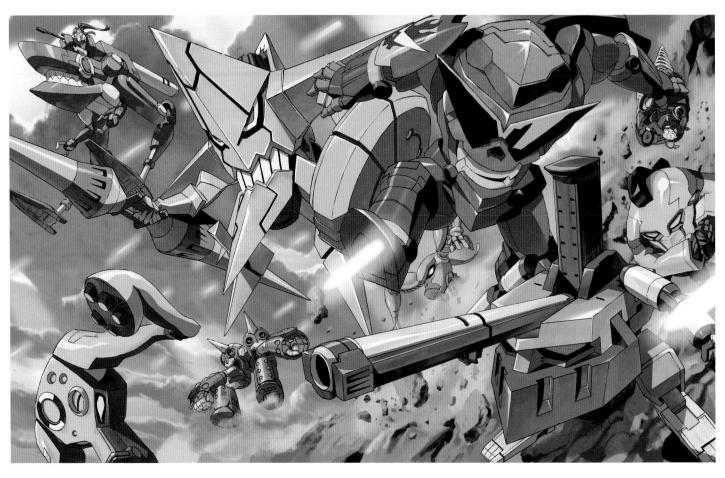

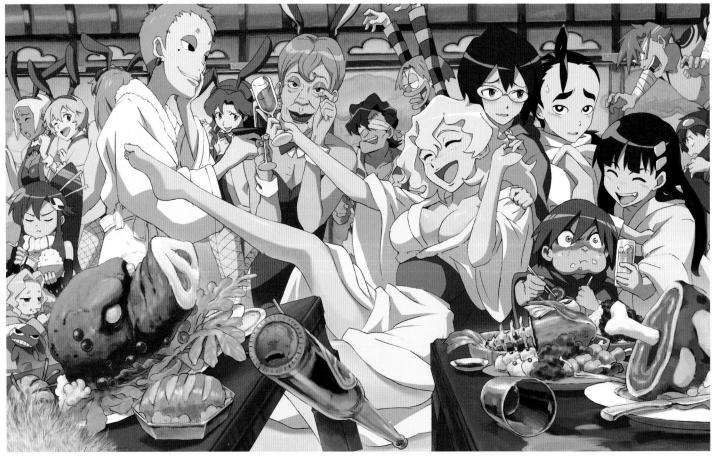

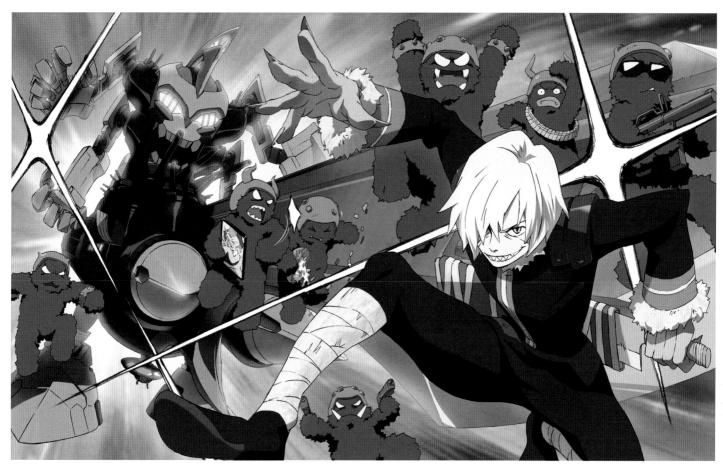

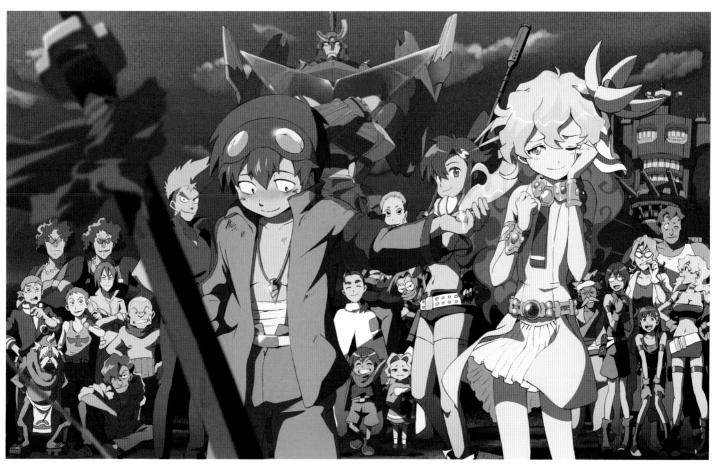

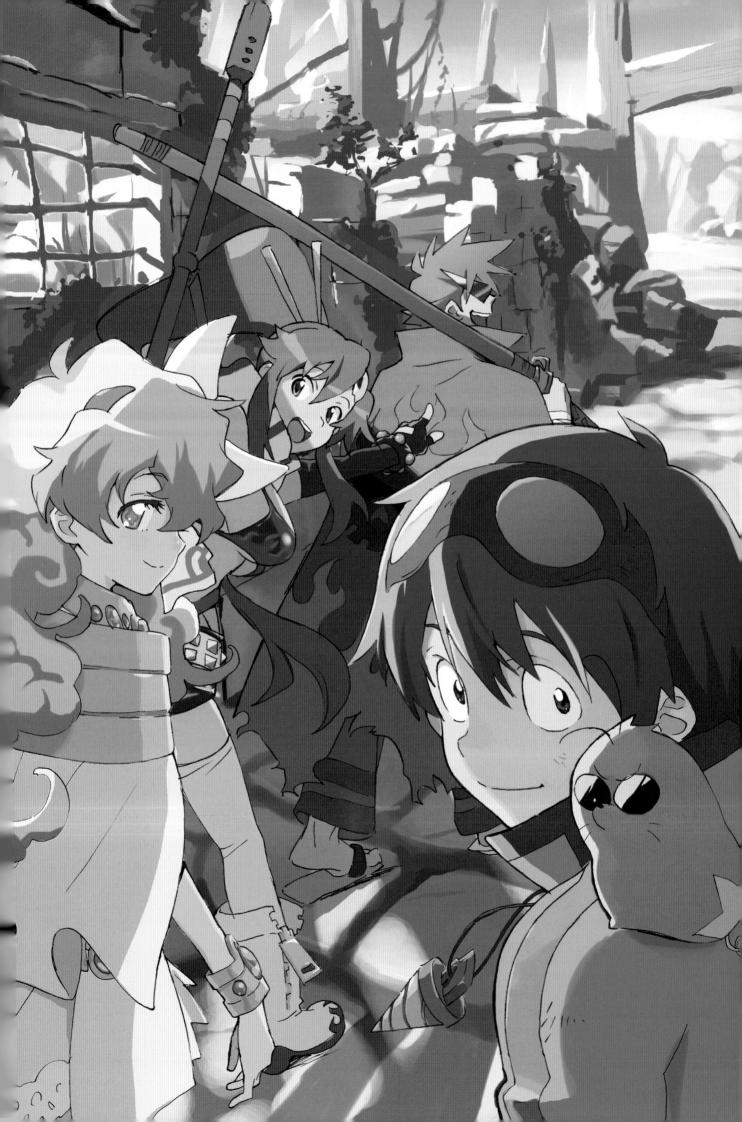

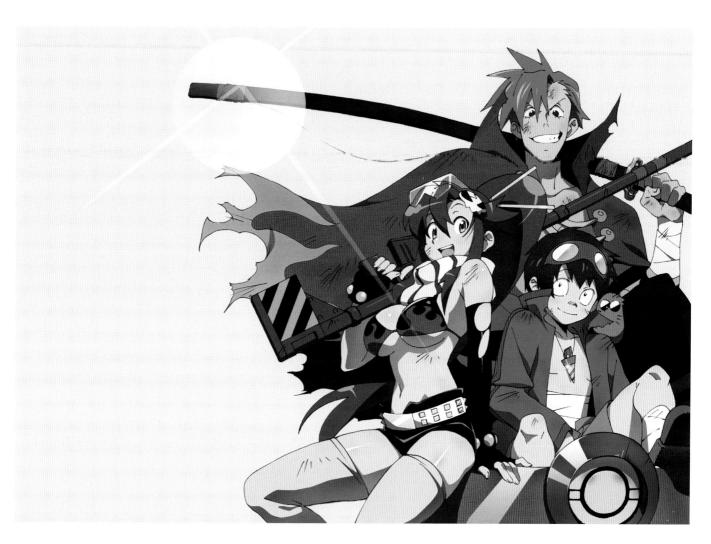

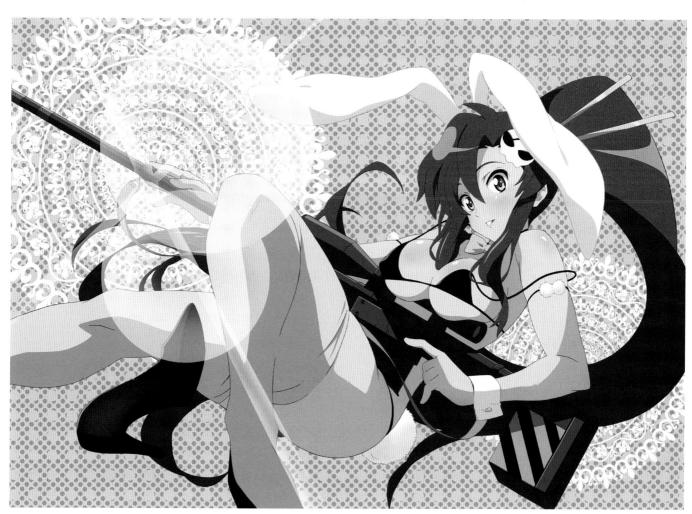

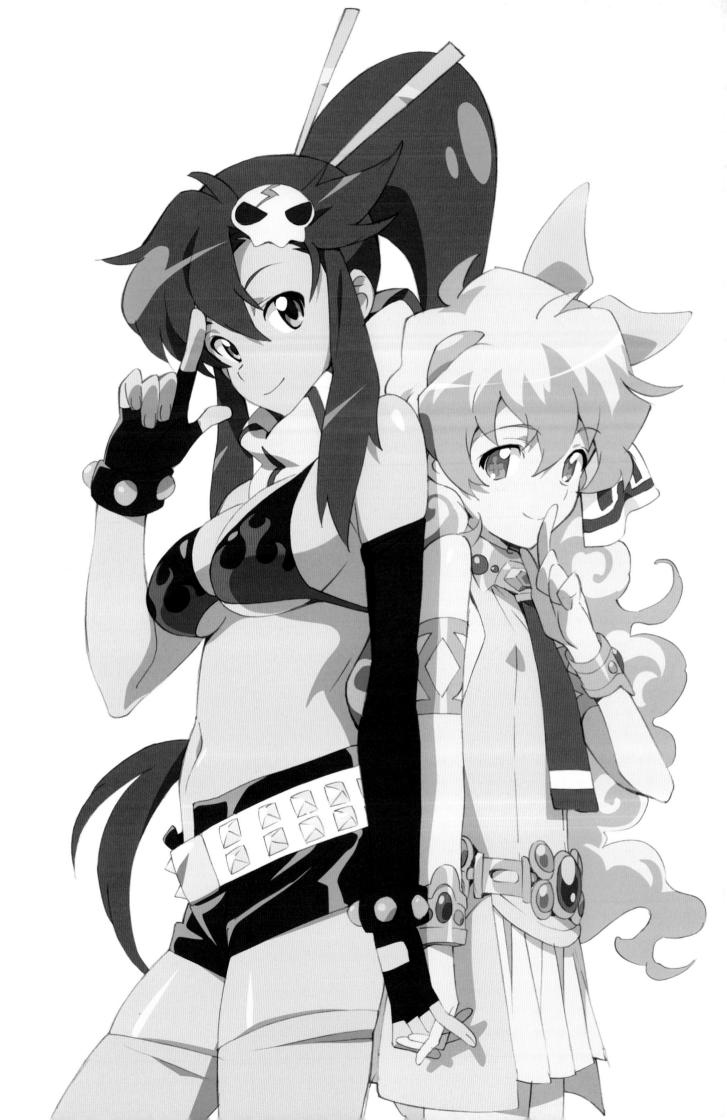

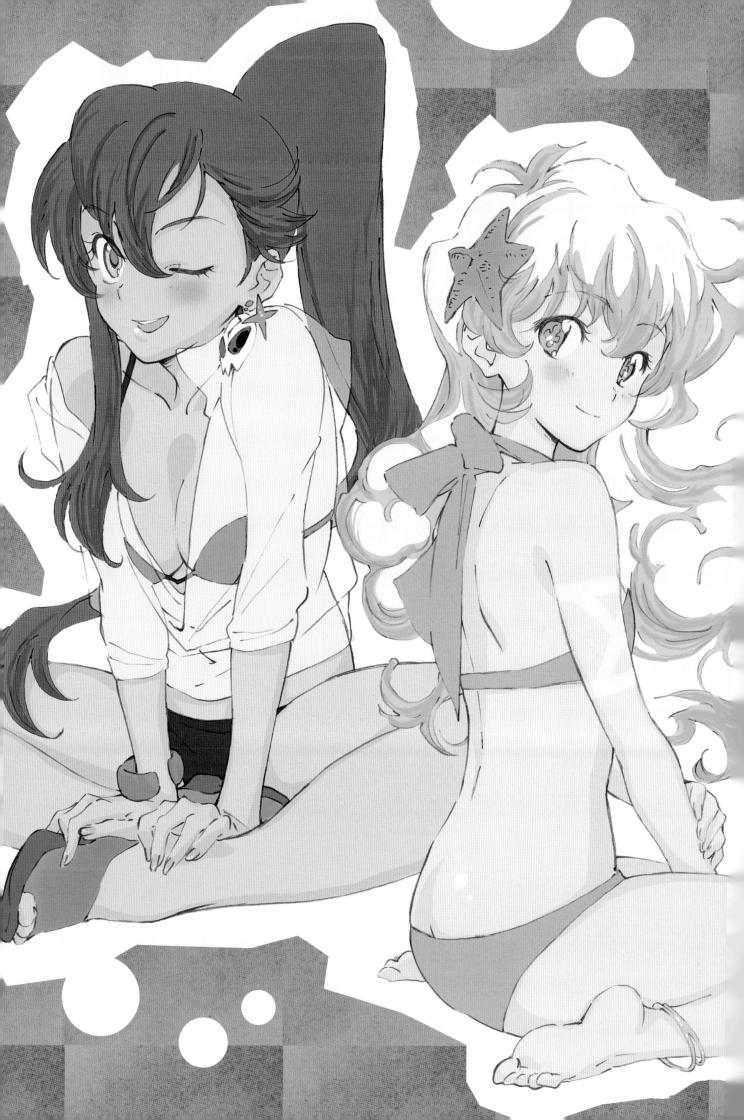

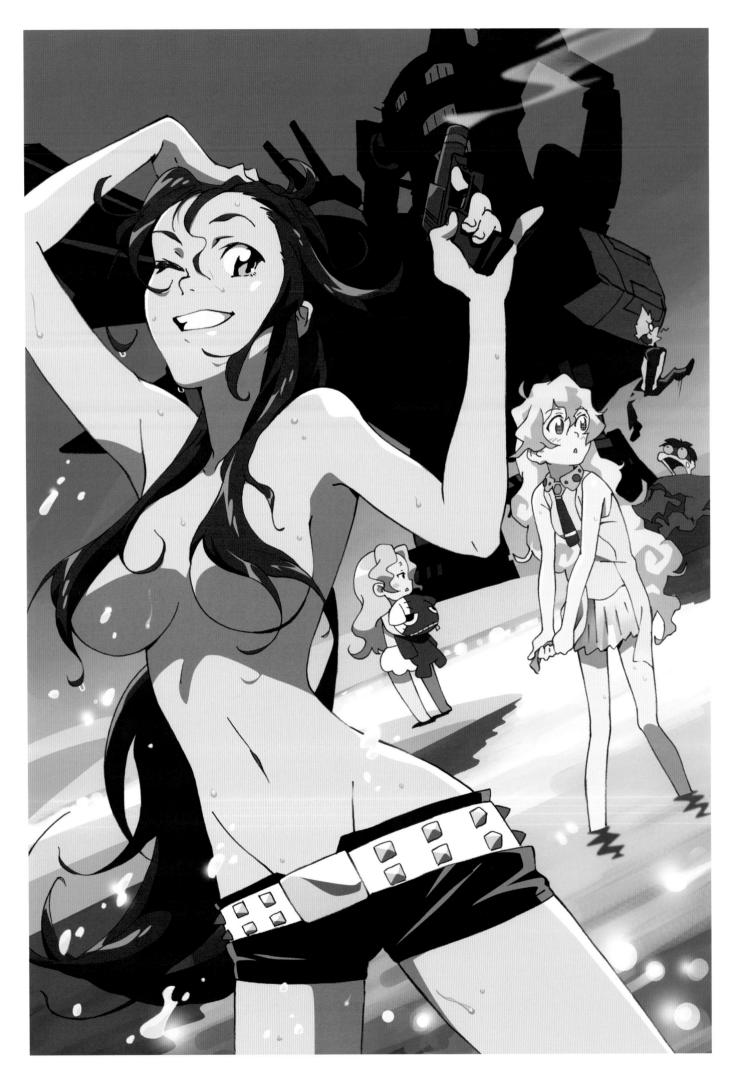

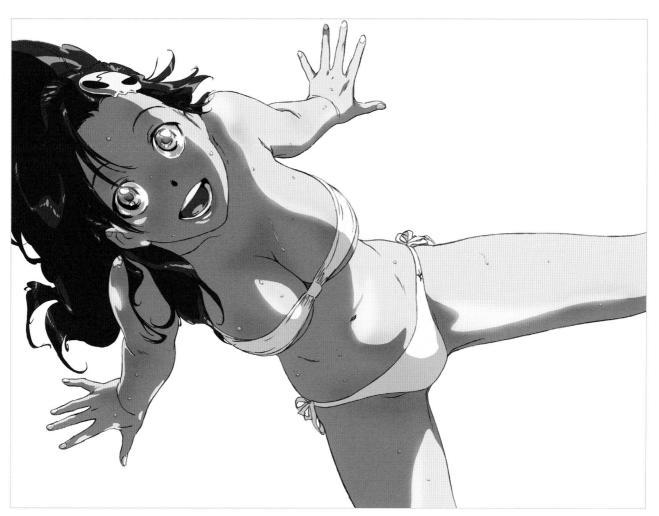

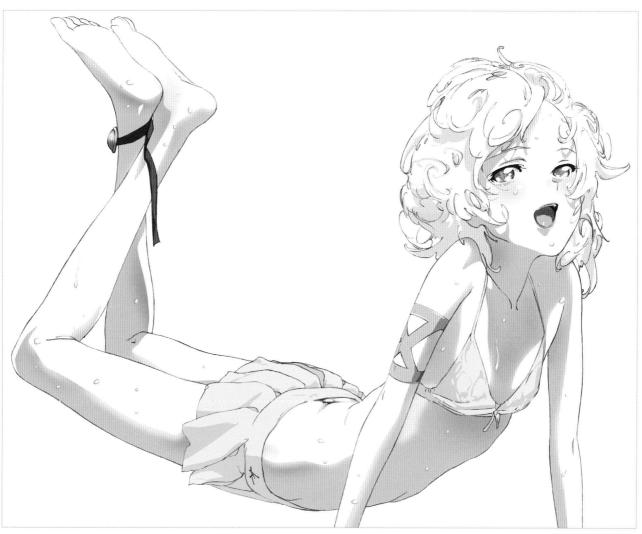

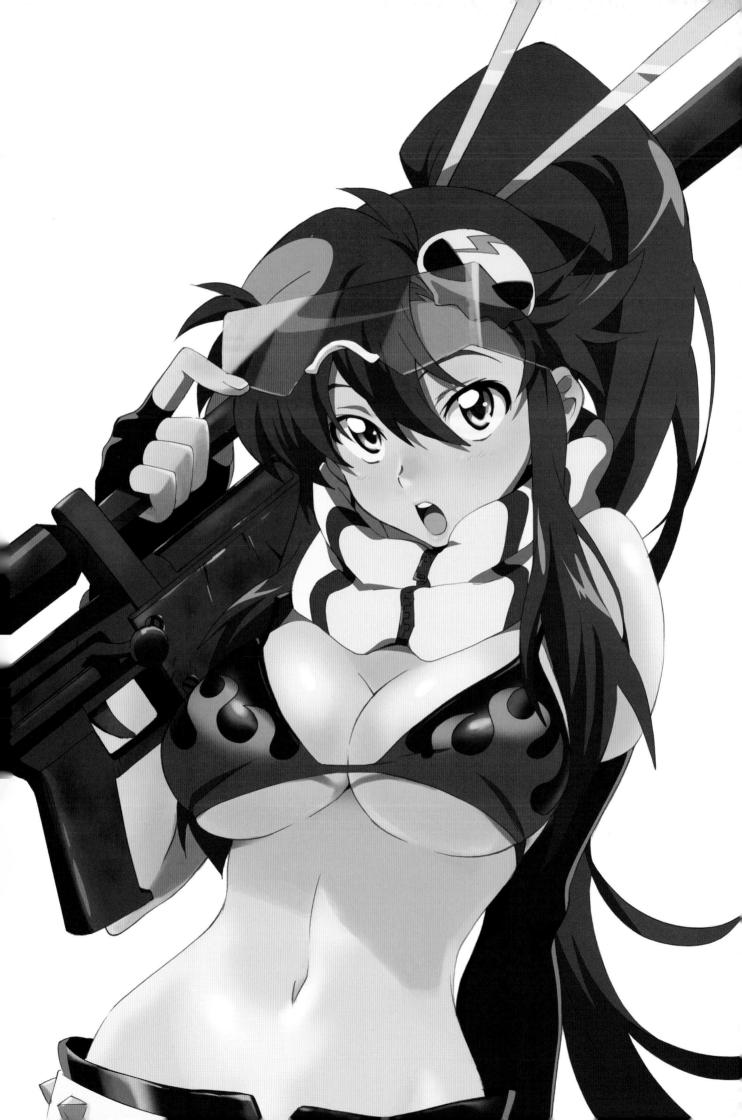

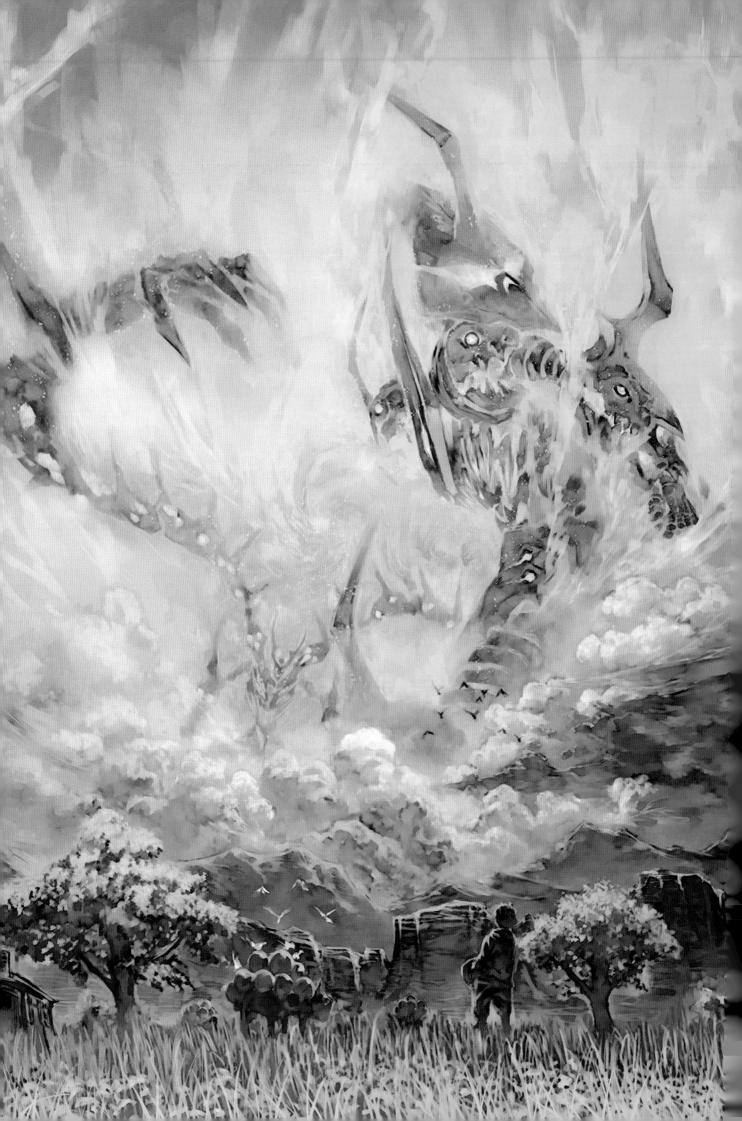

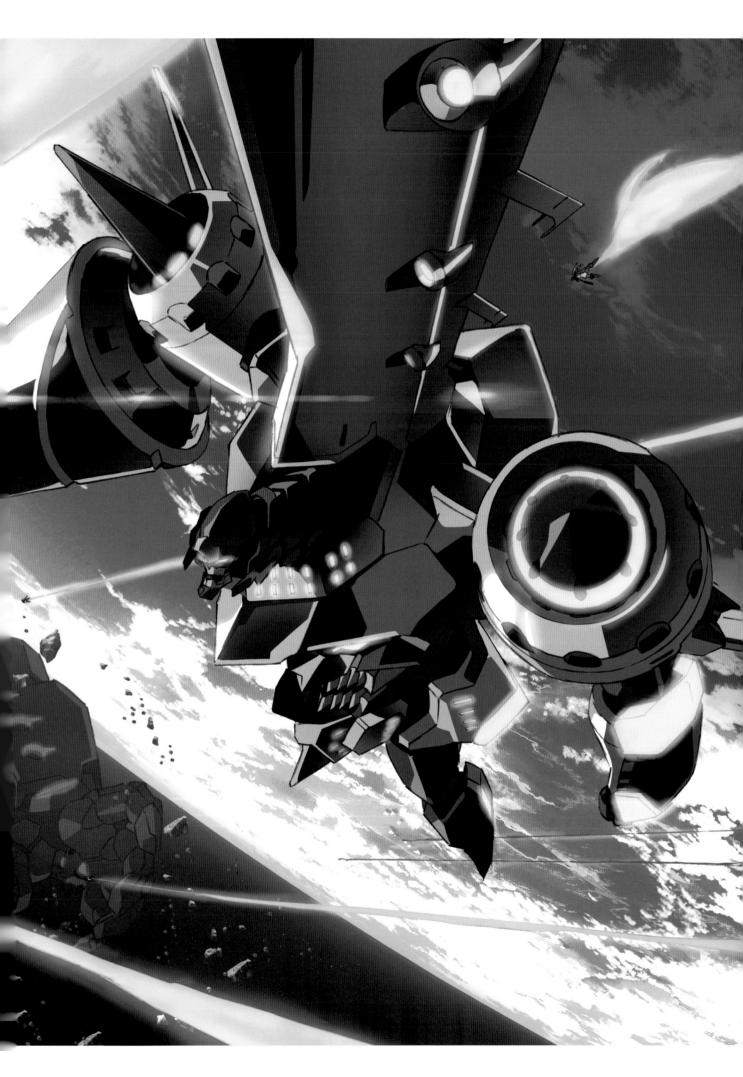

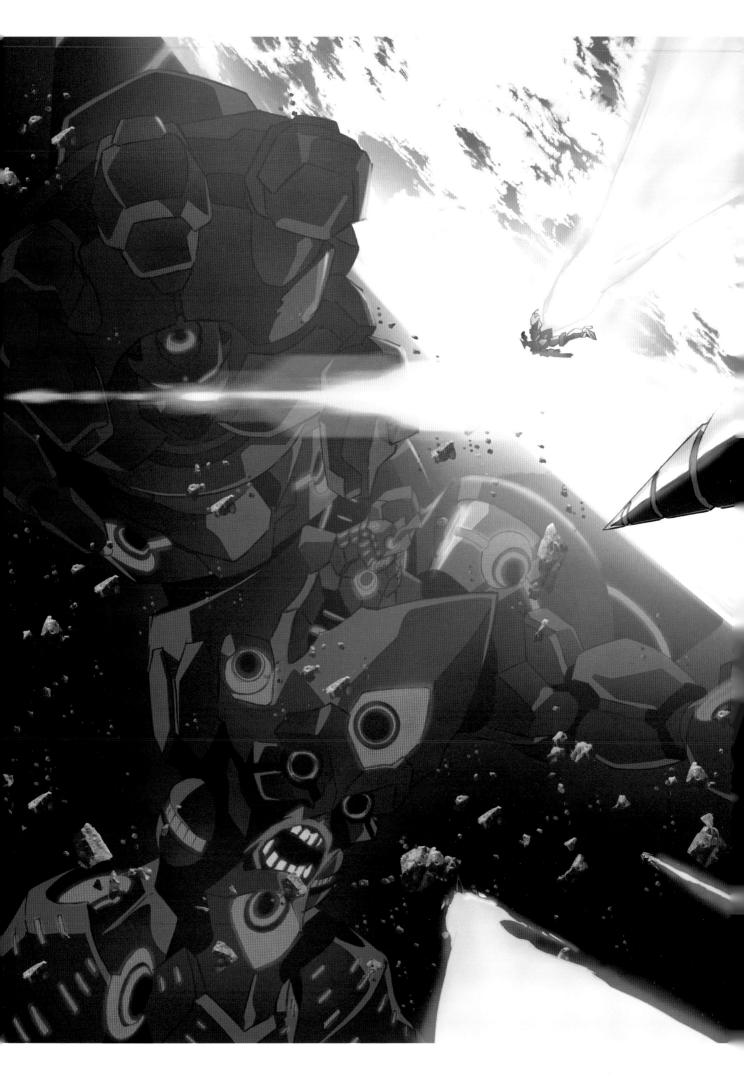

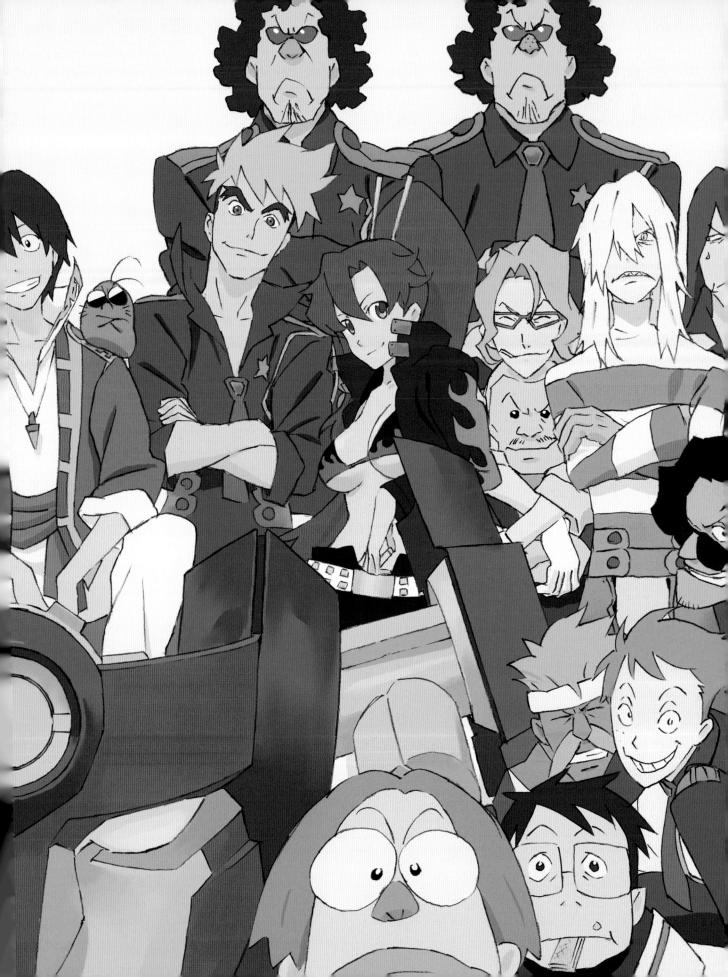

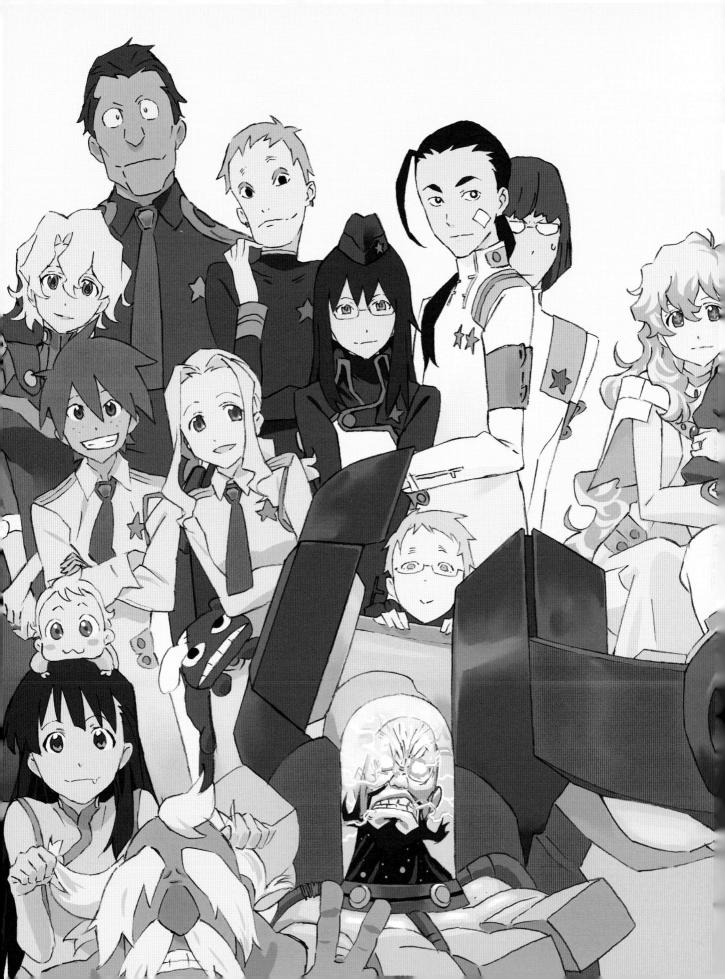

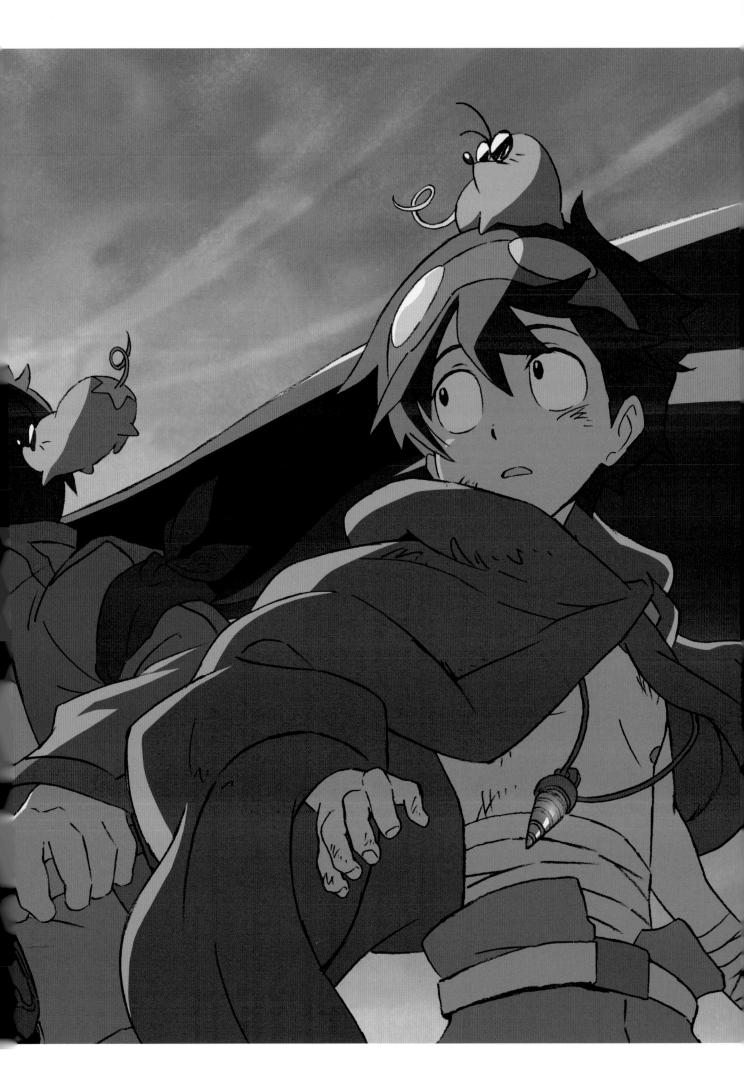

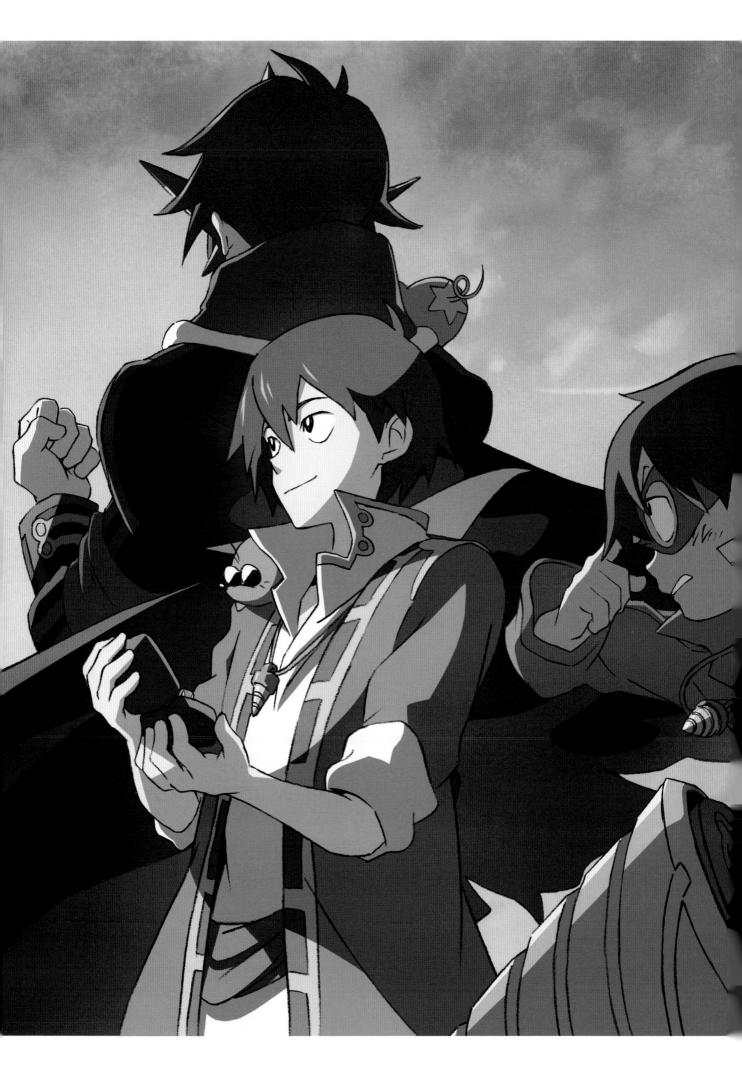

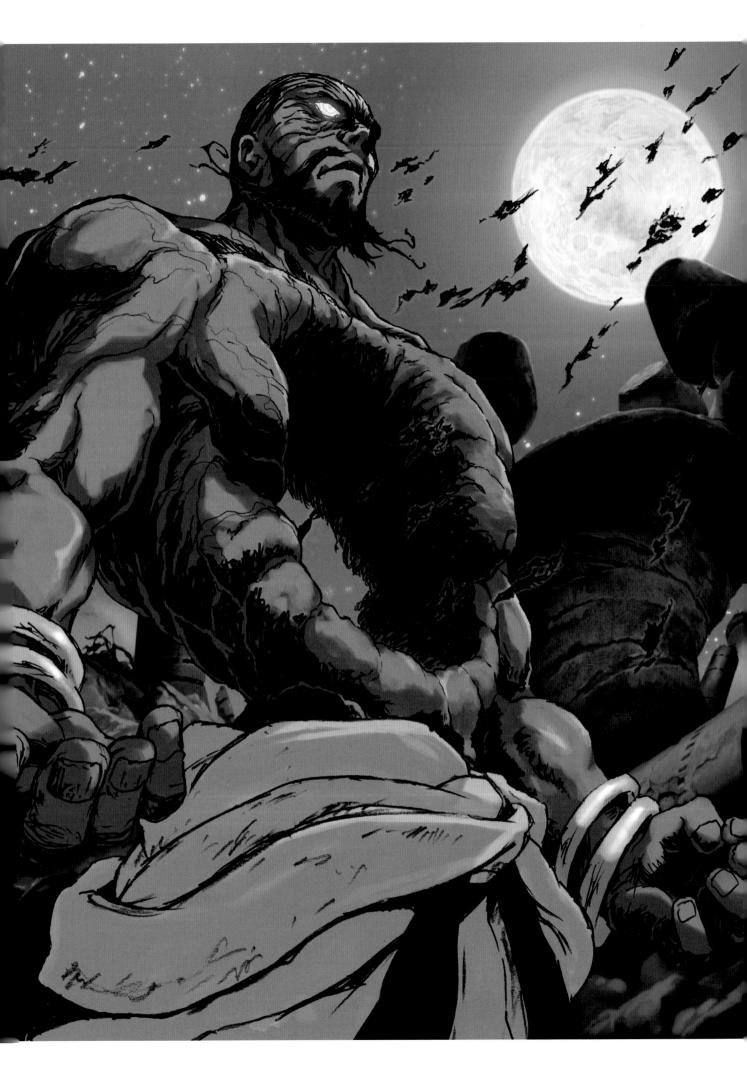

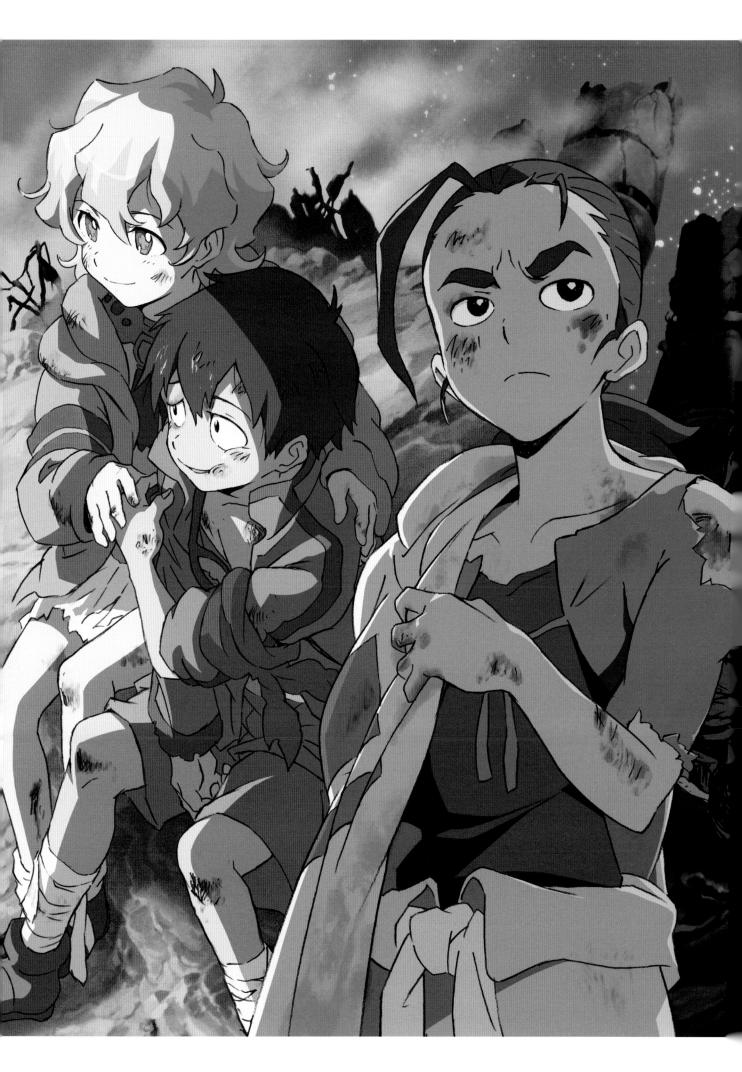

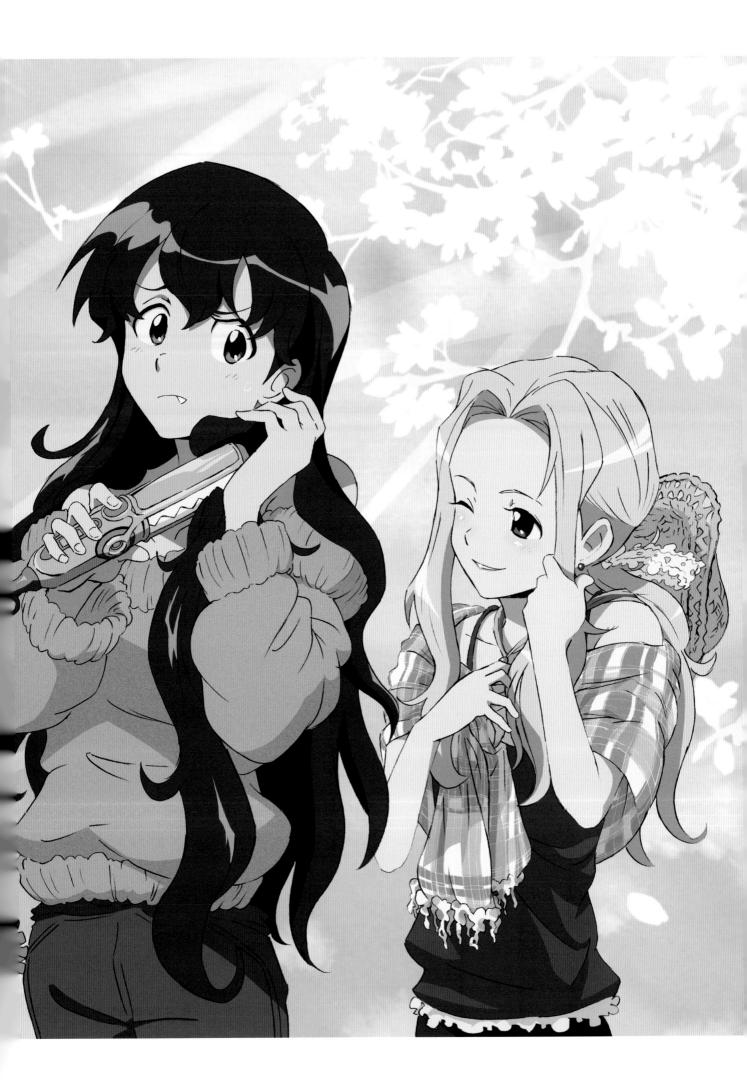

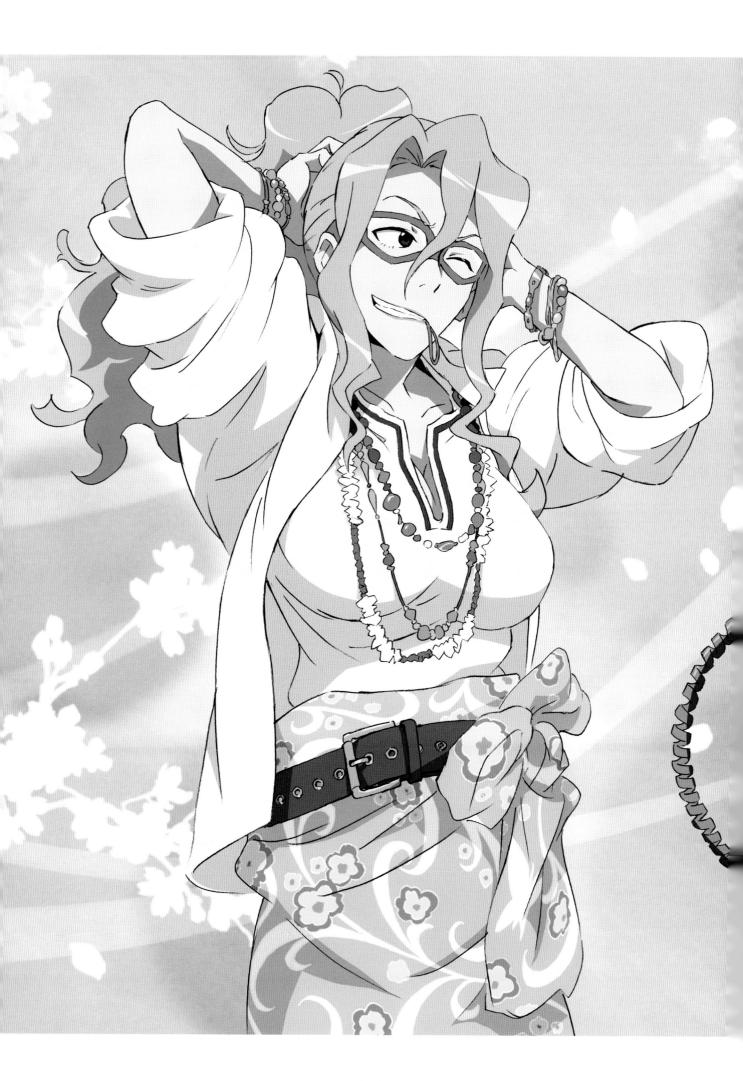

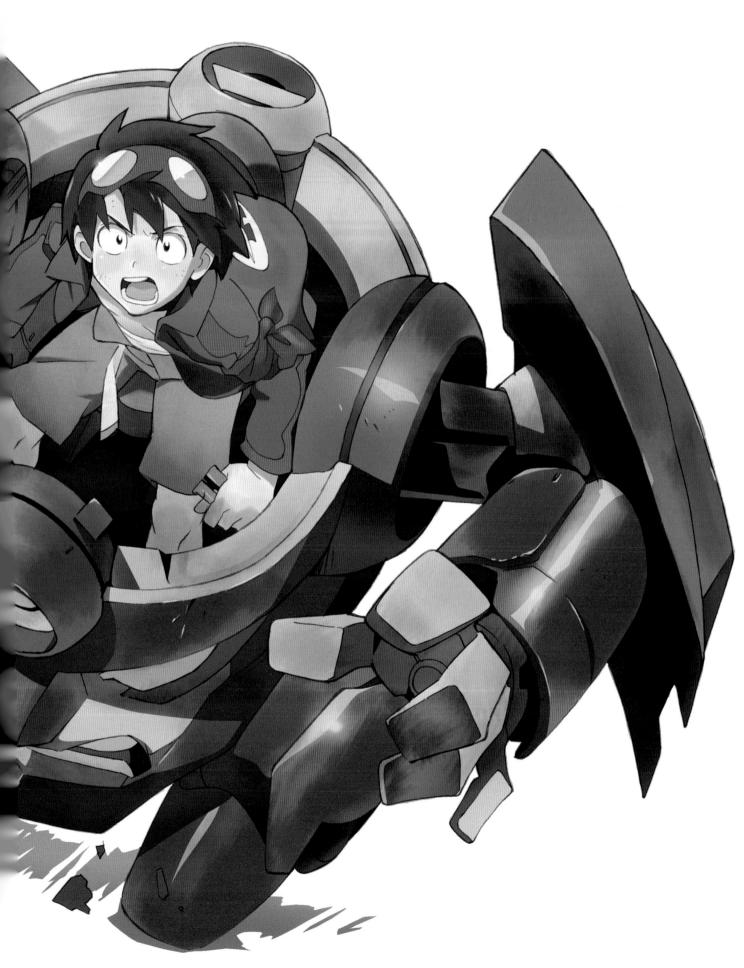

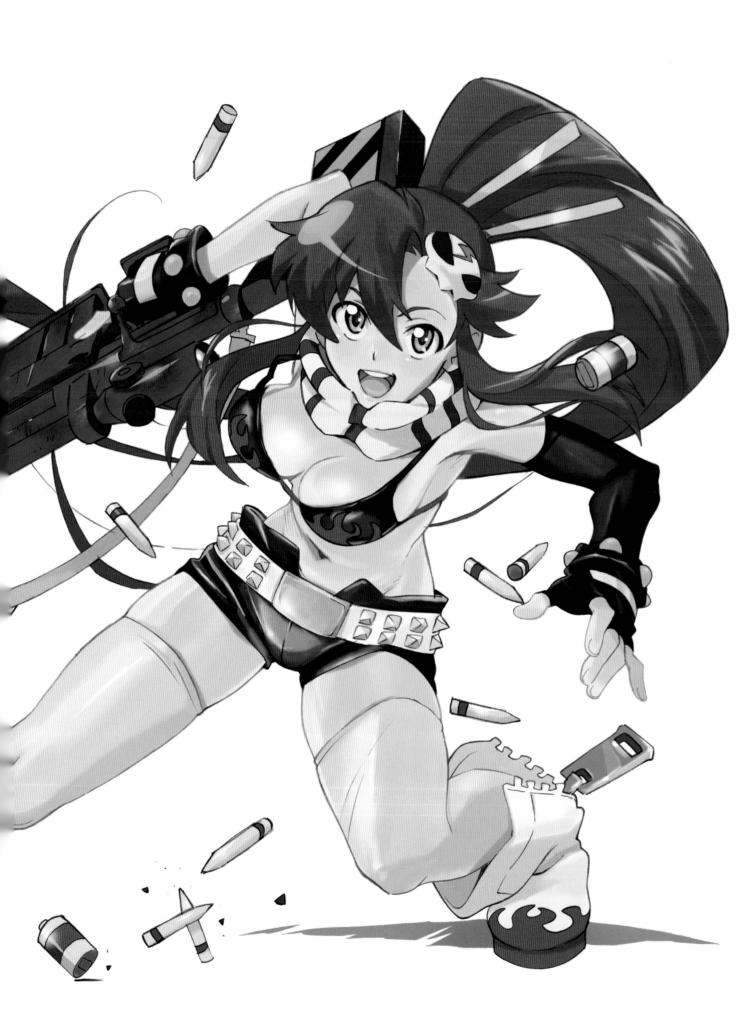

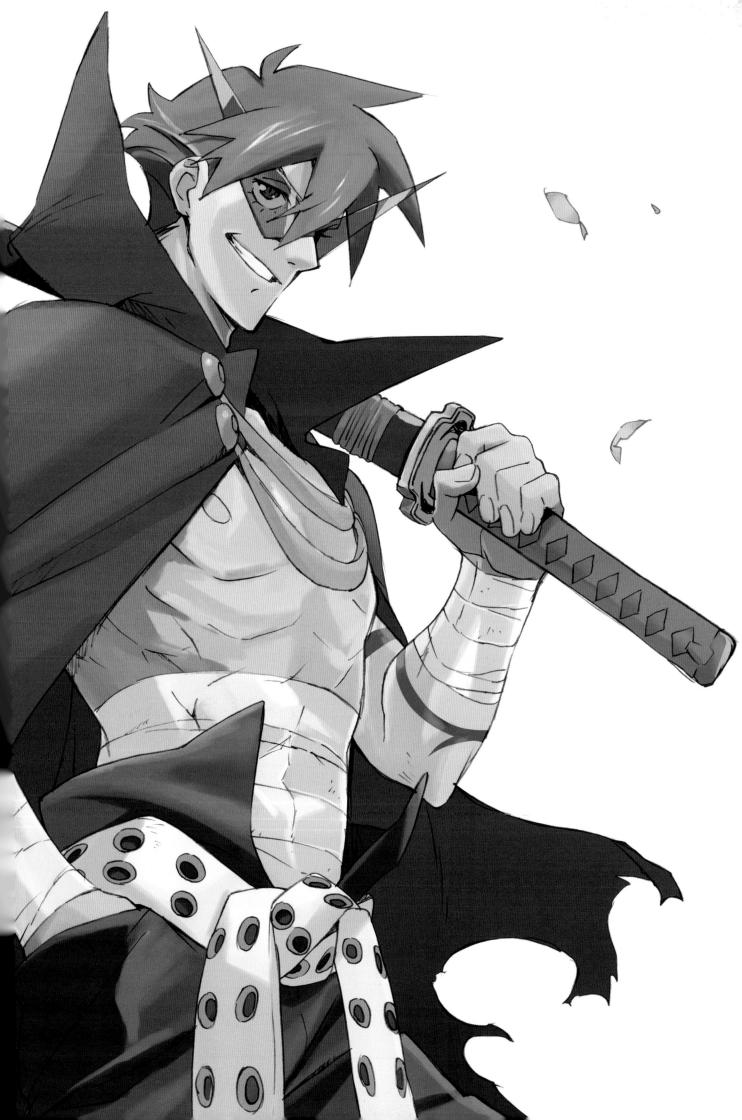

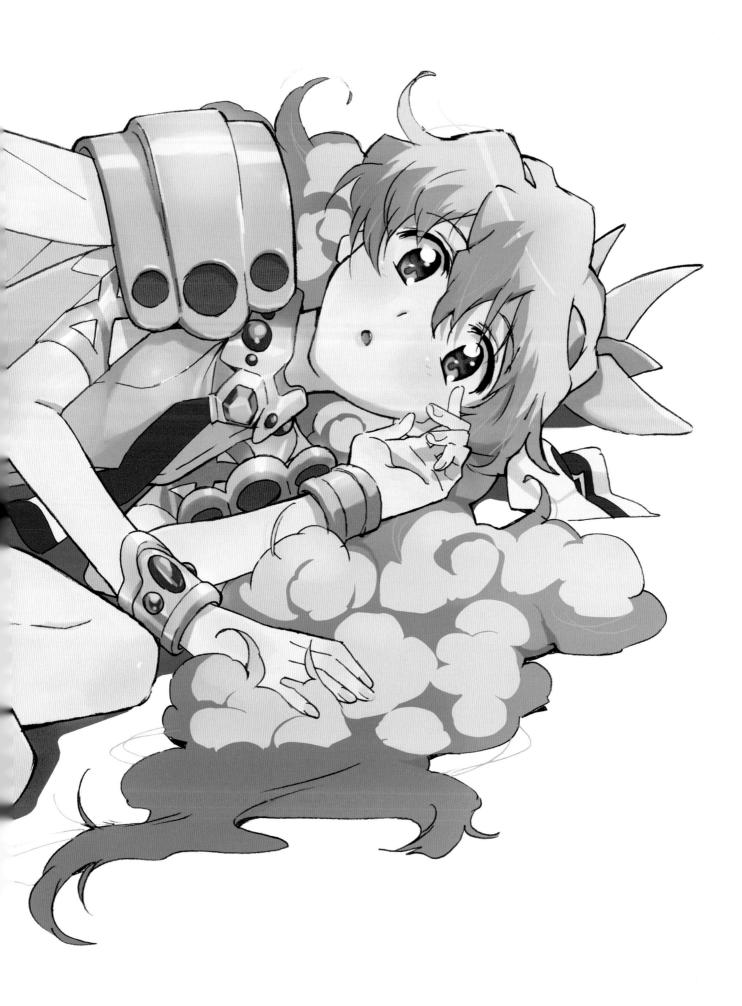

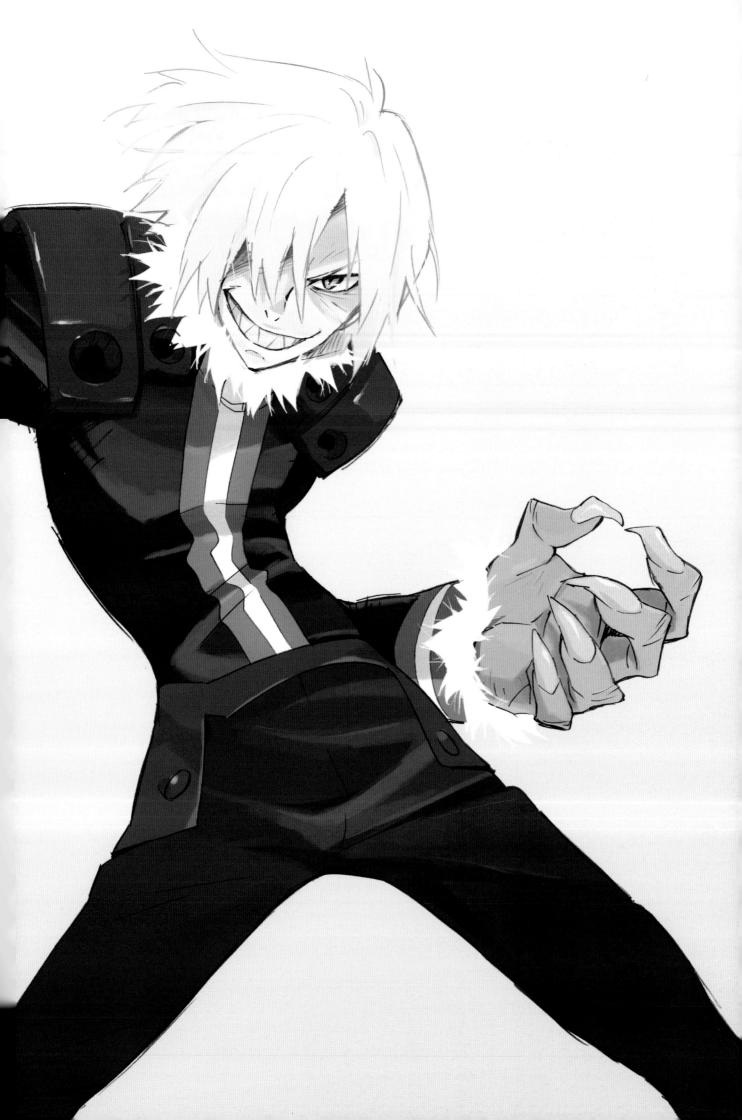

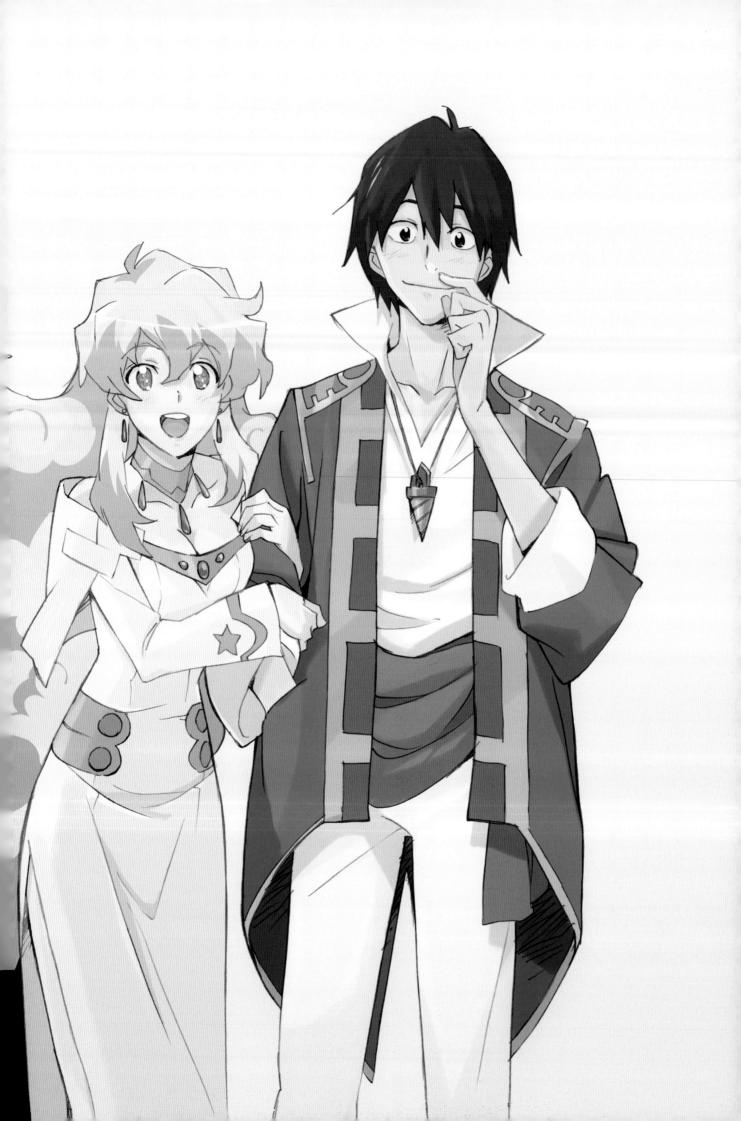

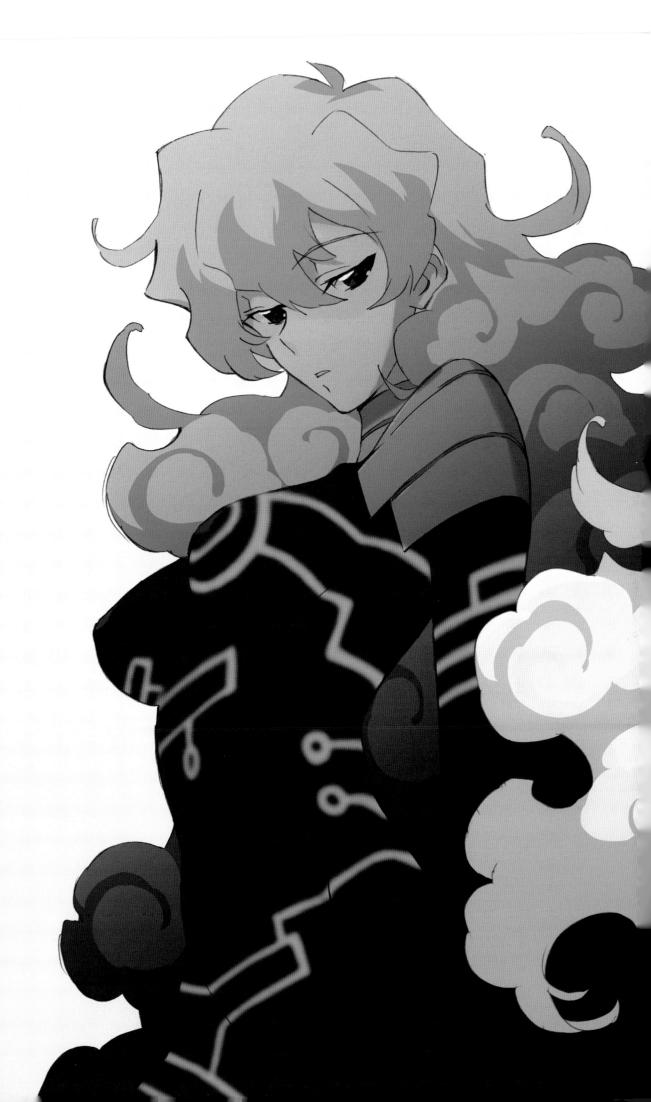

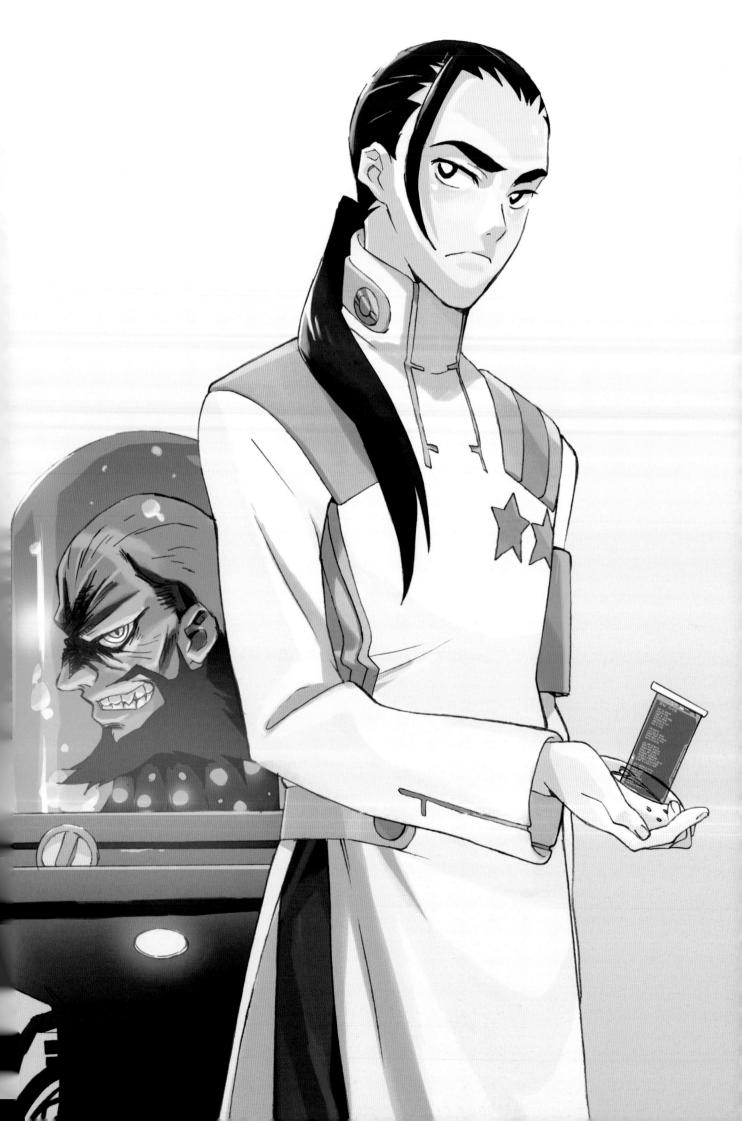

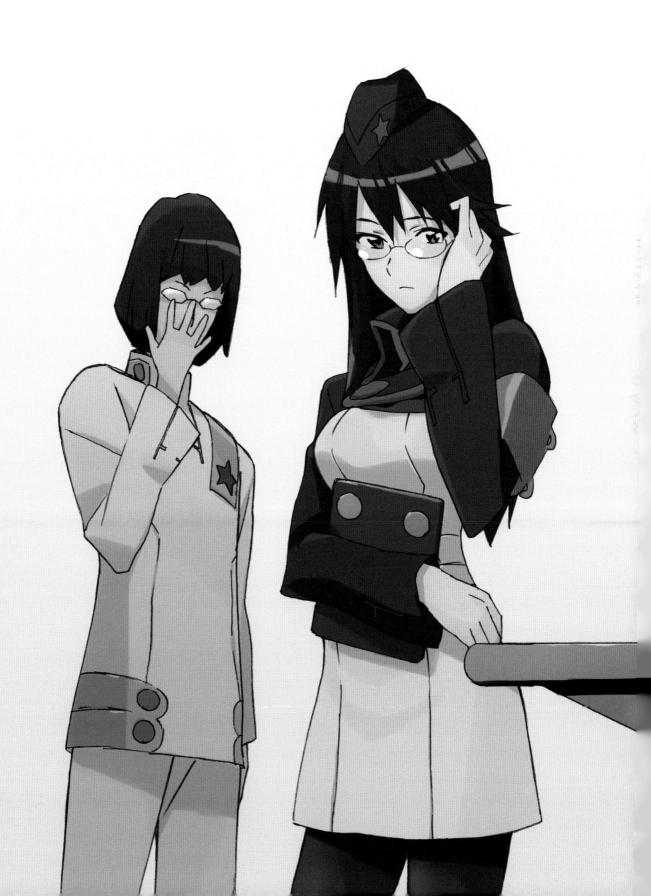

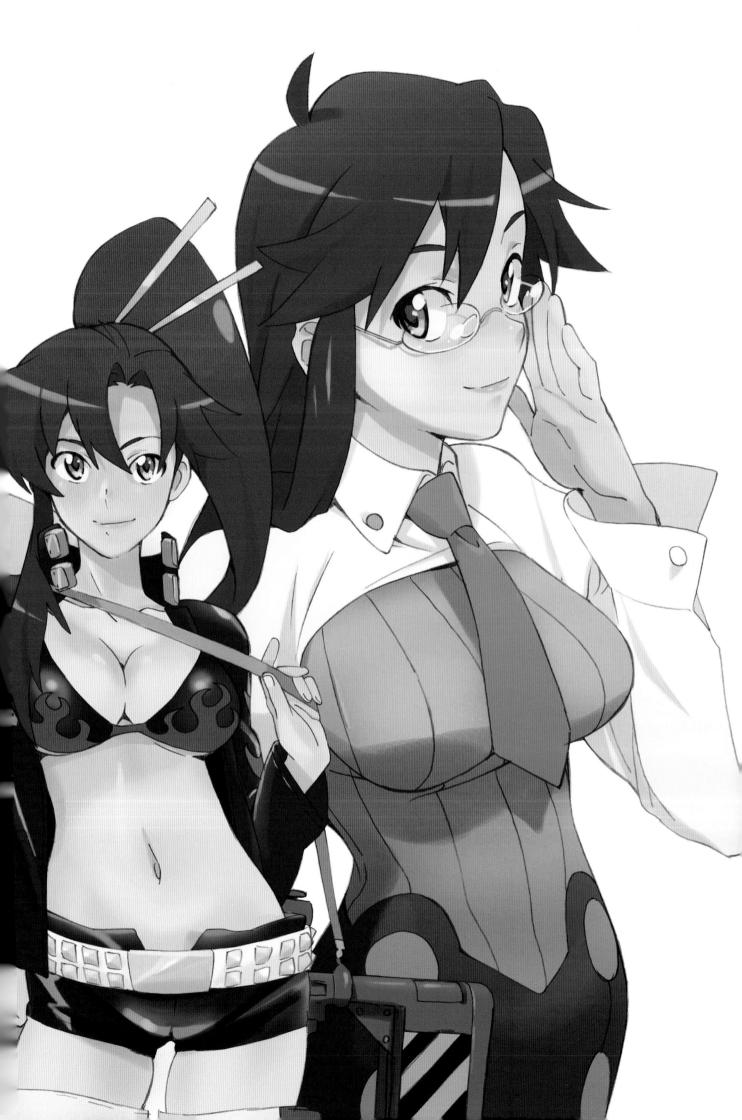

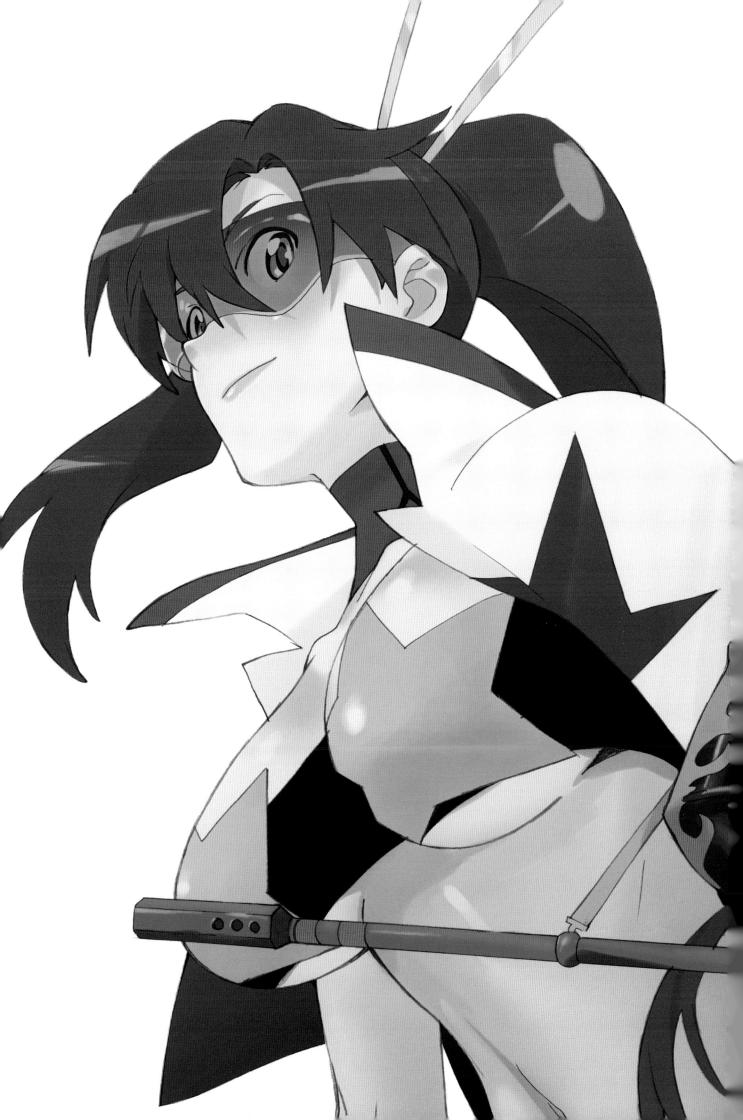

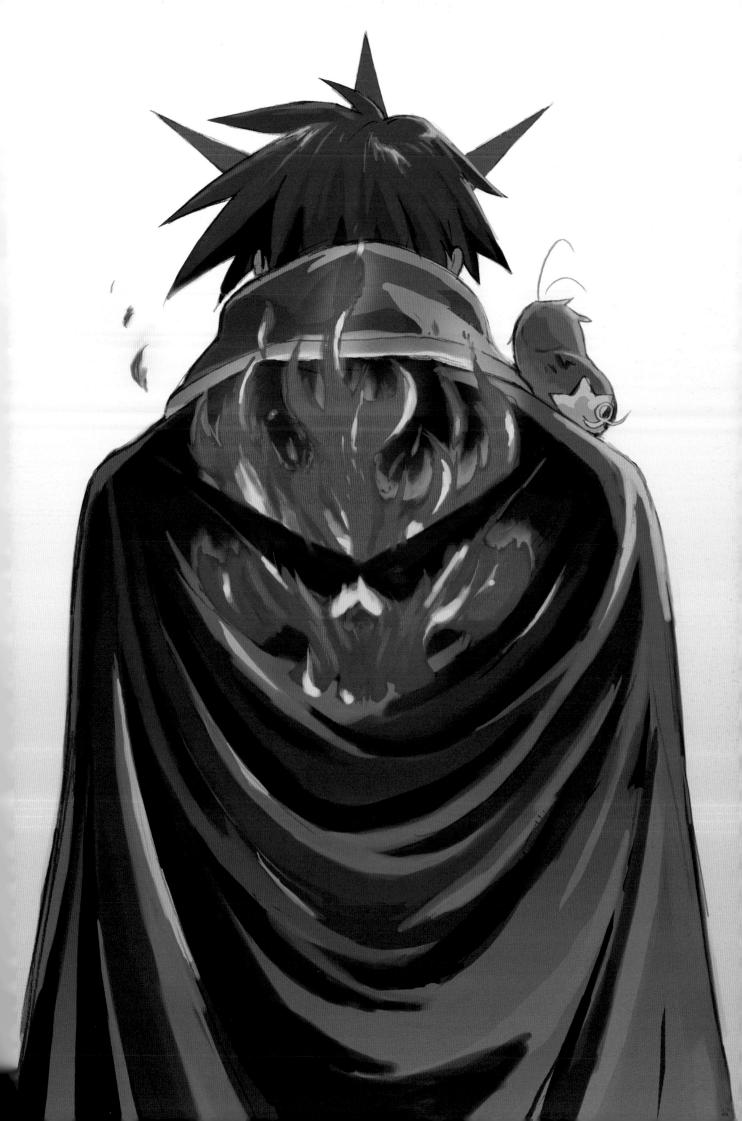

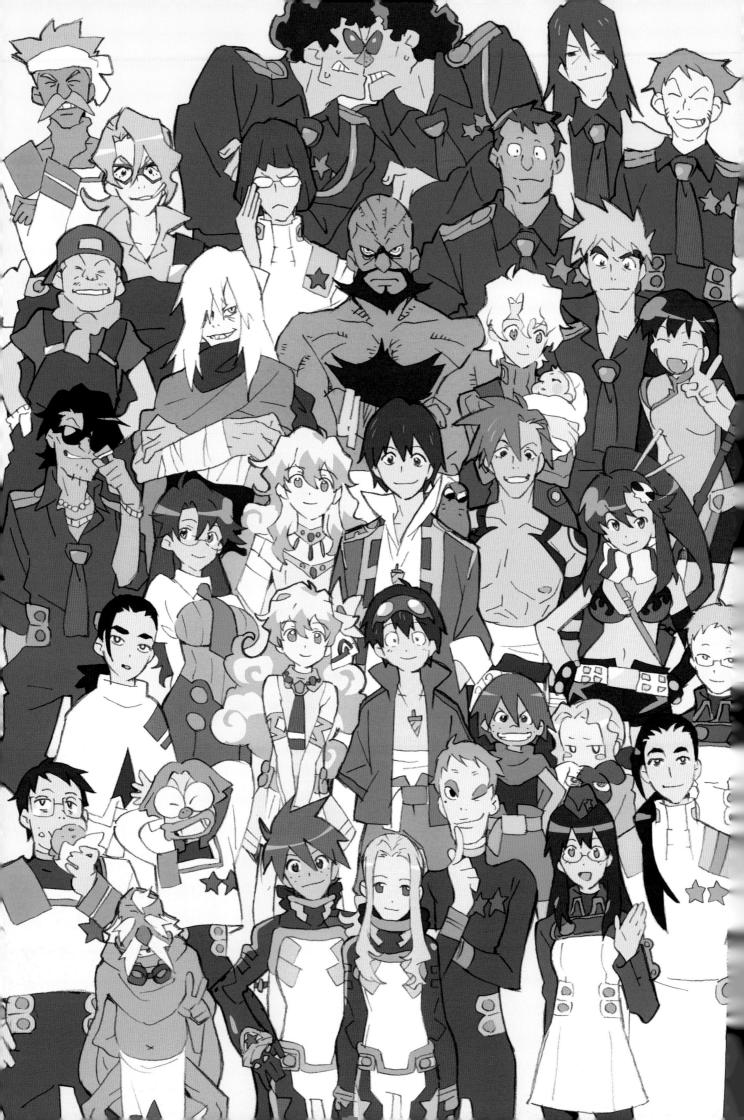

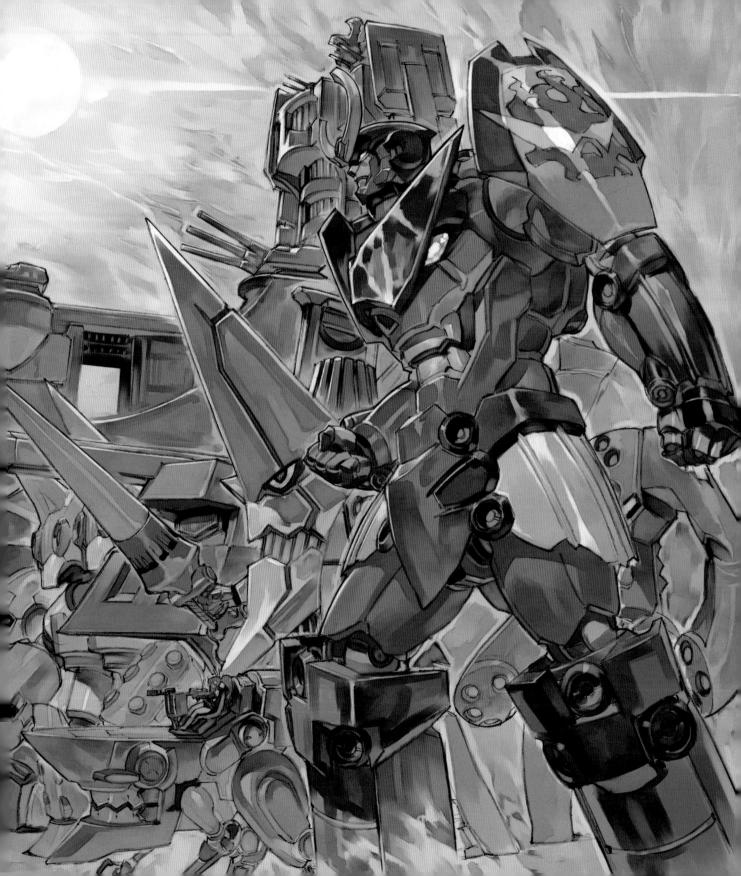

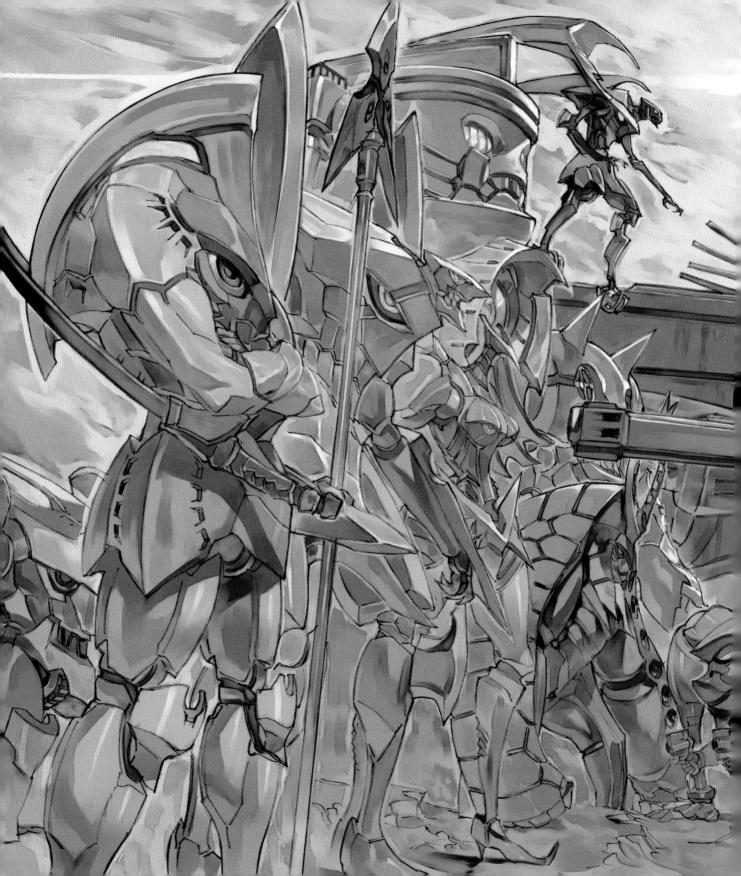

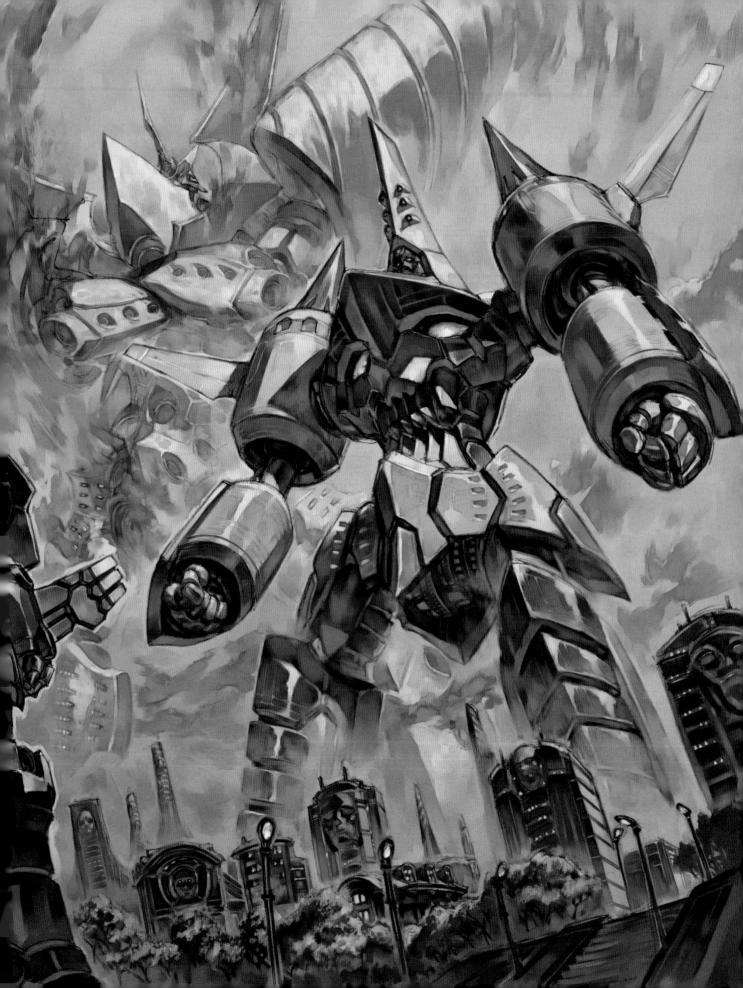

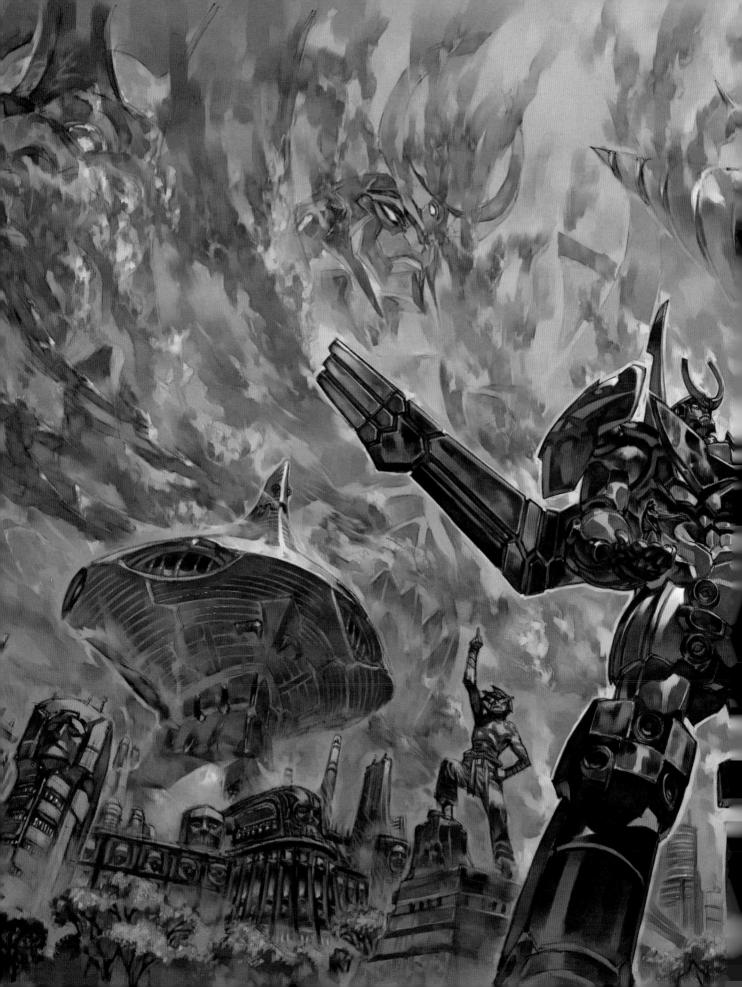

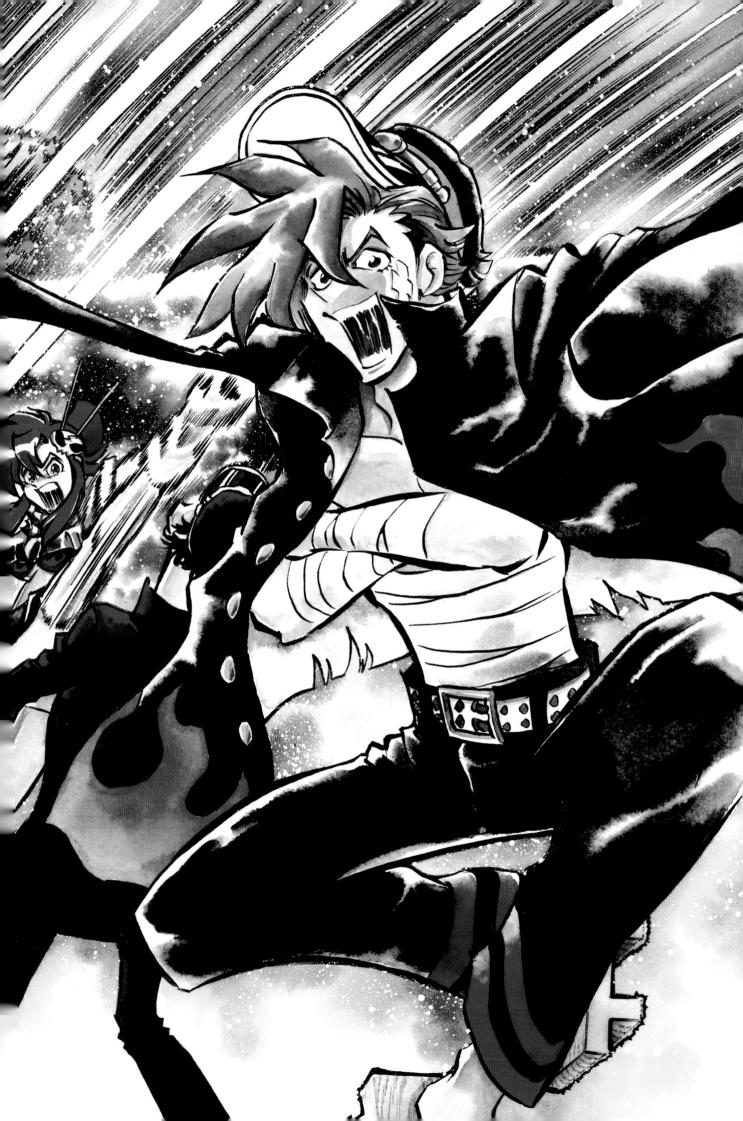

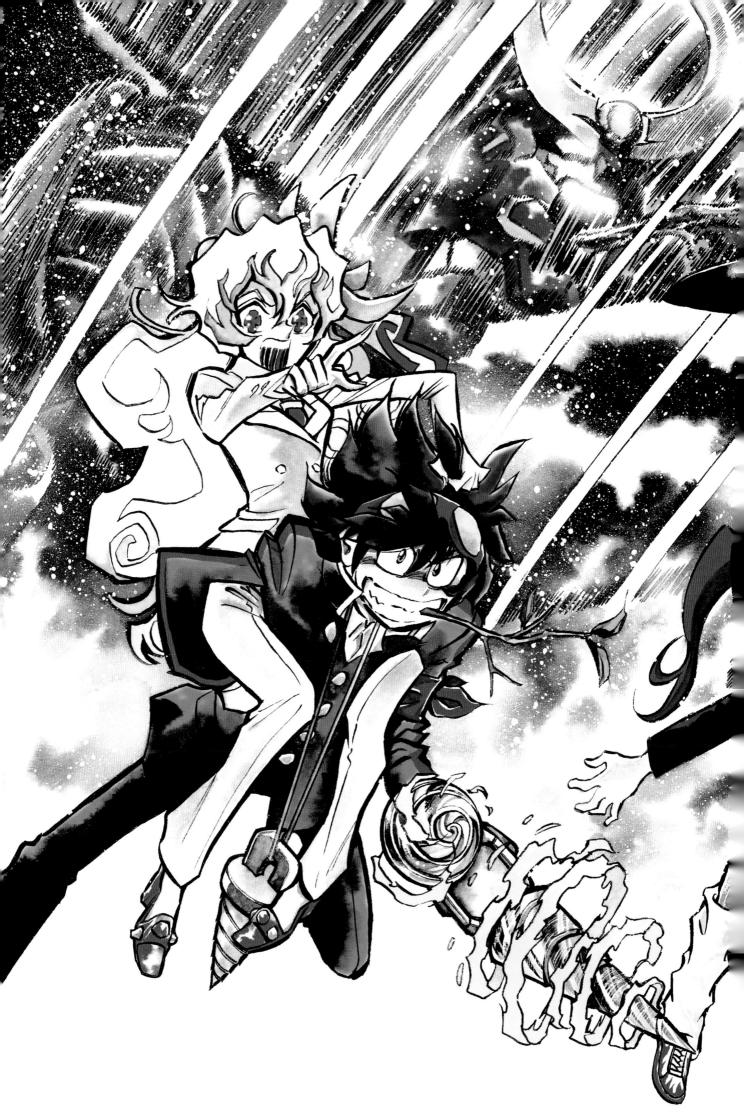

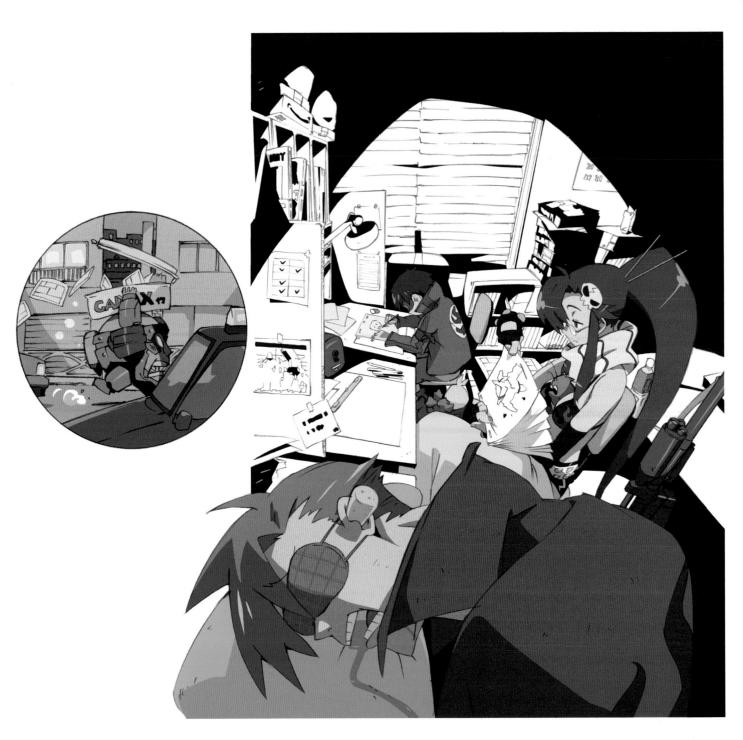

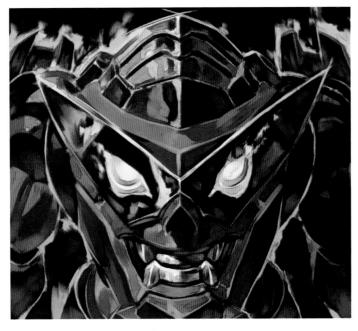

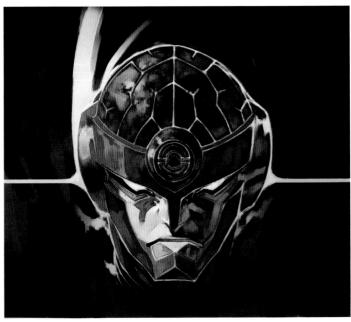

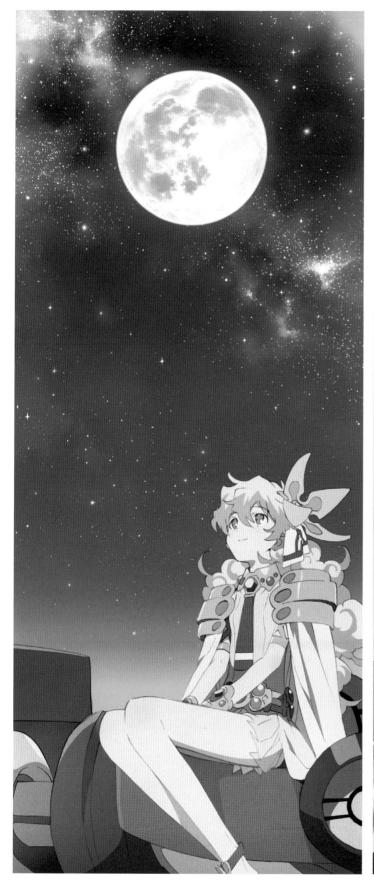

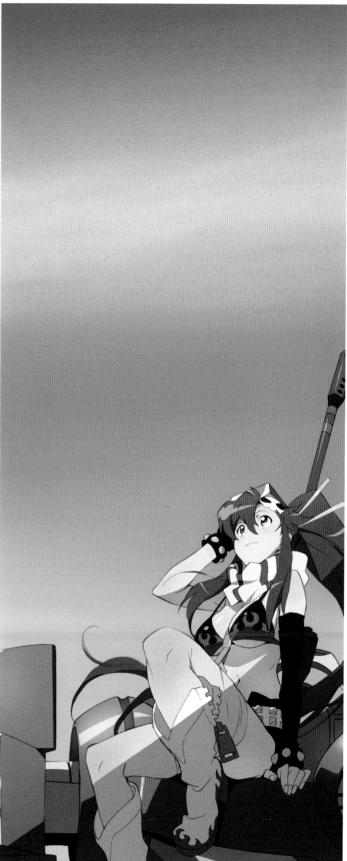

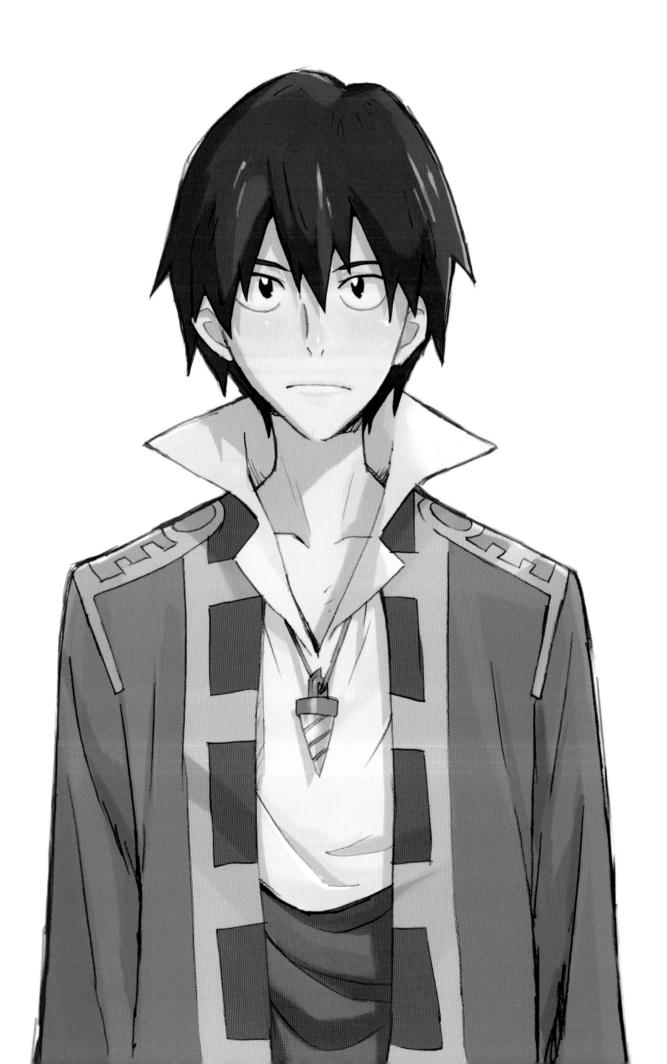

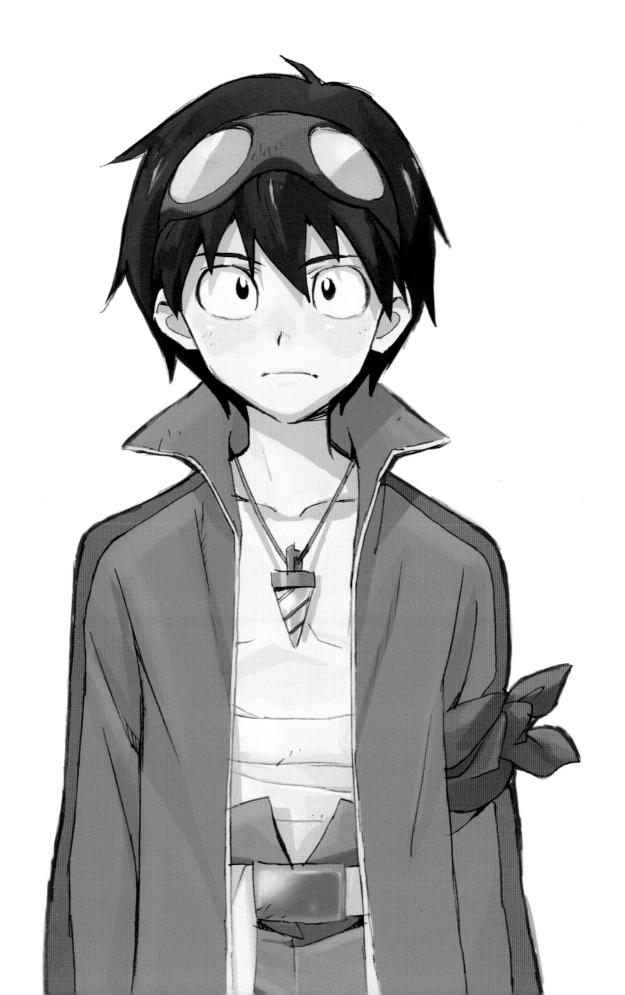

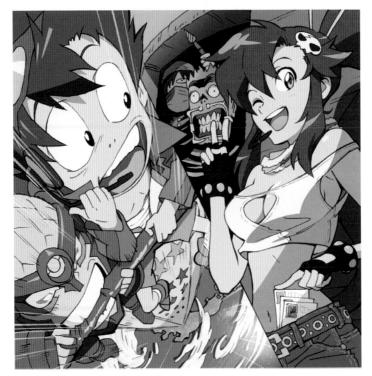

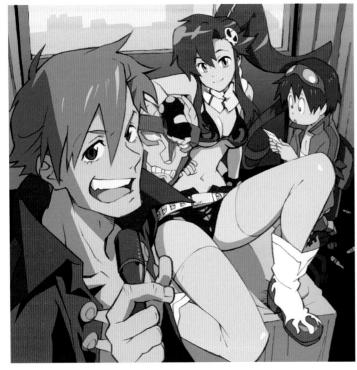

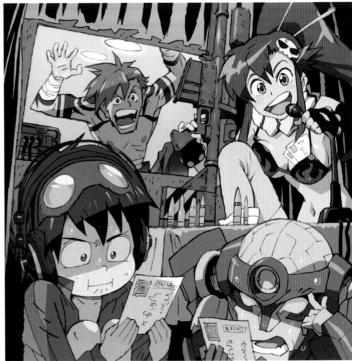

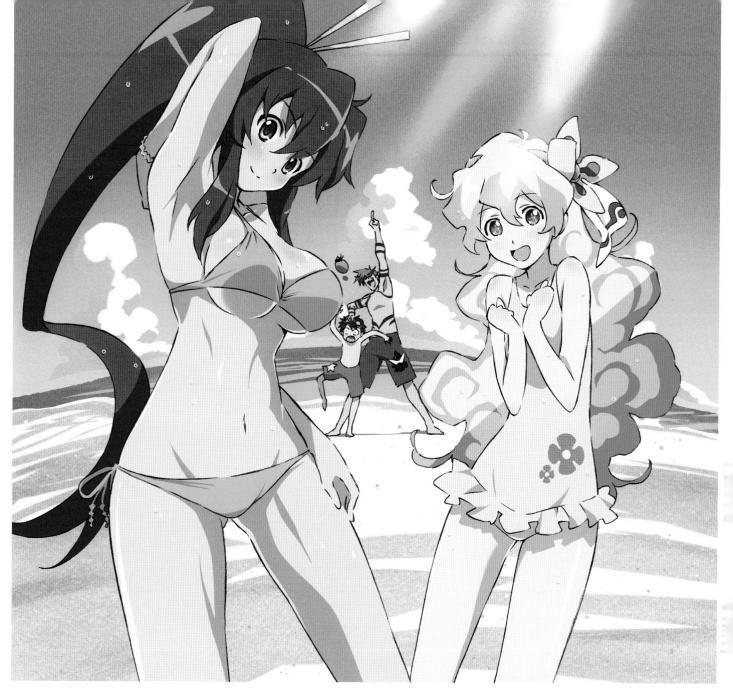

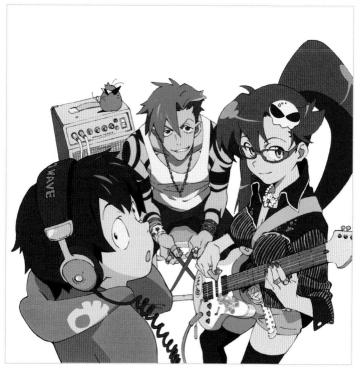

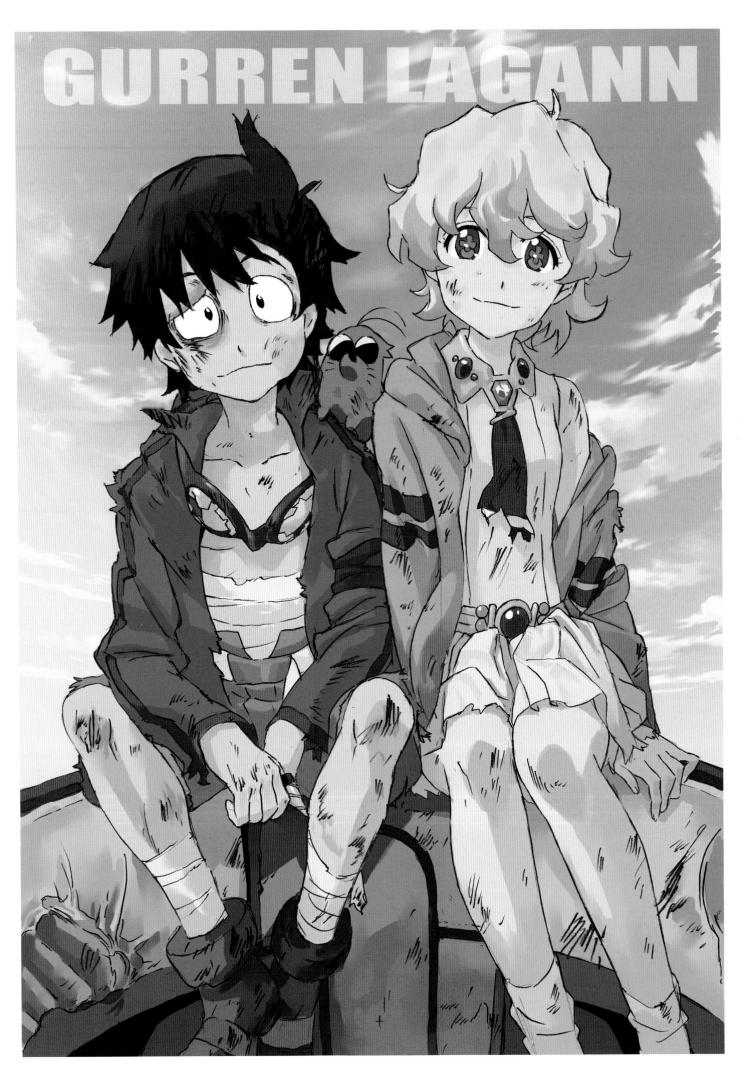

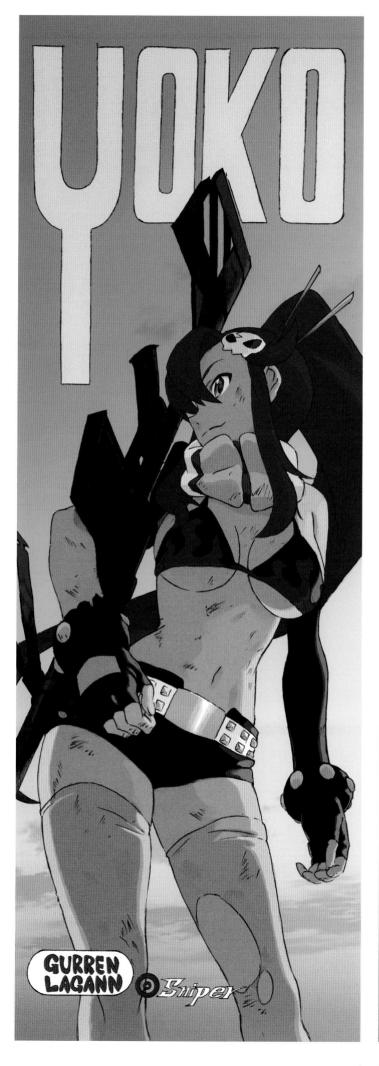

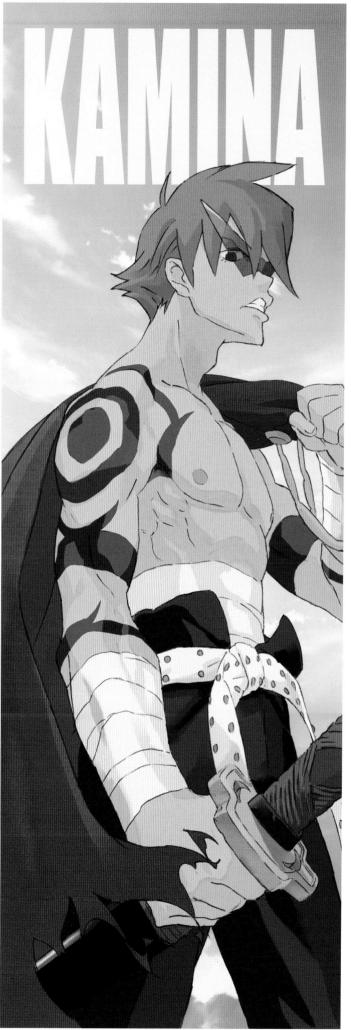

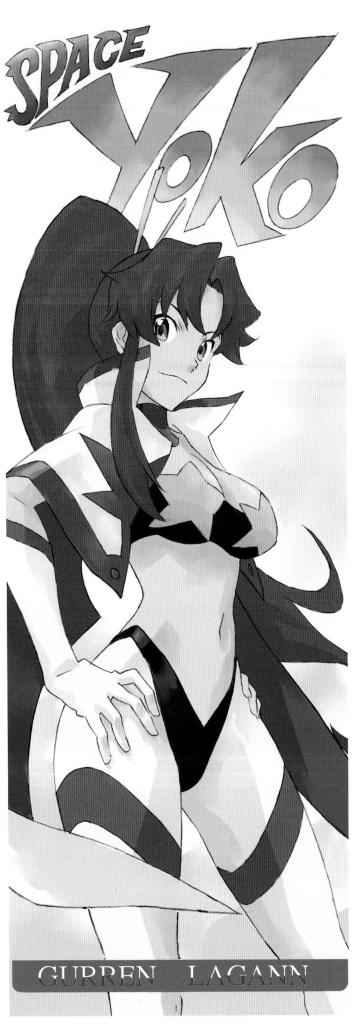

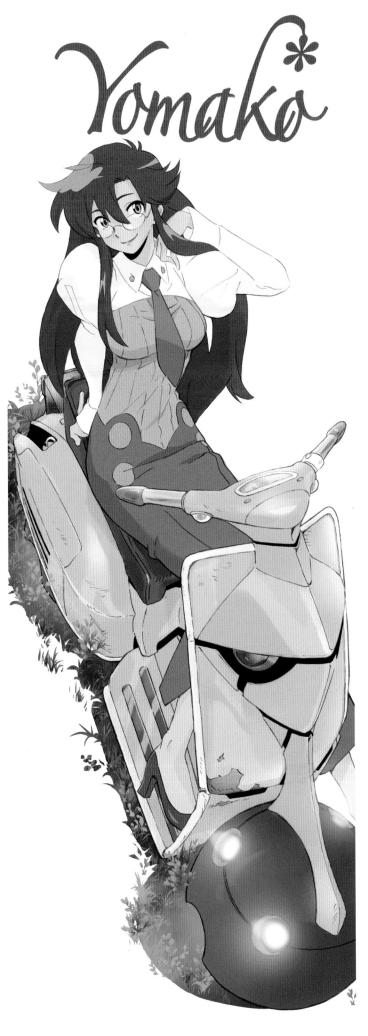

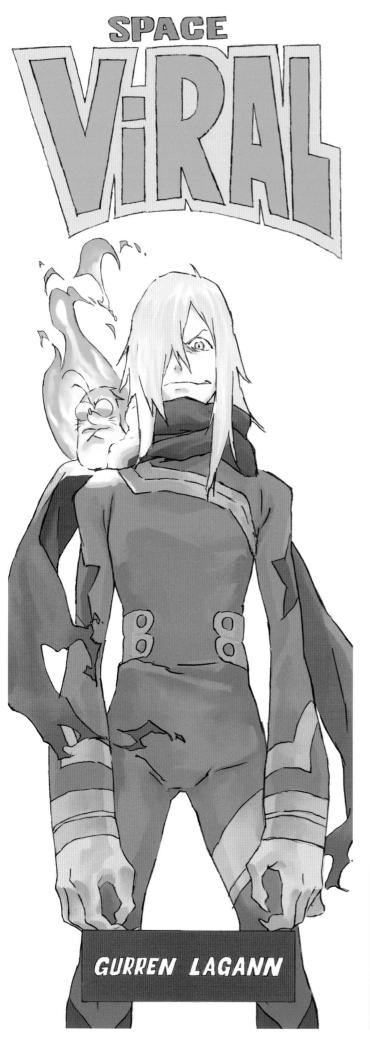

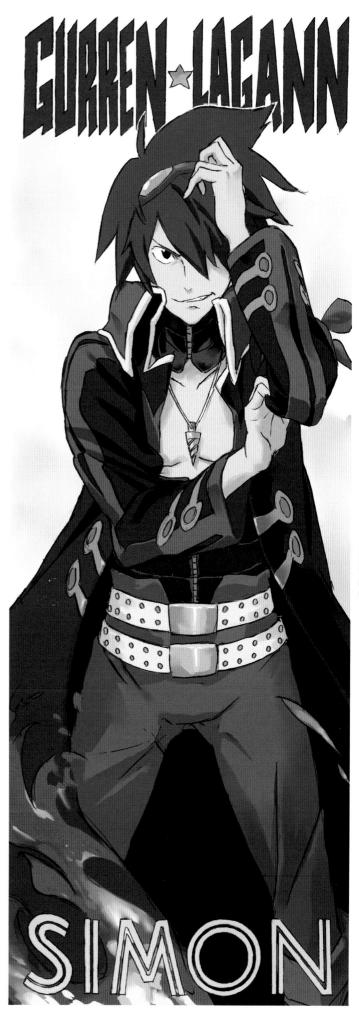

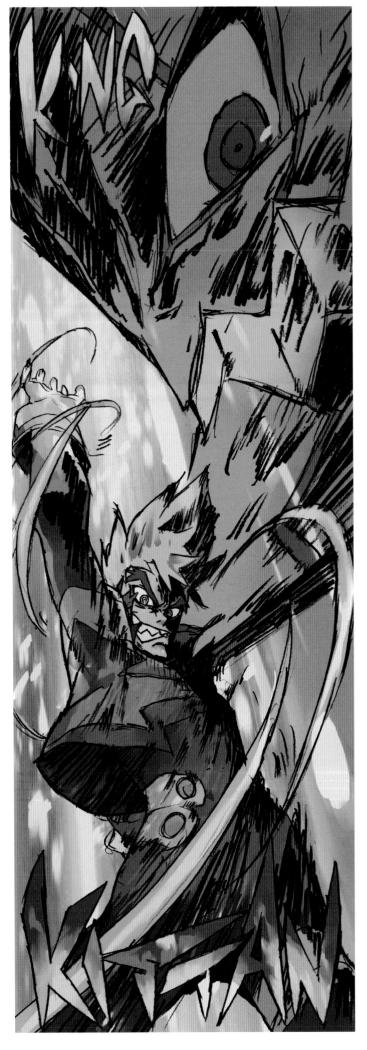

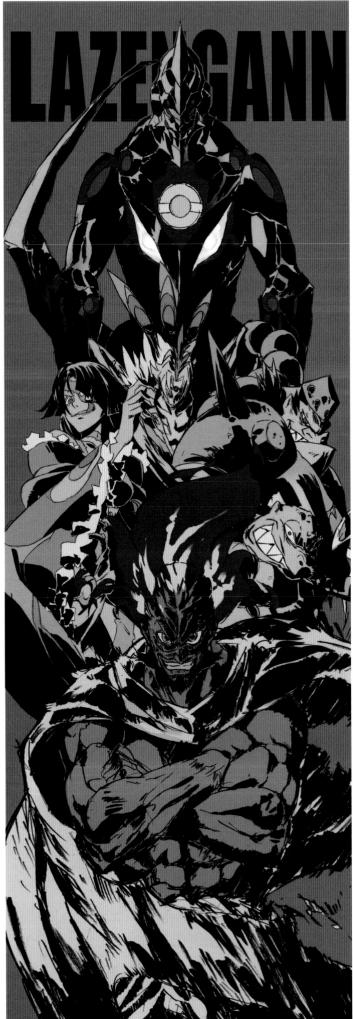

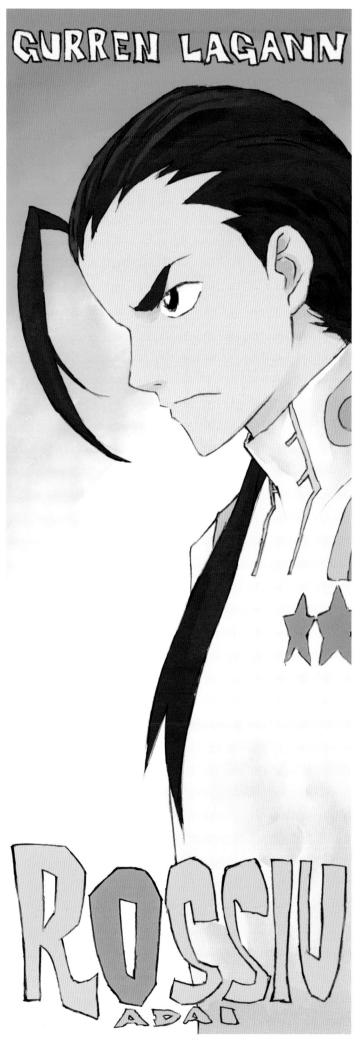

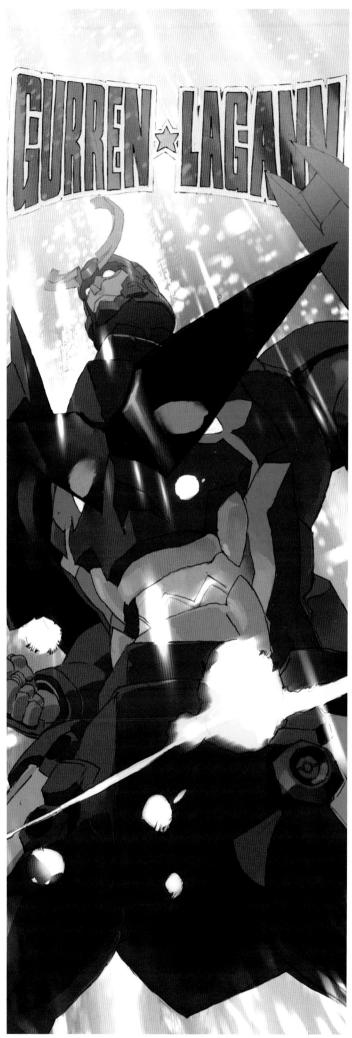

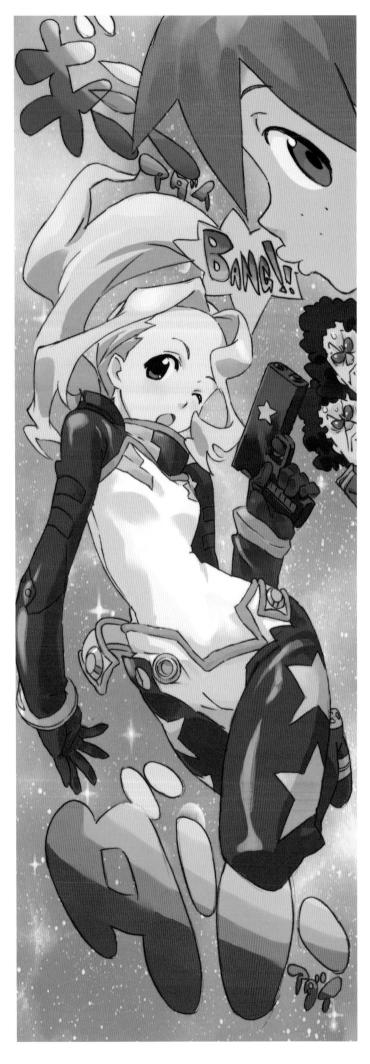

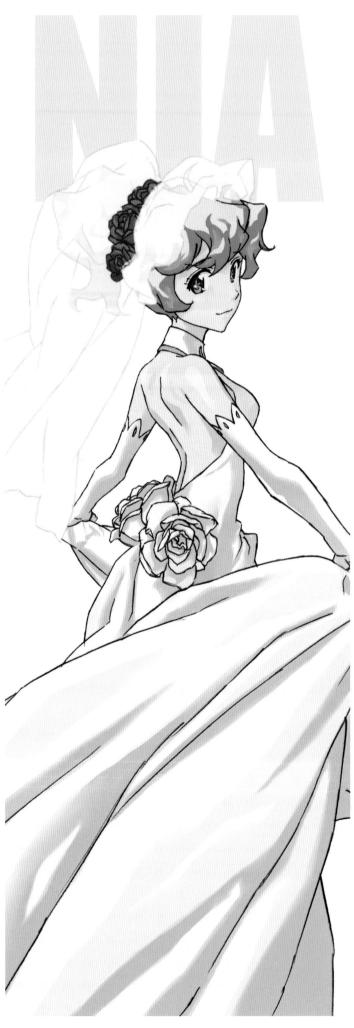

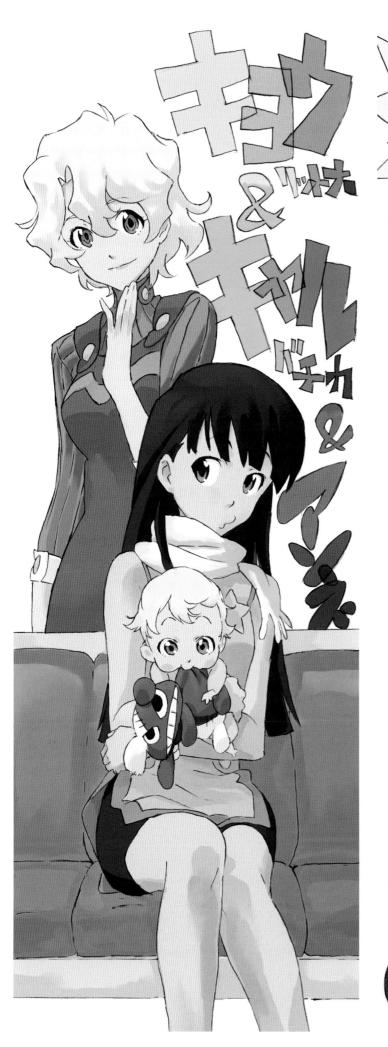

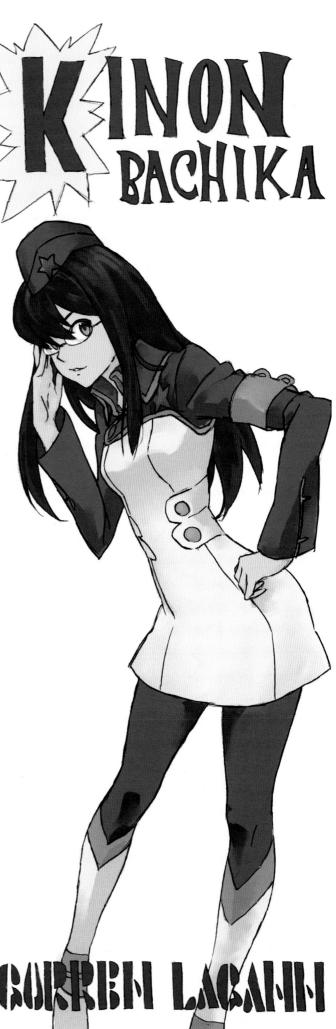

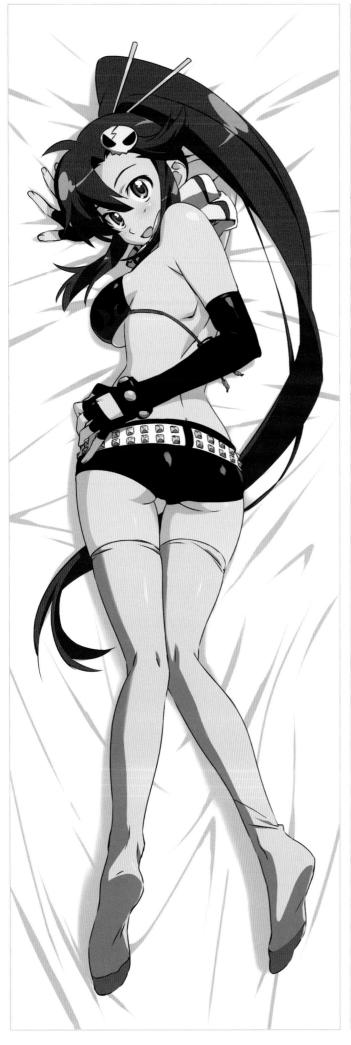

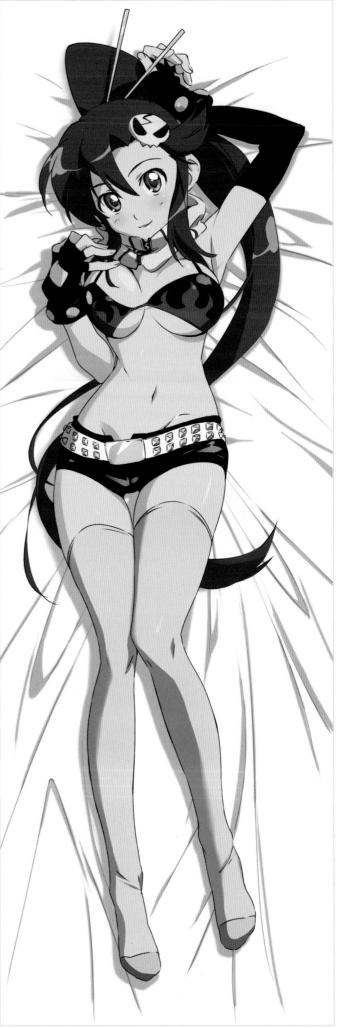

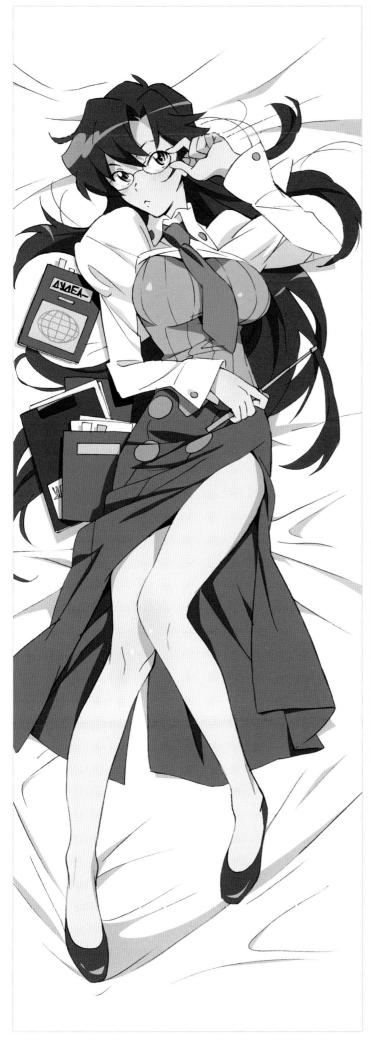

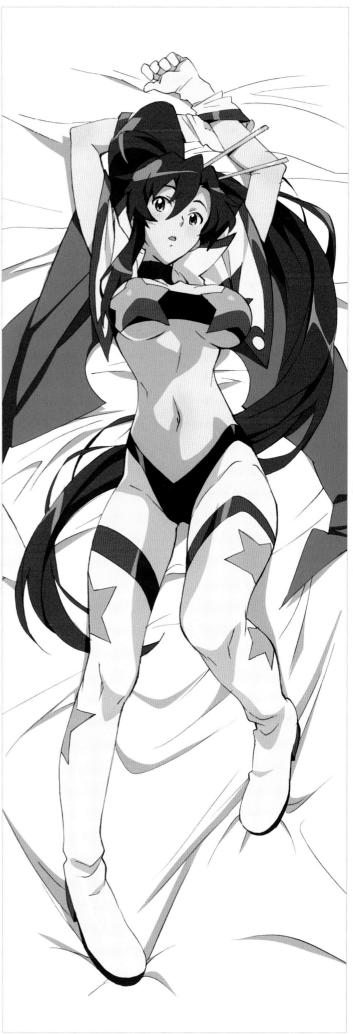

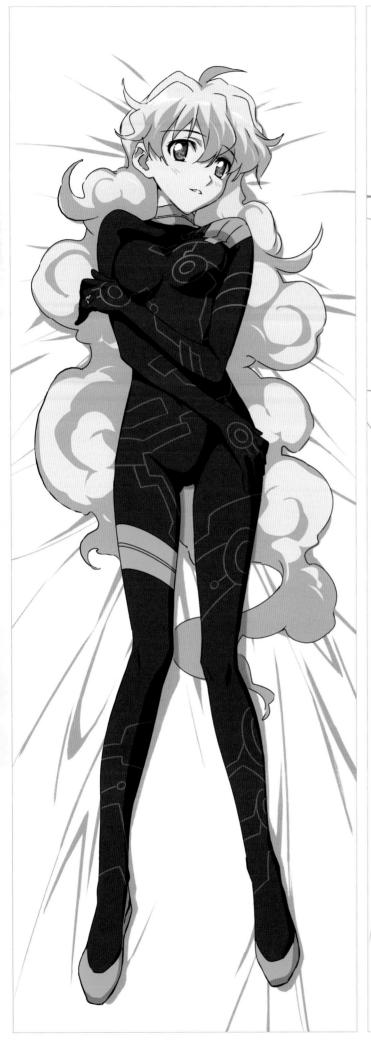

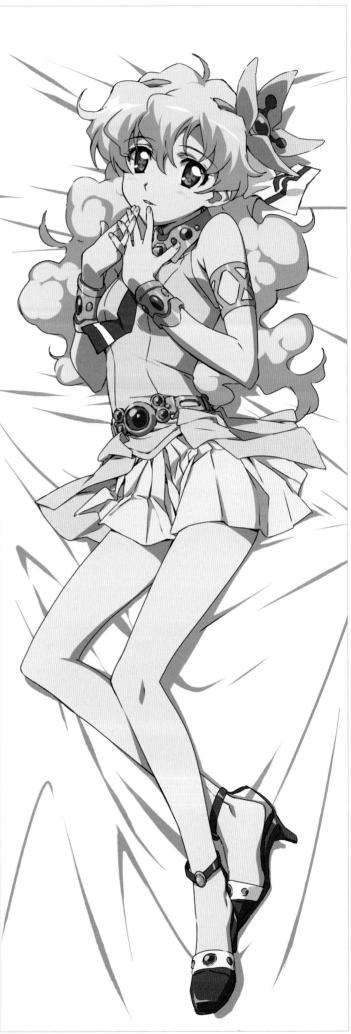

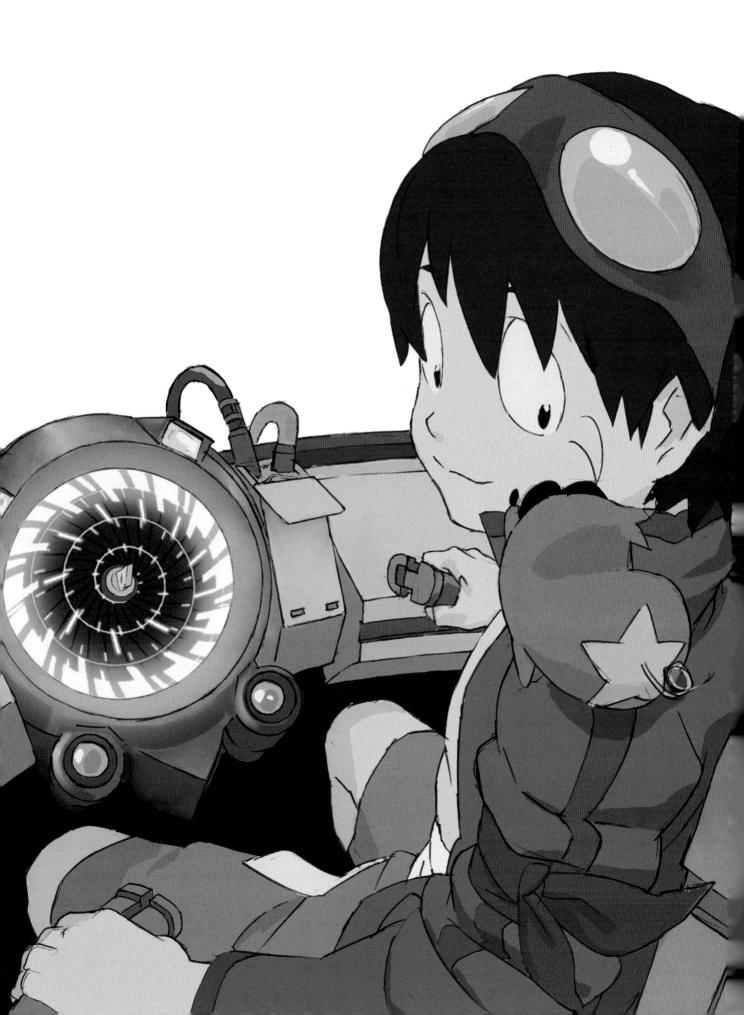

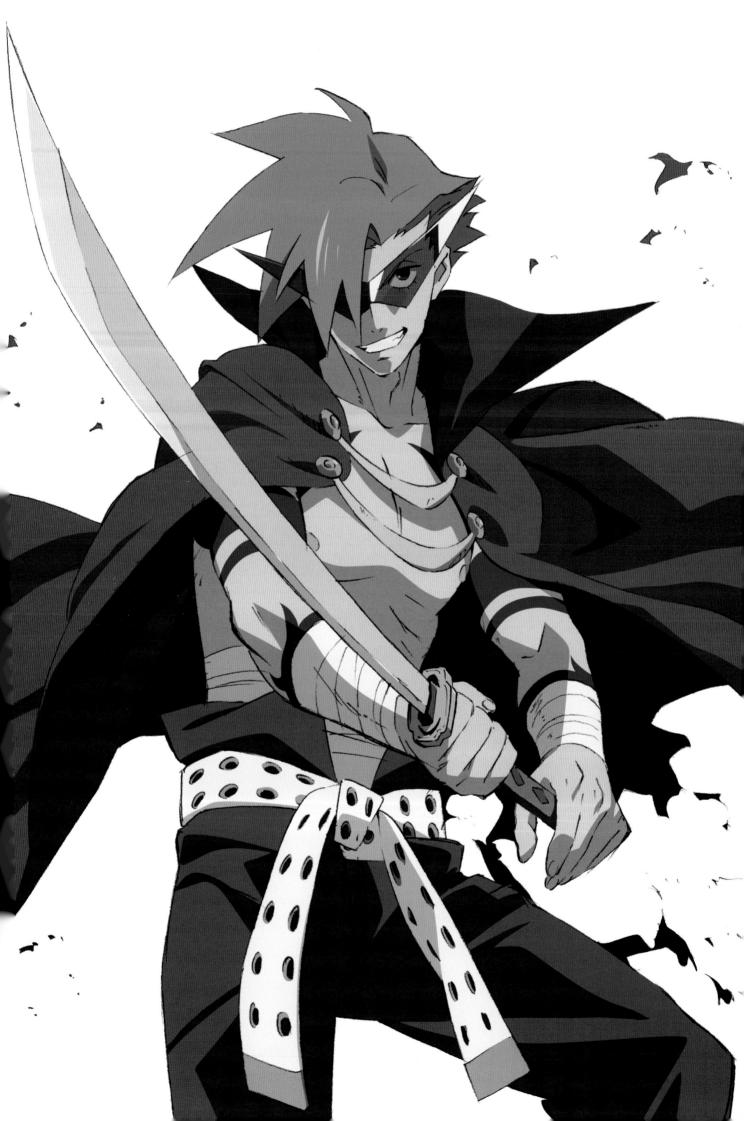

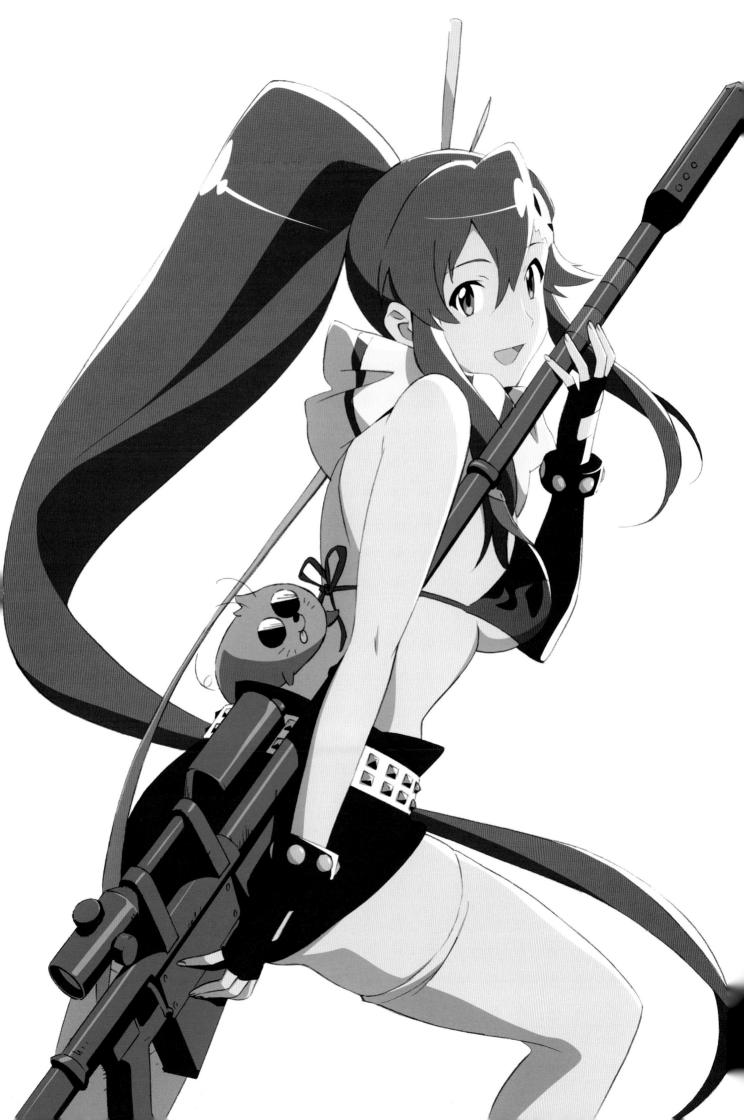

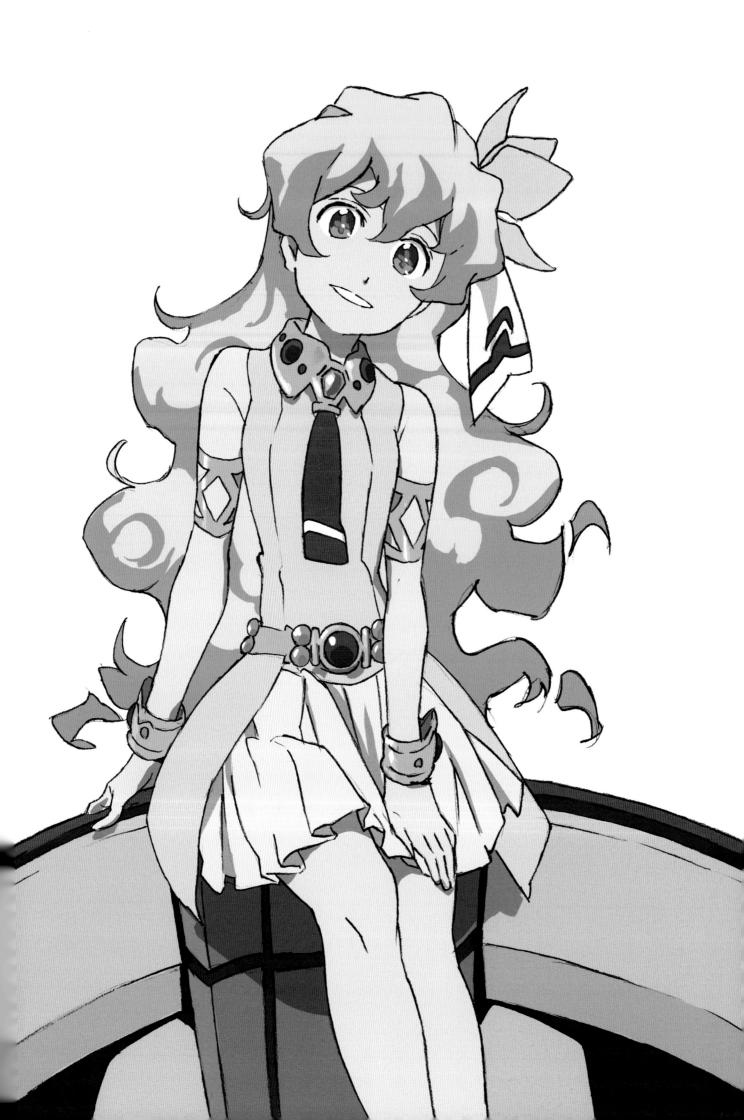

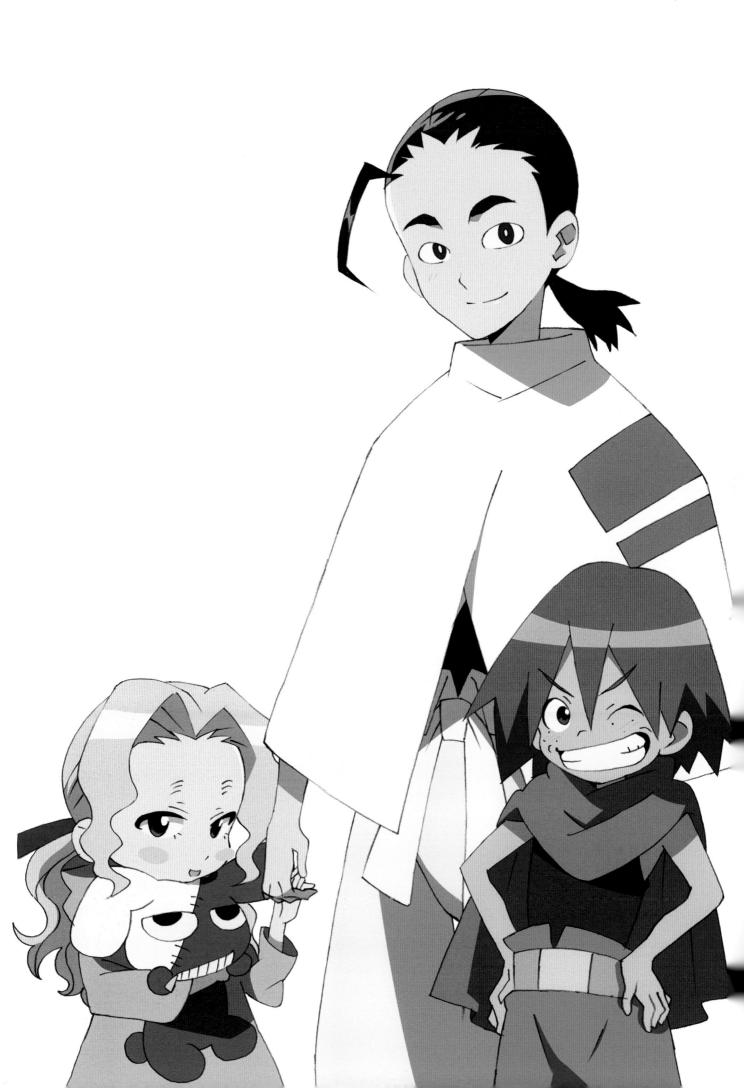

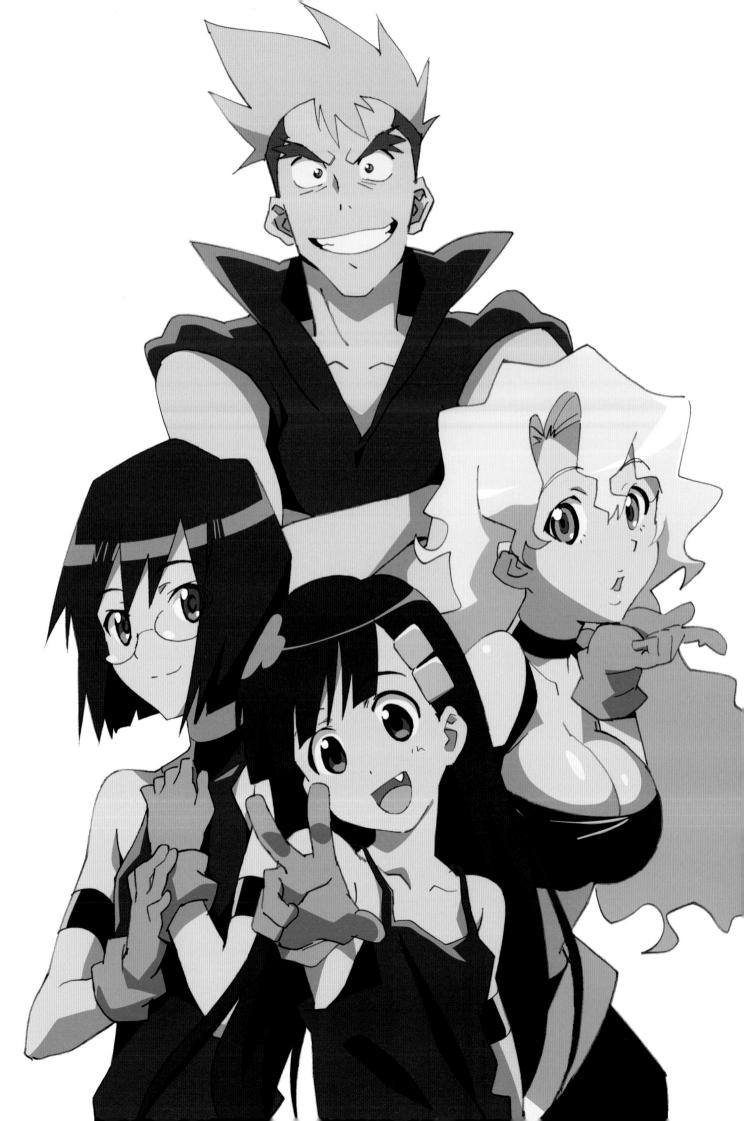

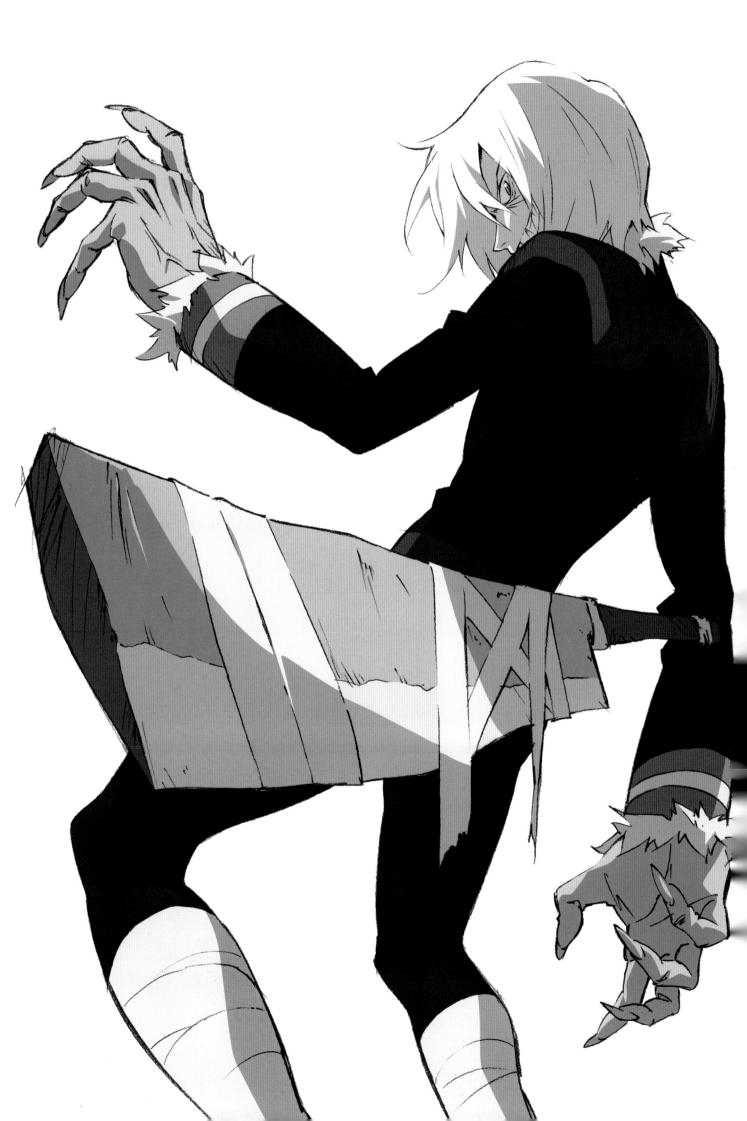

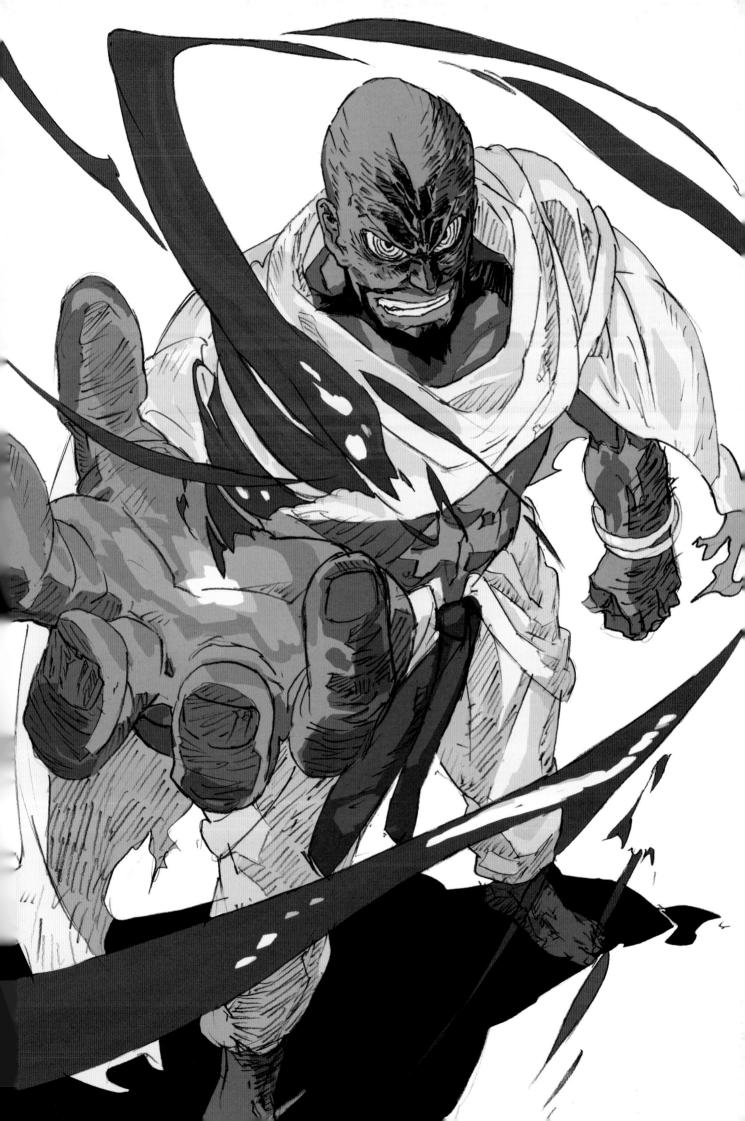

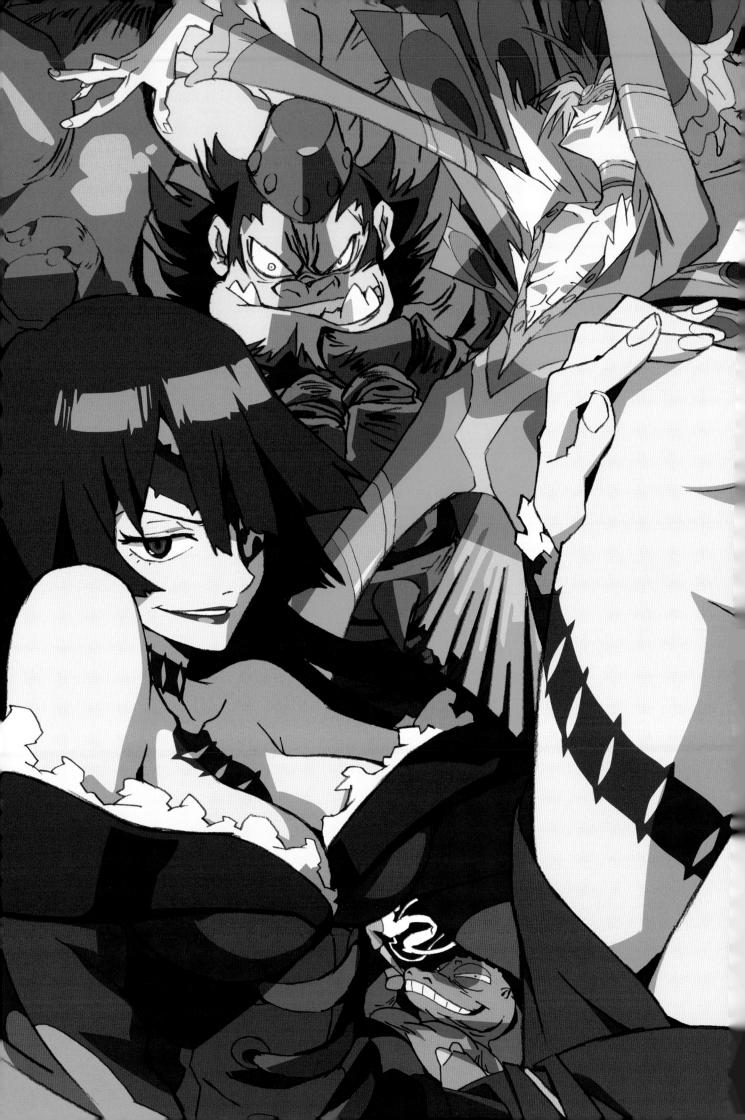

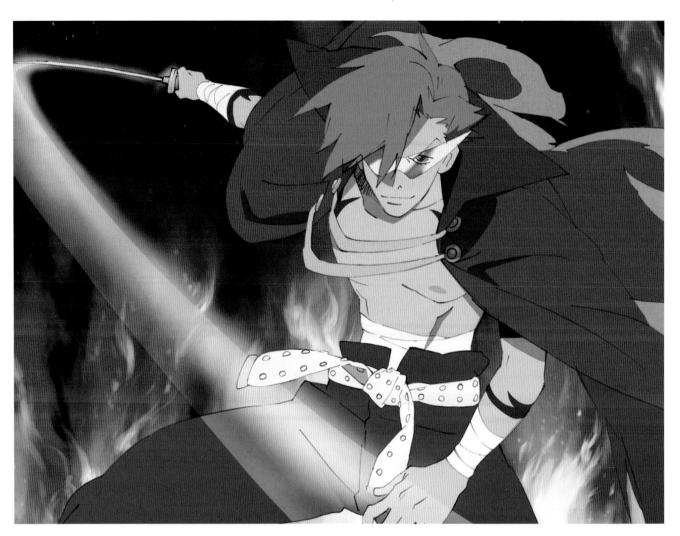

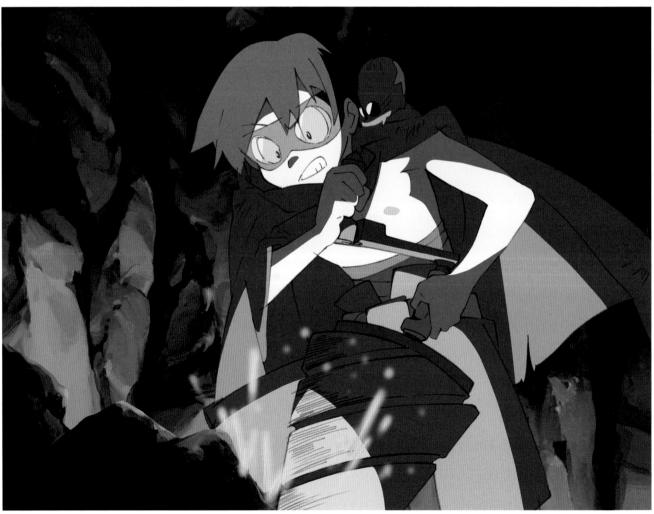

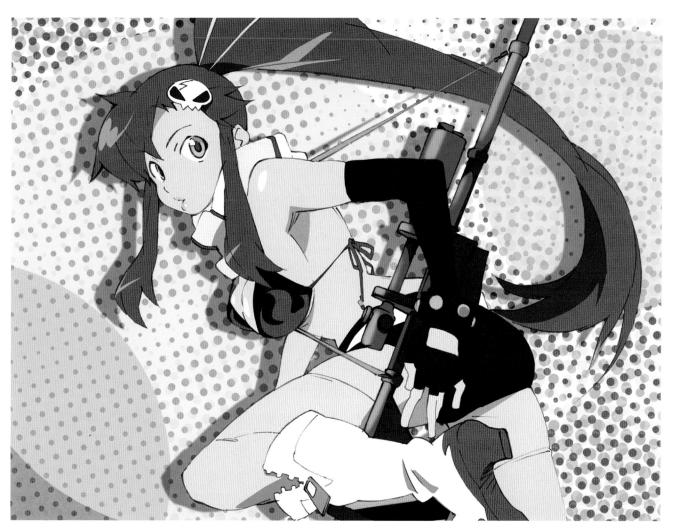

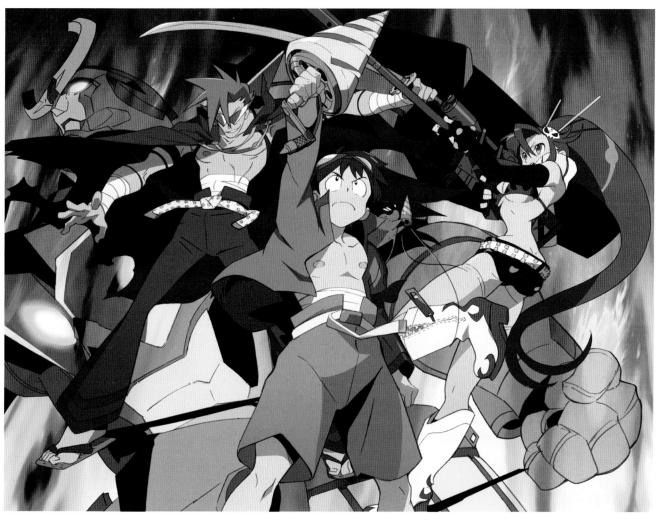

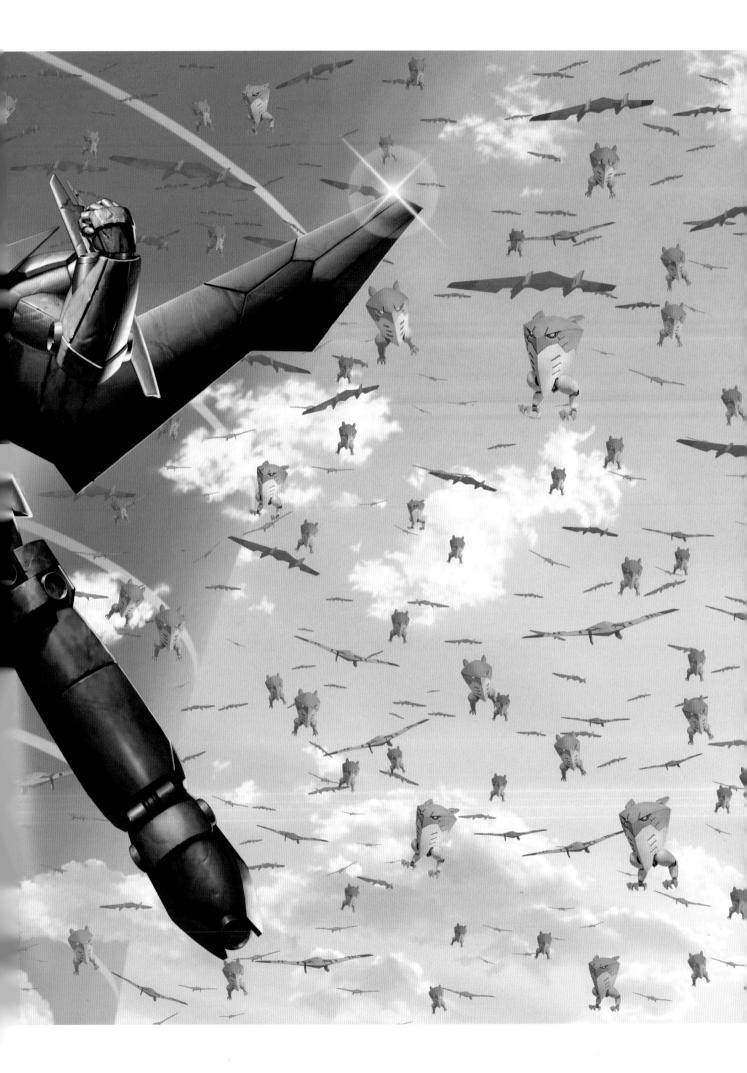

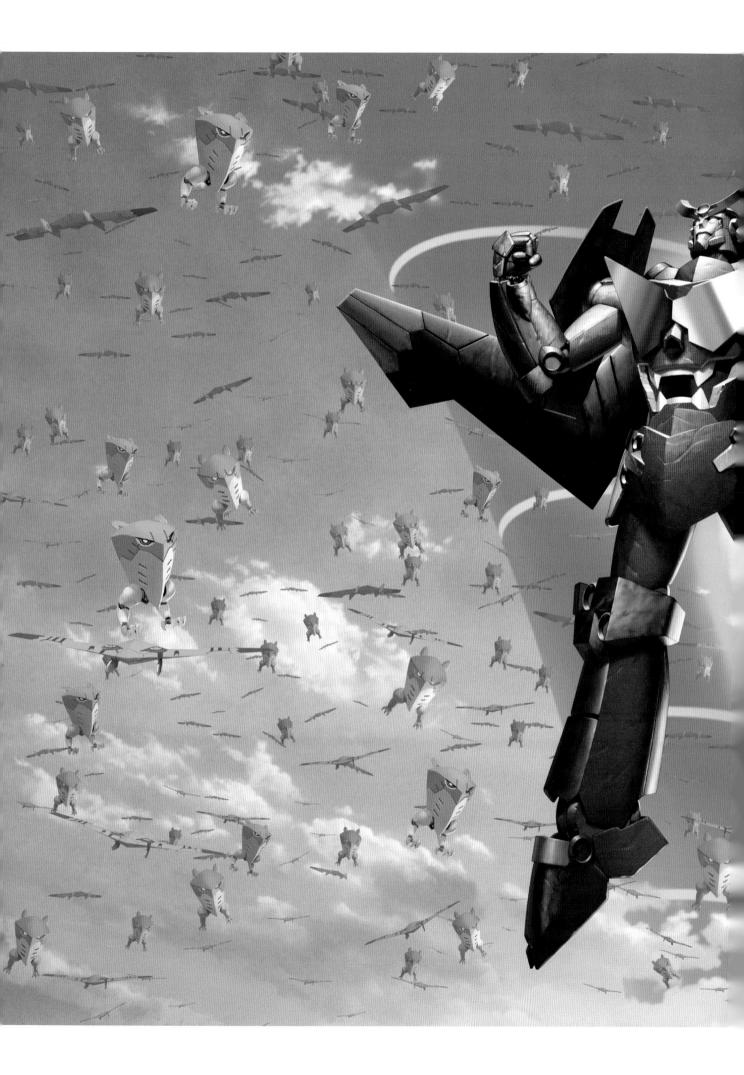

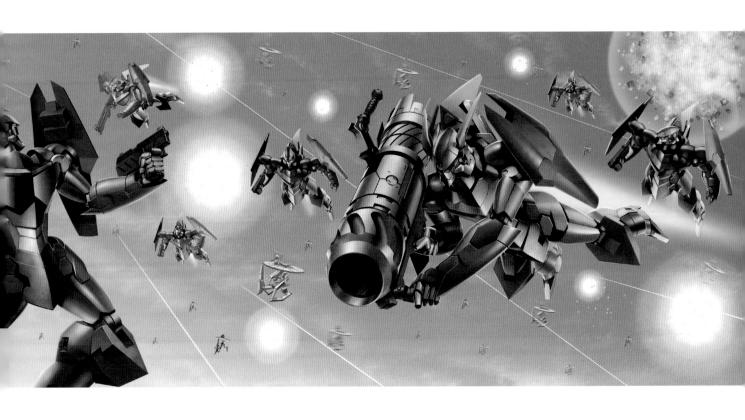

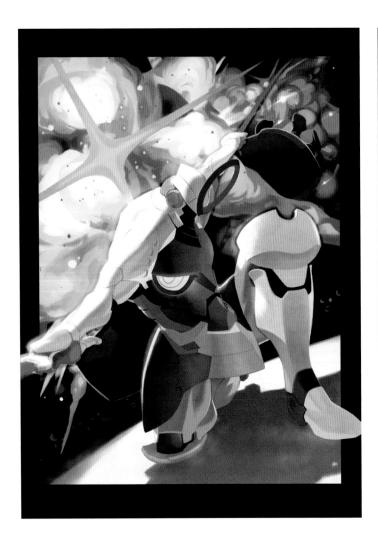

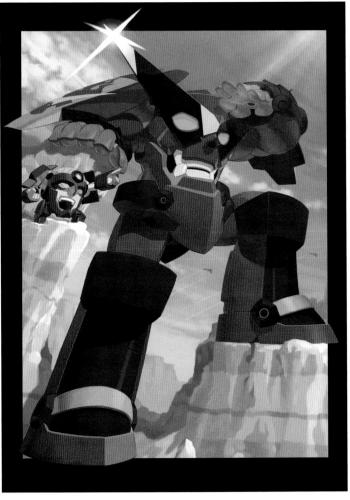

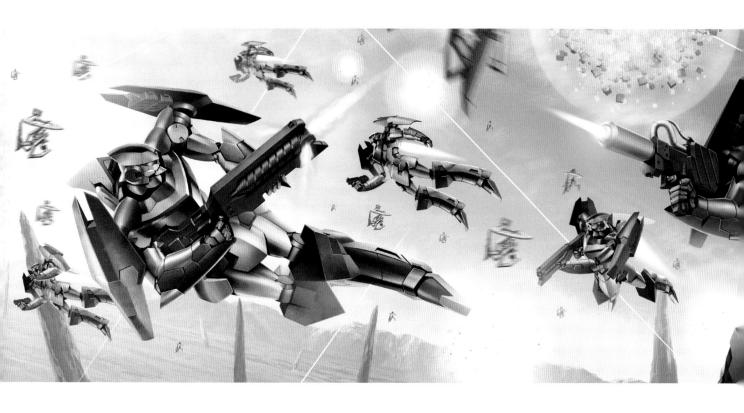

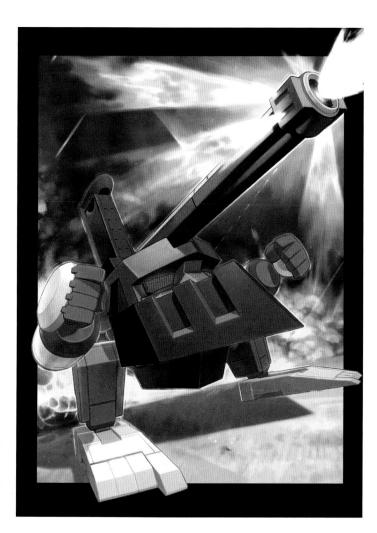

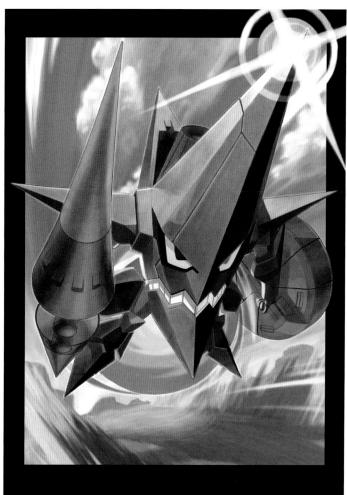

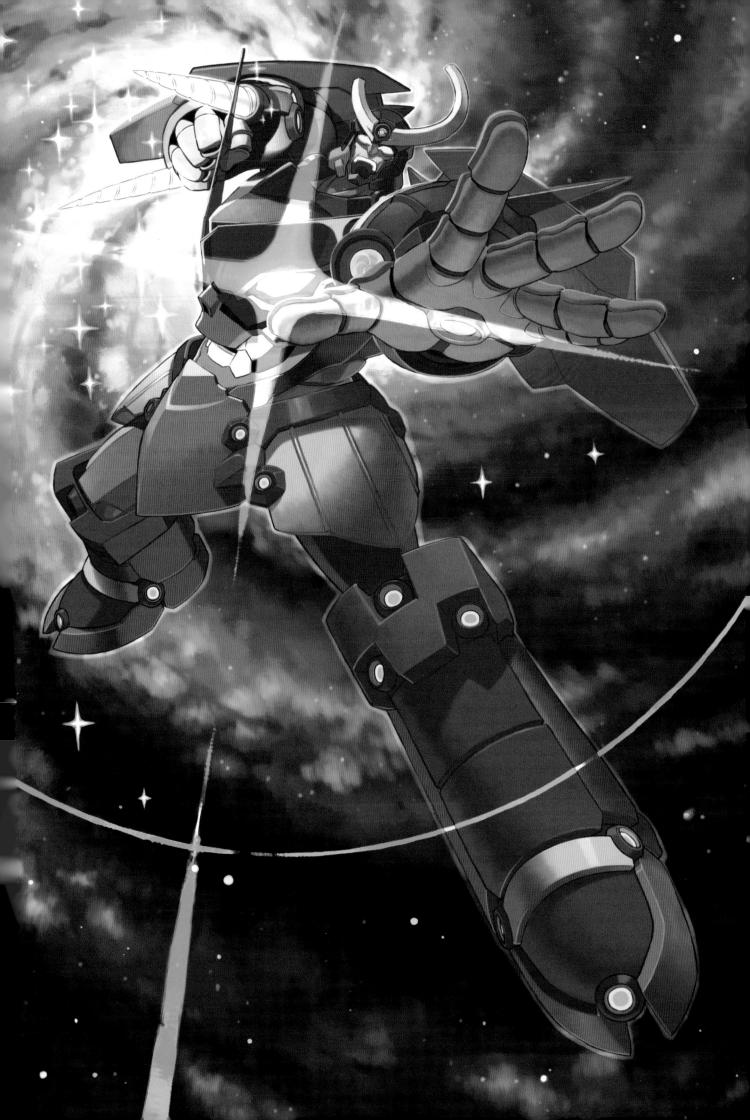

ILLUSTRATIONS INDEX

ILLUSTRATIONS INDEX

P-018

Base Art: ATSUSHI NISHIGORI Finish: SANOKUMI

FUMIHIKO MOROHASHI

Debut: TOKUMA SHOTEN "ANIMAGE MONTHLY" FEBRUARY 2007 ISSUE

P-009

Base Art: YUKA SHIBATA Finish: SANOKUMI SFX: BIHOU

Debut: KADOKAWA SHOTEN "NEWTYPE MONTHLY" JULY 2007 ISSUE

COVER

BG: BIHOU

Base Art: ATSUSHI NISHIGORI Finish: SANOKUMI SFX: ATSUSHI NISHIGORI

Debut: EXCLUSIVE ART FOR THIS BOOK

P-020

Illustration: SUSHIO
Debut:
TOKUMA SHOTEN
"ANIMAGE MONTHLY"
MAY 2007 ISSUE

P-010

Illustration: SUSHIO

Debut: KADOKAWA SHOTEN "NEWTYPE MONTHLY" MAY 2007 ISSUE

P-002

Layout: HIROYUKI IMAISHI Base Art: ATSUSHI NISHIGORI /

YOU YOSHINARI
Finish: SANOKUMI
SFX: DAISUKE KIKUCHI

Debut: MAIN VISUAL FOR TV SERIES

P-022

Illustration: SUSHIO
Finish:
SUSHIO / SANOKUMI

Debut: TOKUMA SHOTEN "ANIMAGE MONTHLY" JUNE 2007 ISSUE

P-012

Base Art: HITOMI HASEGAWA Finish: SANOKUMI BG: JUN TAMAYA

Debut: KADOKAWA SHOTEN "NEWTYPE MONTHLY" SEPTEMBER 2007 ISSUE

P-003

Base Art: ATSUSHI NISHIGORI Finish: SANOKUMI

ATSUSHI NISHIGORI Debut: MAIN VISUAL FOR TV SERIES

P-024

Base Art: CHIKASHI KUBOTAA Finish: SANOKUMI SFX: CHIKASHI KUBOTA

TOKUMA SHOTEN
"ANIMAGE MONTHLY"
SEPTEMBER 2007 ISSUE

P-014

Base Art: KOUICHI MOTOMURA Finish: SANOKUMI BG: BIHOU

Debut: KADOKAWA SHOTEN "NEWTYPE MONTHLY" OCTOBER 2007 ISSUE

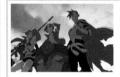

P-004

Base Art: ATSUSHI NISHIGORI Finish: SANOKUMI BG: DAISUKE KIKUCHI

Debut: KADOKAWA SHOTEN "NEWTYPE MONTHLY" SEPTEMBER 2006 ISSUE

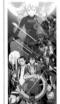

P-025

Base Art: CHIKASHI KUBOTA Finish: SANOKUMI SFX: CHIKASHI KUBOTA

Debut:
TOKUMA SHOTEN "ANIMAGE
MONTHLY" SEPTEMBER 2007 ISSUE

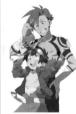

P-016

Base Art: KIKUKO SADAKATA Finish: SANOKUMI

Debut:
KADOKAWA SHOTEN "NEWTYPE MONTHLY FEBRUARY
ISSUE BONUS NEWTYPE
ROMANCE" WINTER 2007

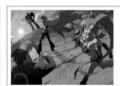

P-006

Base Art:
KOUICHI MOTOMURA
Finish: SANOKUMI
RG: BIHOU

Debut: KADOKAWA SHOTEN "NEWTYPE MONTHLY" JANUARY 2007 ISSUE

P-026

YAMATO KOJIMA Finish: SANOKUMI SFX: HIROMI WAKABAYASHI Debut:

TOKUMA SHOTEN "ANIMAGE MONTHLY" APRIL 2007 ISSUE BONUS CONTENT

P-017

Base Art:
KATSUZOU HIRATA
Finish: SANOKUMI

Debut:
KADOKAWA SHOTEN
"NEWTYPE MONTHLY
APRIL ISSUE BONUS
NEWTYPE ROMANCE"
SPRING 2007

P-008

Base Art: ATSUSHI NISHIGORI Finish: SANOKUMI SFX: ATSUSHI NISHIGORI

Debut:
KADOKAWA SHOTEN
"NEWTYPE MONTHLY"
OCTOBER 2006 ISSUE

P-026

Base Art:
MASAKI YAMADA
Finish:
NORIKO MASHIKO

Debut: GAKUSHU KENKYUSHA "ANIMEDIA MONTHLY" SEPTEMBER 2007 ISSUE

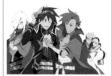

P-017

Base Art: KIKUKO SADAKATA Finish: SANOKUMI

Debut:
KADOKAWA SHOTEN
"NEWTYPE MONTHLY
NOVEMBER ISSUE
BONUS NEWTYPE
ROMANCE" AUTUMN 2007

P-009

Base Art: CHIKASHI KUBOTA Finish: SANOKUMI SFX: CHIKASHI KUBOTA

Debut: KADOKAWA SHOTEN "NEWTYPE MONTHLY" APRIL 2007 ISSUE

P-038

Illustration: HIROKI SHINAGAWA Debut: GAINAX NET "ALTERNATE VISIONS" ROUND 4

P-036

Base Art: SHINGO ABE Finish: SANOKUMI

Debut: KODANSHA "TV MAGAZINE" JULY 2007 ISSUE

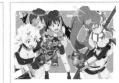

P-027

Base Art: ATSUSHI NISHIGORI Finish: SANOKUMI SFX: ATSUSHI NISHIGORI

Debut: HOBBY JAPAN "HOBBY JAPAN MONTHLY" MAY 2007 ISSUE

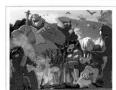

P-039

Illustration: HIROKI SHINAGAWA Debut: GAINAX NET "ALTERNATE VISIONS" ROUND 4

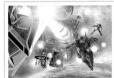

P-036

Illustration: DAISUKE SUZUKI (SANJIGEN)

Debut: KODANSHA "TV MAGAZINE" OCTOBER 2007 ISSUE

P-027

Base Art: KAZUHIRO TAKAMURA Finish: SANOKUMI SFX: KAZUHIRO TAKAMURA BG: BIHOU

Debut: GAKUSHU KENKYUSHA "MEGAMI MAGAZINE" JULY 2007 ISSUE (VOL.86)

P-039

Illustration:
HIROKI SHINAGAWA
Debut:
GAINAX NET
"ALTERNATE VISIONS"
ROUND E

P-037

Illustration:
HIROKI SHINAGAWA
Debut:

GAINAX NET
"ALTERNATE VISIONS"
ROUND 1

P-028

Base Art: SATOSHI YAMAGUCHI Finish: SANOKUMI

BG: JUN TAMAYA

Debut:
GAKUSHU KENKYUSHA
"MEGAMI MAGAZINE"
SEPTEMBER 2007 ISSUE (VOL.88)

P-040

Illustration:
HIROKI SHINAGAWA
Debut:
GAINAX NET
"ALTERNATE VISIONS"
ROUND 5

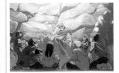

P-037

Illustration: HIROKI SHINAGAWA

Debut:
GAINAX NET
"ALTERNATE VISIONS"
ROUND 1

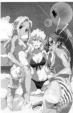

P-029

Base Art:
YAMATO KOJIMA
Finish: SANOKUMI

JUN TAMAYA

DECEMBER 2007 ISSUE (VOL.91)

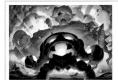

P-040

Illustration: HIROKI SHINAGAWA

Debut: GAINAX NET "ALTERNATE VISIONS" ROUND 6

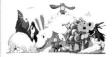

P-037

Illustration: HIROKI SHINAGAWA

Debut:
GAINAX NET
"ALTERNATE VISIONS"
ROUND 2

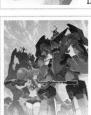

P-030

Base Art: YOU YOSHINARI Debut: VOL.02 COVER

P-040

Illustration: HIROKI SHINAGAWA

Debut:
GAINAX NET
"ALTERNATE VISIONS"
ROUND 6

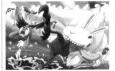

P-037

Illustration: HIROKI SHINAGAWA

Debut:
GAINAX NET
"ALTERNATE VISIONS"
ROUND 2

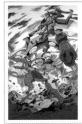

P-031

HIROAKI TOMITA
Finish: SANOKUMI

BG: HIROAKI TOMITA

Debut: KODANSHA "TV MAGAZINE" AUGUST 2007 ISSUE

P-040

Illustration: HIROKI SHINAGAWA

Debut: GAINAX NET "ALTERNATE VISIONS" FINAL ROUND

P-037

Illustration: HIROKI SHINAGAWA

Debut: GAINAX NET "ALTERNATE VISIONS" ROUND 3

P-032

AKIRA AMEMIYA
Finish: SANOKUMI

Debut: KODANSHA "TV MAGAZINE" MAY 2007 ISSUE

P-040

Illustration: HIROKI SHINAGAWA

Debut:
GAINAX NET
"ALTERNATE VISIONS"
FINAL ROUND

P-038

Illustration: HIROKI SHINAGAWA

Debut: GAINAX NET "ALTERNATE VISIONS" ROUND 3

P-034

AKIRA AMEMIYA
Finish: SANOKUMI

Debut: KODANSHA "TV MAGAZINE" JUNE 2007 ISSUE

P-055

Base Art: MASAHITO ONODA Finish: SANOKUMI

Debut: TOKUMA SHOTEN "MOEMAGE" FIRST ISSUE

P-051

Illustration: HIROKI SHINAGAWA

Debut: KADOKAWA SHOTEN "COMPTIQ MONTHLY" JULY 2008 ISSUE

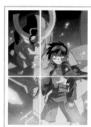

P-041

Base Art: ATSUSHI NISHIGORI Finish: SANOKUMI SFX: ATSUSHI NISHIGORI

Debut: ANIMATED FILM "THE CRIMSON LOTUS CHAPTER" MAIN VISUAL

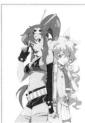

P-056

Base Art: ATSUSHI NISHIGORI Finish: SANOKUMI

Debut: ICHIJINSHA "CHARA * MEL" VOL.6 COVER

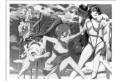

P-051

Illustration: HIROKI SHINAGAWA

Debut: KADOKAWA SHOTEN "COMPTIQ MONTHLY" AUGUST 2008 ISSUE

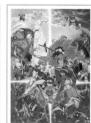

P-042

Base Art: YOU YOSHINARI

Debut:
ANIMATED FILM
"THE CRIMSON LOTUS
CHAPTER" MAIN VISUAL

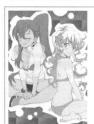

P-057

Illustration: ATSUSHI NISHIGORI

Debut: ICHIJINSHA "CHARA★MEL" VOL.6 PIN-UP

P-052

Illustration: HIROKI SHINAGAWA

KADOKAWA SHOTEN
"COMPTIQ MONTHLY"
SEPTEMBER 2008 ISSUE

P-043

Base Art: ATSUSHI NISHIGORI Finish: SANOKUMI SFX: ATSUSHI NISHIGORI BG: HIROKI SHINAGAWA

Debut: ANIMATED FILM OPENING PARTY MAIN VISUAL

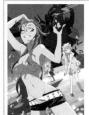

P-058

Base Art: RYOJI MASUYAMA Finish: SANOKUMI

Debut:
GAKUSHU KENKYUSHA
"MEGAMI MAGAZINE"
NOVEMBER 2008
ISSUE (VOL.102)

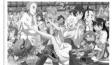

P-052

Illustration: HIROKI SHINAGAWA

Debut: KADOKAWA SHOTEN "COMPTIQ MONTHLY" OCTOBER 2008 ISSUE

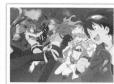

P-044

Base Art: ATSUSHI NISHIGORI Finish: SANOKUMI

Debut: KADOKAWA SHOTEN "NEWTYPE MONTHLY" APRIL 2008 ISSUE

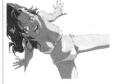

P-059

IKUO KUWANA

Finish: HIROMI WAKABAYASHI

Debut: GAKUSHU KENKYUSHA "MEGAMI MAGAZINE" OCTOBER 2008 ISSUE BONUS CONTENT (VOL.101)

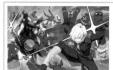

P-053

Illustration: HIROKI SHINAGAWA

Debut: KADOKAWA SHOTEN "COMPTIQ MONTHLY" NOVEMBER 2008 ISSUE

P-046

Base Art: HIROYUKI IMAISHI Finish: SANOKUMI

Debut: KADOKAWA SHOTEN "NEWTYPE MONTHLY" OCTOBER 2008 ISSUE

P-059

IKUO KUWANA

Finish: SANOKUMI

Debut:
GAKUSHU KENKYUSHA
"MEGAMI MAGAZINE"
OCTOBER 2008 ISSUE
BONUS CONTENT (VOL.101)

P-053

Illustration: HIROKI SHINAGAWA

Debut: KADOKAWA SHOTEN "COMPTIQ MONTHLY" DECEMBER 2008 ISSUE

P-048

IKUO KUWANA
Finish: SANOKUMI

SFX: FUMIHIKO MOROHASHI

Debut: KADOKAWA SHOTEN "NEWTYPE MONTHLY" NOVEMBER 2008 ISSUE

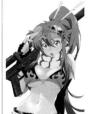

P-060

ATSUSHI NISHIGORI Finish: SANOKUMI SFX: ATSUSHI NISHIGORI

Debut: GAKUSHU KENKYUSHA "MEGAMI MAGAZINE" OCTOBER 2008 ISSUE COVER (VOLUM)

P-054

Illustration: ATSUSHI NISHIGORI

Debut: BIJUTSU SHUPPANSHA "COMICKERS ART STYLE" VOL.7 COVER

P-050

Base Art: KOUICHI MOTOMURA Finish: SANOKUMI

SFX: TOYONORI YAMADA

Debut: KADOKAWA SHOTEN "NEWTYPE MONTHLY" AUGUST 2008 ISSUE

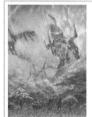

P-061

Illustration: YOU YOSHINARI

Debut: ANIMATED FILM "THE SPIRAL STONE CHAPTER" MAIN VISUAL

P-055

Layout: ATSUSHI NISHIGORI Base Art: RYOTA HAYATSU Finish: SANOKUMI

Debut: TOKUMA SHOTEN "ANIMAGE MONTHLY" AUGUST 2008 ISSUE

P-050

Base Art: ATSUSHI NISHIGORI Finish: SANOKUMI

SFX: FUMIHIKO MOROHASHI

Debut: KADOKAWA SHOTEN "NEWTYPE MONTHLY" SEPTEMBER 2008 ISSUE

P-092

Illustration: YOU YOSHINARI

Debut: ANIPLEX TV EDITION DVD VOLUME 8 BONUS BOX

P-078

Illustration: ATSUSHI NISHIGORI Debut: ANIPLEX TV EDITION DVD VOLUME 4 JACKET

P-062

Base Art: AKIRA AMEMIYA Finish: SANOKUMI

SFX: FUMIHIKO MOROHASHI BG: BIHOU

Debut: KADOKAWA SHOTEN "NEWTYPE MONTHLY" FEBRUARY 2009 ISSUE

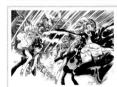

P-094

Illustration:
KAZUHIKO SHIMAMOTO
Debut:

Debut: ANIPLEX TV EDITION DVD VOLUME 5 BONUS DISK

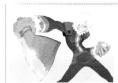

P-080

Illustration: ATSUSHI NISHIGORI

Debut: ANIPLEX TV EDITION DVD VOLUME 5 JACKET

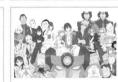

P-064

Base Art: SUSHIO Finish: SANOKUMI / SUSHIO

Debut: KADOKAWA SHOTEN "NEWTYPE MONTHLY" APRIL 2009 ISSUE

P-096

Illustration:
YUSUKE YOSHIGAKI
Debut:
ANIPLEX TV EDITION
DVD VOLUME 1
BONUS DISK

P-082

Illustration: ATSUSHI NISHIGORI

Debut: ANIPLEX TV EDITION DVD VOLUME 6 JACKET

P-066

Illustration: HIROKI SHINAGAWA

Debut:
KADOKAWA SHOTEN
"COMPTIQ MONTHLY"
FEBRUARY 2009 ISSUE

P-096

Illustration: YOU YOSHINARI

Debut: ANIPLEX ORIGINAL SOUNDTRACK CD JACKET

P-084

Illustration: ATSUSHI NISHIGORI

Debut: ANIPLEX TV EDITION DVD VOLUME 7 JACKET

P-068

Illustration: HIROKI SHINAGAWA

Debut: KADOKAWA SHOTEN "COMPTIQ MONTHLY" MARCH 2009 ISSUE

P-096

Illustration: YOU YOSHINARI

Debut: ANIPLEX ORIGINAL SOUNDTRACK CD JACKET

P-086

Illustration: ATSUSHI NISHIGORI

Debut: ANIPLEX TV EDITION DVD VOLUME 8 JACKET

P-070

Illustration: HIROKI SHINAGAWA

Debut: KADOKAWA SHOTEN "COMPTIQ MONTHLY" APRIL 2009 ISSUE

P-097

Base Art: ATSUSHI NISHIGORI Finish: SANOKUMI SFX: ATSUSHI NISHIGORI BG: BIHOU

Debut: SONY MUSIC RECORDS "SKY-BLUE DAYS" (GURREN LAGANN DISC) CD JACKET

P-088

Illustration: ATSUSHI NISHIGORI Debut: ANIPLEX TV EDITION DVD VOLUME 9 JACKET

P-072

Illustration: ATSUSHI NISHIGORI

Debut: ANIPLEX TV EDITION DVD VOLUME 1 JACKET

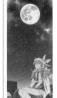

P-097

Finish: SANOKUMI SFX: ATSUSHI NISHIGORI BG: BIHOU

Base Art: ATSUSHI NISHIGORI

DEBUT: SONY MUSIC RECORDS "CONTINUING WORLD" (GURREN LAGANN DISC) CD JACKET

P-089

Illustration: ATSUSHI NISHIGORI Debut: ANIPLEX TV EDITION DVD VOLUME 9 JACKET

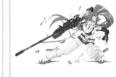

P-074

ATSUSHI NISHIGORI

Debut: ANIPLEX TV EDITION DVD VOLUME 2 JACKET

P-098

Illustration: ATSUSHI NISHIGORI

Debut: ANIPLEX BEST SOUND CD JACKET

P-090

Illustration: YOU YOSHINARI

Debut: ANIPLEX TV EDITION DVD VOLUME 2 BONUS BOX

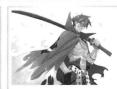

P-076

Illustration: ATSUSHI NISHIGORI

Debut: ANIPLEX TV EDITION DVD VOLUME 3 JACKET

P-107

Illustration SUSHIO

P-103

SUSHIO Debut. MOVIC STICK POSTER

P-100

Base Art: TADASHI HIRAMATSU Finish: SANOKUMI SFX: TADASHI HIRAMATSU

Debut: TABLIER COMMUNICATIONS RADIO CD "ONSEN TOPPA GURREN LAGANN KADIO" TOPPA 1 JACKET

P-108

Illustration SUSHIO

Debut: MOVIC STICK POSTER

P-104

YUKA SHIBATA BG: BIHOU

Debut: MOVIC STICK POSTER

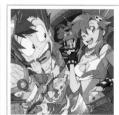

P-100

Base Art: TADASHI HIRAMATSU Finish: SANOKUMI SFX: TADASHI HIRAMATSU

Debut: TABLIER COMMUNICATIONS RADIO CD "ONSEN TOPPA GURREN LAGANN RADIO" TOPPA 2 JACKET

P-108

SUSHIO

Debut: MOVIC STICK POSTER

P-104

Illustration: SUSHIO

Debut: MOVIC STICK POSTER

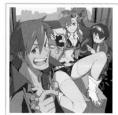

P-100

Base Art: TADASHI HIRAMATSU Finish: SANOKUMI SFX: TADASHI HIRAMATSU

Debut: TABLIER COMMUNICATIONS RADIO CD "ONSEN TOPPA GURREN LAGANN RADIO" TOPPA 3 JACKET

Illustration: SUSHIO

Debut: MOVIC STICK POSTER

P-105

Illustration SUSHIO

MOVIC STICK POSTER

P-100

Base Art: YUKA SHIBATA SANOKUMI

Debut: MOVIC ZIPPER

P-109

Illustration: SUSHIO

Debut: MOVIC STICK POSTER

P-105

SUSHIO

Debut: MOVIC STICK POSTER

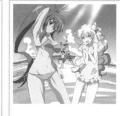

P-101

Base Art: SATOSHI YAMAGUCHI Finish: JUN TAMAYA BG: JUN TAMAYA Debut

P-110

KAZUHIRO TAKAMURA Finish: SANOKUMI SFX: KAZUHIRO TAKAMURA Debut: COSPA YOKO BODY

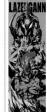

P-106

Illustration: SUSHIO

Debut: MOVIC STICK POSTER

P-101

MOVIC FAN

Layout: ATSUSHI NISHIGORI Base Art: AKIKO NAKAMURA Finish: SANOKUMI

ANIPLEX CHARACTER SONG CD JACKET

P-110

PILLOW COVER

KAZUHIRO TAKAMURA Finish: SANOKUMI SFX: KAZUHIRO TAKAMURA

COSPA YOKO BODY PILLOW COVER

P-106

Illustration: SUSHIO

MOVIC STICK POSTER

P-102

Illustration SUSHIO

Debut: MOVIC STICK POSTER

P-111

Base Art: ATSUSHI NISHIGORI Finish: SANOKUMI SFX: ATSUSHI NISHIGORI COSPA YOKO BODY PILLOW COVER SPACE LOOK & YOMAKO

P-107

Illustration SUSHIO

MOVIC STICK POSTER

P-103

SUSHIO MOVIC STICK POSTER

P-124

Illustration: YUJI KAIDA

Debut:
KOTOBUKIYA
"TENGEN KADOU
GURREN LAGANN"
PLASTIC MODEL

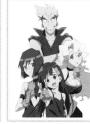

P-118

KOUICHI MOTOMURA Finish: SANOKUMI KONAMI TRADING CARD

P-111

Base Art: ATSUSHI NISHIGORI Finish: SANOKUMI SFX: ATSUSHI NISHIGORI

COSPA YOKO BODY PILLOW COVER SPACE LOOK & YOMAKO

P-126 Illustration: HUMBOLDT

Debut: "TENGEN KADOU GULAPARL" (MASS PRODUCTION / GGIMY / DARY) PLASTIC MODEL PACKAGE

P-119

Base Art: CHIKASHI KUBOTA Finish: SANOKUMI

KONAMI TRADING CARD

P-112

KAZUHIRO TAKAMURA Finish: SANOKUMI SFX: KAZUHIRO TAKAMURA

Debut: COSPA NIA BODY PILLOW COVER

P-126

Illustration HIDEKI ISHIKAWA

KOTOBUKIYA "GURREN" PLASTIC MODEL PACKAGE

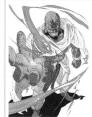

P-120

Base Art: SUSHIO KONAMI TRADING CARD

P-112

Base Art: KAZUHIRO TAKAMURA Finish: SANOKUMI SFX: KAZUHIRO TAKAMURA Debut

COSPA NIA BODY PILLOW COVER

P-126

HIDEKI ISHIKAWA KOTOBUKIYA "ENKI" PLASTIC MODEL PACKAGE

P-121

Base Art: HIROYUKI IMAISHI Finish: SANOKUMI

P-113

Base Art: SUSHIO Finish: SANOKUMI / SUSHIO SFX: TOMOHIKO KOMIYA Debut: KONAMI TRADING CARD

P-127

Illustration: HIDEKI ISHIKAWA KOTOBUKIYA "KING KITTAN" PLASTIC MODEL PACKAGE

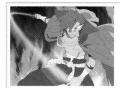

P-122

KONAMI TRADING CARD

Base Art: AKEMI HAYASHI Finish: SANOKUMI SFX: AKEMI HAYASHI BG: BIHOU

Debut: KONAMI UNRELEASED ILLUSTRATION

P-114

Base Art: CHIKASHI KUBOTA Finish: SANOKUMI

KONAMI TRADING CARD

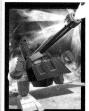

P-127

HIDEKI ISHIKAWA

Debut: KOTOBUKIYA "DAYAKKAISER" PLASTIC MODEL PACKAGE

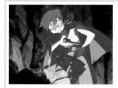

P-122

Base Art: AKEMI HAYASHI Finish: SANOKUMI SFX: AKEMI HAYASHI BG: BIHOU

KONAMI UNRELEASED ILLUSTRATION

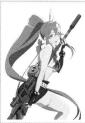

P-115

Base Art: CHIKASHI KUBOTA Finish: SANOKUMI

Debut: KONAMI TRADING CARD

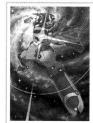

P-128

HIDEKI ISHIKAWA KOTOBUKIYA "GURREN LAGANN" PLASTIC MODEL PACKAGE

P-123

Base Art: AKEMI HAYASHI Finish: SANOKUMI SFX: AKEMI HAYASHI BG: BIHOU

Debut: KONAMI UNRELEASED ILLUSTRATION

P-116

Base Art: SUSHIO

Debut: KONAMI TRADING CARD

P-123

Base Art: YUKA SHIBATA Finish: SANOKUMI BG: BIHOU

KONAMI UNRELEASED ILLUSTRATION

P-117

Base Art: KIKUKO SADAKATA Finish: SANOKUMI

Debut: KONAMI TRADING CARD

ART WORKS Crimson Lotus / Spiral Stone

ENGLISH EDITION CREDITS

English Translation - M. KIRIE HAYASHI Proof Reading - MICHELLE LEE

UDON STAFF

Chief of Operations - ERIK KO
Managing Editor - MATT MOYLAN
Director of Marketing - CHRISTOPHER BUTCHER
Marketing Manager - STACY KING
Associate Editor - ASH PAULSEN
Production Manager - JANICE LEUNG
Japanese Liaisons - M. KIRIE HAYASHI, STEVEN CUMMINGS

JAPANESE EDITION CREDITS

special thanks

株式会社ガイナックス 株式会社アニブレックス 株式会社徳間書店 株式会社学習研究社 株式会社講談社 株式会社一迅社 株式会社ホビージャパン 株式会社美術出版社 株式会社ムービック コナミ株式会社 株式会社壽屋 株式会社コスパ タブリエ・コミュニケーションズ株式会社 株式会社ソニー・ミュージックレコーズ

art direction + design 上杉季明 (マッハ55号)

chief editor 榎本郁子 梶井斉 editor

三枝あすか

発行者 井上伸一郎

発行 株式会社角川書店

発売 株式会社角川グループパブリッシング

TENGENTOPPA GURREN LAGANN ILLUSTRATIONS: GURREN LAGANN

© GAINAX, KAZUKI NAKASHIMA / Aniplex, KDE-J, TV TOKYO, DENTSU © GAINAX, KAZUKI NAKASHIMA/Gurren Lagann-Movie Committee

Edited by KADOKAWA SHOTEN

First published in Japan in 2009 by KADOKAWA CORPORATION, Tokyo. English translation rights arranged with KADOKAWA CORPORATION, Tokyo. through Tuttle-Mori Agency, Inc., Tokyo.

> English edition published by UDON Entertainment Corp. 118 Tower Hill Road, C1, PO Box 20008, Richmond Hill, Ontario, L4K 0K0, Canada

Any similarities to persons living or dead is purely coincidental.

No part of this publication may be reproduced, stored in retrieval systems, or transmitted in any form or by any means (electronic, mechanical photocopying, recording, or otherwise) without the prior written permission of the publisher.

www.UDONentertainment.com

Printed by Suncolor Printing Co. Ltd. E-mail: suncolor@netvigator.com

First Printing: April 2014 ISBN-13: 978-1-927925-07-2 ISBN-10: 1-927925-07-X

Printed in Hong Kong